Girton: Thirty years…

…in the life of a Cambridge College

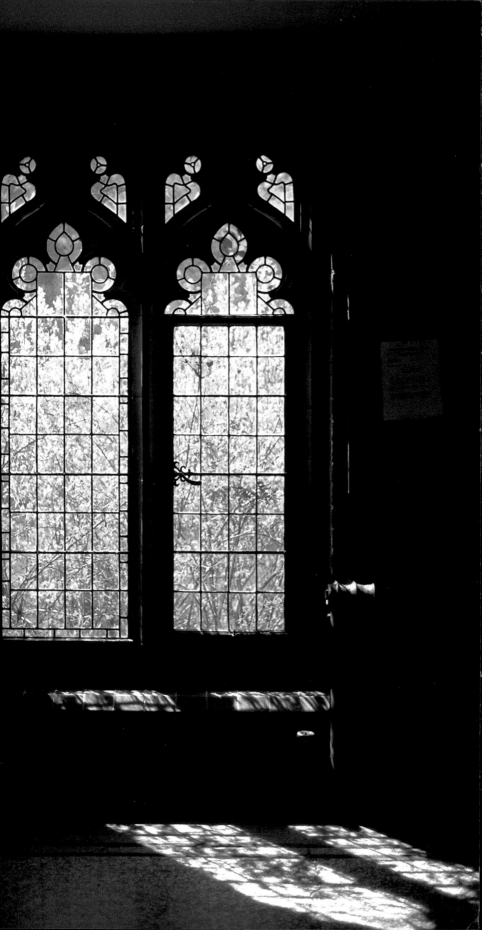

Girton: Thirty years…

…in the life of a Cambridge College

Compiled by Marilyn Strathern

THIRD MILLENNIUM
PUBLISHING, LONDON

Copyright © Girton College and
Third Millennium Publishing Ltd

First published in 2005 by Third Millennium Publishing Ltd,
a subsidiary of Third Millennium Information Ltd

2–5 Benjamin Street
London
EC1M 5QL
www.tmiltd.com

ISBN 1 903942 34 9

British Library Cataloguing in Publication Data

A CIP catalogue record for this book is available from the
British Library.

Edited by Val Horsler

Designed by Matthew Wilson

Printed by MKT Print d.d., Slovenia

Huge thanks are due to all the contributors to this volume who
responded generously and enthusiastically when asked to participate.
Generous too were the resources, efforts, time and care given to the
enterprise by busy members of the College. Many of them are also
authors and you will find their names elsewhere in the book. The
name of the former Vice-Mistress, Gillian Jondorf, does not appear
under any particular contribution, but her influence is to be found
throughout.

The contributions have been edited and, in some cases, shortened,
and notes and references have been kept to a minimum. The full
original texts are to be found in the Girton Archive.

Picture Acknowledgements:
Photographs on pages 2, 5, 7, 9, 10, 11, 16, 24, 40, 41 (top two), 42,
43, 53, 64, 70, 72, 74, 75, 76/7, 78, 83, 90, 96, 102, 110, 112, 122, 124,
127, 130, 136, 137, 138, 143, 154, 159, 175, 178 © Peter Ashley; pages
6, 12, 13, 14/15, 19, 30 (left and bottom right), 32, 39, 45, 48, 65, 73,
146, 147, 156, 157, 164 © Girton College; pages 117, 118, 125 © Nigel
Luckhurst; pages 126, 128/9 © Nigel Stead; pages 20, 185, 186, 187 ©
Stephen Bond; page 18 © Robin Miralles; page 27 © Neville Taylor;
page 30 (top right) © John Thompson; page 31 © JET Photographic;
page 41 © Peter Sparks; page 57 © Beck, *Daily Telegraph*; page 103
© Helen Chown; page 163 © Lucinda Douglas-Menzies; page 165
© Frances Gandy; page 177 © A C Cooper Ltd

Every effort has been made to trace and credit copyright holders; we
will be pleased to correct any unintentional errors or omissions in
subsequent editions of this book.

Contents

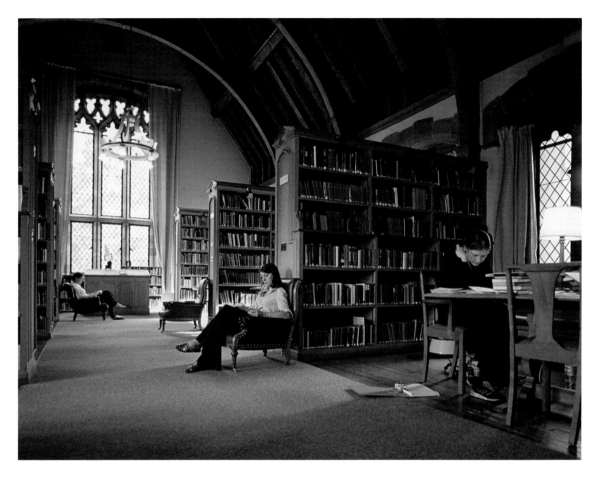

Foreword

Alison Richard

Vice-Chancellor, University of Cambridge

The colleges lie at the heart of the University. Evolving over the last 800 years, they have allowed Cambridge to solve a modern organisational problem that could never have been foreseen by their medieval founders. The brilliance of the collegiate system is the way it has allowed the University to configure the last 100 years of expansion – the period when our modern disciplines got into their stride and 'education for all' began to acquire a reality. 'Growing large, remaining intimate' is a theme that the Mistress of Girton College takes up at the end of this splendid volume. For Cambridge has been able to grow while offering a supportive working environment quite distinct from the laboratory or department, and, in that intimacy, provide opportunities for crossing boundaries in teaching and research, generational boundaries and, more and more, international boundaries. And, very importantly, Cambridge has been able to grow in response to an increasing demand for higher education from people who would never before have contemplated such a move in their lives.

But if the colleges lie at the heart of the University, then the reverse is also true, and not least in the case of Girton. The colleges exist to promote the education of students and enhance the research of staff. The changing nature of disciplines; innovations in practices of teaching and scholarship; a keen interest in what Cambridge students go on to do after they have graduated; how an academic establishment can relate to a wider world – these are simultaneously facets of University and college life alike. In the accounts that follow, we see very clearly just how that close relationship between the two was to give Girton its reason for 'going mixed'.

This ambitious book makes much else clear as well! It is an original work from an original college – the first college at either Cambridge or Oxford for women was also the first of the women's colleges to take men. But what I appreciate most about this volume is its bold attempt to put the character of college life into a broader context, and to answer the 'why' question as well as the 'how'.

In sum, there is much that will be of value here to anyone interested in higher education, in how structure and culture can be designed and deployed to create the ideal environment for the creation and importing of knowledge. This is also a book for those who want to know how old places stay young, and how pioneering pasts are turned into pioneering futures. What is written about Girton from the many contributors to this book is also written about the University.

It is my pleasure and pride to be part of Cambridge – and my particular pride to welcome this book as a contribution to understanding, through the prism of a unique college, what makes it what it is.

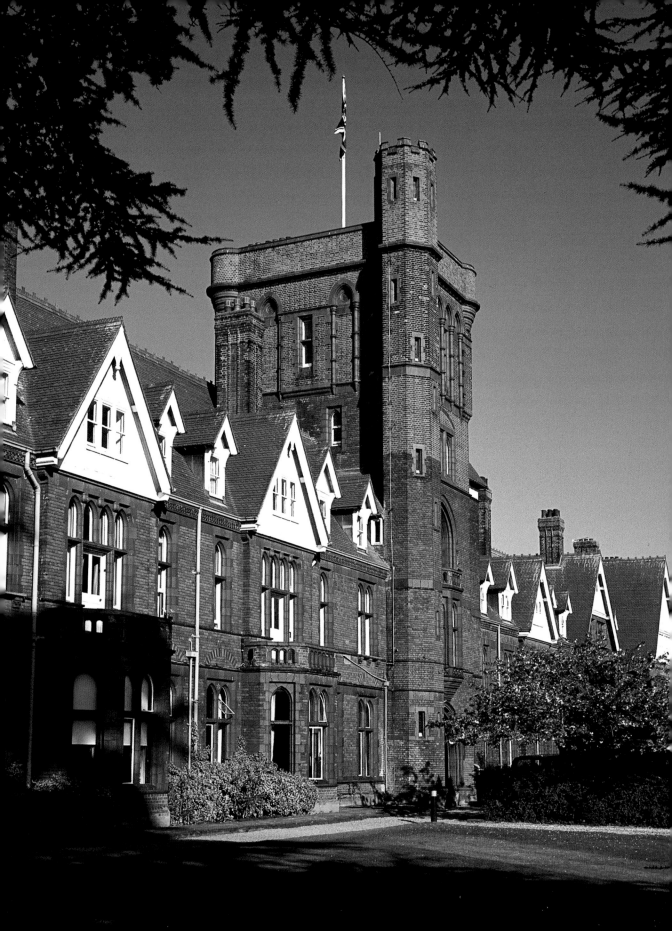

Introduction

Trevor Rayment

Thirty years is a short time in the life of a Cambridge college; but, for Girton, thirty years is the time between the decision to admit men to the College and the construction of an archive building and IT suite for Girton's Library. At first sight it may seem odd to select such different punctuation marks in the history of the College, and this stimulates the question: what has happened since 1976 to make it so? This collection of essays reflects upon the events leading up to and following the decision. It looks back over thirty years, drawing upon the story of the previous 110, and in so doing illuminates the path for the next generation.

Girton: Thirty years… in effect takes up where Muriel Bradbrook's *'That Infidel Place'*, published in the centenary year of 1969, left off. But it is not just a continuing history of the College. It is more than that: a way of looking forward while looking back, challenging some of the issues of the past while drawing the beginnings of conclusions for the future, and celebrating some great achievements.

When I joined Girton in the early 1980s, the College was already fully mixed and both Fellows and students were completely comfortable with its status. The extent and depth of the upheavals that led to the decision to go mixed were not to be seen. It was as if the College had always been mixed – except for the preponderance of sensible traditions that only a women's college might generate. Girton was remarkable for the warm welcome it proffered to new Fellows, students and staff. The personal accounts in the early chapters of this book give a human perspective to a decision that, with the benefit of hindsight, was inevitable. These essays do portray the fears and uncertainties felt during those transitional months and years, but, much more, they transmit the overwhelming surprise and pleasure that the

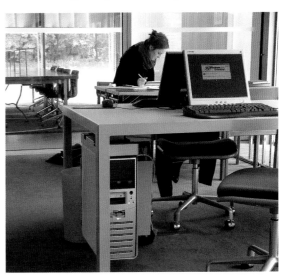

Part of the new IT suite in the Duke Building

transition from single-sex to co-residence went so smoothly. It is refreshing to see that those who played such pivotal roles claim so little personal credit for the success.

Going mixed proved to be just the beginning of change. It is freely admitted in these pages that, in 1976, Girton was responding first to changes within Cambridge and then to the changing expectations of society. But few realised at that time how much more change would be imposed upon university education over the next thirty years. Many contributors to this book have given the greater part of their working lives to educating students at Girton. Their reflections are independent-minded, not always in agreement, sometimes providing uncomfortable reading. The issues raised are central to the debate of what constitutes first a Cambridge education, and then a university education. What should be the role of an academic in the twenty-first century? Is there a future for independent scholarship?

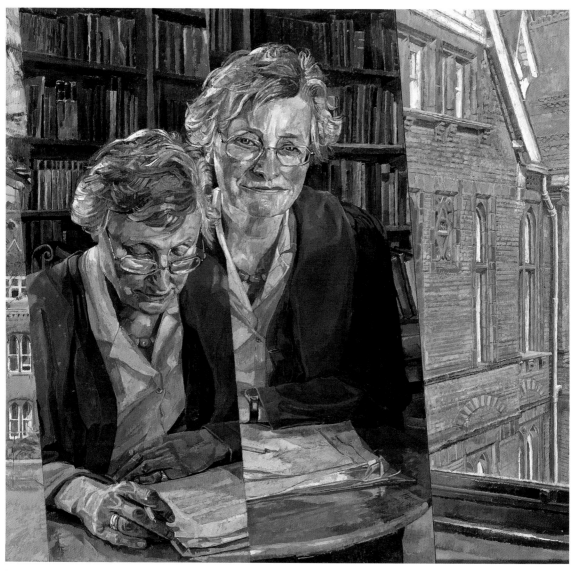

Marilyn Strathern, Mistress 1998–present, painted by Daphne Todd RP

changing environment of access, audit and accountability, allowing organisational reinvention while remaining true to its core objectives of pursuing the highest standards of scholarship and providing the widest and deepest education for all its members.

Through personal histories, this book shows how Girton has changed the outlook of students and Fellows. Compelling stories are told of lives whose threads link continents and cultures; stories of life-shaping experiences; stories that link Girton to the world and the world to Girton. Much has been written of and by the new generation of Girtonians. Less has been said by those of the previous generation whose vision of Girton was so radically changed in 1976. Now that the visible changes have long been completed, we see with clarity that those aspects of Girton that make it so special – its history of pioneering education, the creation of opportunity and the sense of community – reunite the generations. This book creates a new opportunity for dialogue between generations of Girtonians.

I must finish by acknowledging those who have steered the book from the beginning: Professor Dame Marilyn Strathern, the Mistress of Girton, and Val Horsler, the editor. Val was the first to perceive the timeliness of this book and the need to retell the story of Girton; the Mistress saw the opportunity to formulate a new type of college narrative. Only through their gentle cajoling of contributors, boundless enthusiasm and consistent attention to detail has this remarkable account of a unique community emerged.

These pages show that, for Girton, the clash of the past thirty years has not been between academic freedom and public accountability, but between academic freedom and lack of finances. The same is true of Cambridge as a whole. A deliberate reduction of public funds for collegiate education, and an unforeseen change in UK taxation law, have converged to raise the spectre of long-term insolvency. This has provided unexpected benefits to the whole college community, inasmuch as it has compelled the colleges to re-evaluate their priorities and to cut away peripheral expenditure. To an outsider, the adoption of 'company style' management accounts is an obvious first step, but within Cambridge this was a revolution. Knowing the actual cost of things that college communities take for granted, such as eating together, has compelled colleges to give them their proper value. Girton has a long-standing tradition of employing College Teaching Officers who have international reputations for teaching and scholarship. Among the challenges the University faces is precisely the re-evaluation of the role that colleges play in the education of undergraduates. Girton exemplifies the extent to which the University relies upon the colleges for core teaching in many disciplines. Thus it has found itself at the forefront of the debate on how the University may respond to the

After graduating in Chemistry from Durham and gaining his DPhil at Oxford, Trevor Rayment came to Cambridge in 1980 as the first BP-Linnett Fellow in Chemistry at Sidney Sussex. He was subsequently appointed Lecturer and Reader in the Department of Chemistry. His research interests lie in the development of novel techniques for studying surfaces and interfaces of materials in their working state, especially those involved in catalysis and electrochemistry. He has been a Fellow of Girton since 1984 and has also served as Tutor, Director of Studies in Physical Sciences (jointly with Julia Riley) and Vice-Mistress.

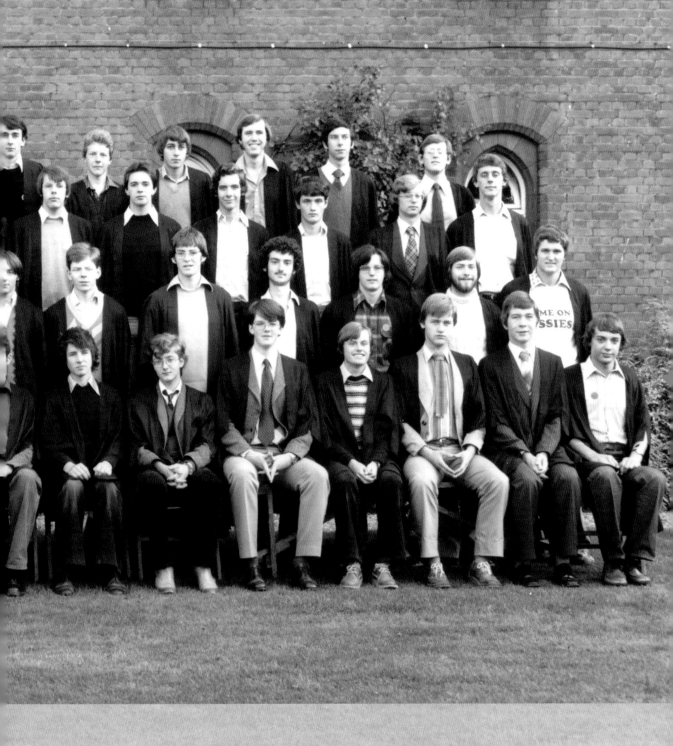

PART ONE: WATERSHED

Chapter 1
Girton goes mixed

The announcement that Girton's Governing Body had resolved 'in addition to the admission of women, the admission of men to the College' was circulated to Old Girtonians by a cyclostyled insert in the 1976 *Newsletter*. This was in the same term that Brenda Ryman succeeded Muriel Bradbrook as Mistress. Fellows were to be admitted at once, graduates the following year and undergraduates sometime after 1978. In several of the accounts that follow, the first entrants replay the moment in terms of their own first arrival.

'Great news – Girton is going mixed'
Diana Barkley

I recall my mother's excitement as she opened the front door of our London home on her return from Cambridge one autumnal Sunday afternoon in November 1976. 'Great news – Girton is going mixed.'

For a fresh-faced, first-year medical student at London University this did not seem all that momentous. But later I understood what a huge step Girton had taken as the first Oxbridge women's college to admit men.

My mother, Brenda Ryman, had officially been in her position as Mistress of Girton for only a month when the Governing Body resolved to admit men. The change was very much in keeping with her decisive personality, progressive views and support of mixed university

education. 'Obviously there are some people who don't favour change but it has been extensively debated and there is no undue opposition,' she said in an article entitled 'Calm Girton told: Men are on way' (*Daily Mail*, November 1976). She was never shy of radical change – after all, she had just taken up her position at Girton under rather unprecedented circumstances, commuting between London and Cambridge, working half the week as Professor of Biochemistry at London University and the other half as Mistress of Girton, and juggling family life as well. She was also the first married Mistress, a situation that had also required change: my father was given dining rights so that he did not have to be a guest when he ate with her at High Table.

Before the decision to open Girton's doors to men, the Governing Body had agreed on the need for the College to remain attractive to the best students, given that women had recently gained the opportunity to apply to men's colleges in the centre of Cambridge. However, some people were very concerned about the practicalities: could male and female students easily live side by side in Girton? My mother seemed to feel this would not be a major issue. I recall her saying (with a smile) that she did not see too much of a problem, given that there already seemed to be an almost equal number of male and female students on their way to the bathroom on a Sunday morning.

Previous pages: the first men undergraduates, autumn 1979

Brenda Ryman was determined that Girton students would embrace co-residence wholeheartedly and move quickly to become a mixed college to be reckoned with. She shared her ambitious target with us at home: 'Girton will have women engineers and a men's football blue in the first years of mixed undergraduate admissions.' Today those targets may not seem so stretching, but that is only because of what has been achieved since those early days, with dramatic changes in opportunities for men and women. An article from an unlikely source on women in science and technology (*Vogue*, 1986), citing Brenda Ryman and entitled 'Outstanding women in a field of learning once considered poison to the female intellect', highlighted the weaknesses of women in sciences and new branches of technology; it quoted the interesting statistics that, at that time, twice as many boys as girls took O-levels and A-levels in computer studies and that in university engineering courses there were around 55,000 male students to 4,000 female students.

Although only from the sidelines, I am delighted to have witnessed the very exciting time when Girton went mixed. I am grateful to have been brought up in a household that offered educational equality to both sexes. As a second generation full-time working mother I intend to instill the same belief in my children, that enormous opportunities in any chosen career are open to them. I was amused when, looking through some press cuttings to prepare this article, I read an interview with my mother in the *Cambridge Evening News* ('Girton head set for 7-day working week', October 1976): when asked whether her children had suffered any traumatic effects through not having the undivided attention of their mother, 'I don't see any signs of it,' she said with a smile. I certainly don't feel so, but I may not be the best judge!

Diana Barkley qualified in Medicine at London University, and then practised hospital medicine for eight years, including a period of immunology research for her MD thesis. She subsequently joined the pharmaceutical industry and currently runs a company providing medical and scientific communication services for international pharmaceutical companies.

The first men Fellows
John Marks

The year 1976 was a good one for me. I had retired from a senior management post in London to return to academic medicine in Cambridge, and Dr Biddy Kingsley Pillars, with whom I had shared a room at Addenbrooke's Hospital for some years, asked if I would like to join her as the second Director of Medical Studies at Girton College. I was assured that Girton would be delighted to have me but that, because of the female strictures of the Foundation, she was afraid that it would be without a Fellowship. I agreed, and joined the College in this role in October 1976. It was one of the best decisions I have ever made.

Some two months later the change to a mixed Foundation was announced, and in January 1977 Frank Wilkinson and I were admitted as the first male Fellows. It might have been expected that, in such an entrenched female foundation (the first to be founded for women), an invasion by males would have been greeted with horror and strenuously resisted. Certainly these, in reverse, were the attitudes of many of those within the male bastions of Cambridge academia, which were slowly and unwillingly becoming mixed. Indeed, it would be more accurate to say that they were not becoming truly mixed, but were taking in as small a proportion of women as could be seen to be compatible with the concept of a mixed community.

John Marks supervises medical students in 1988

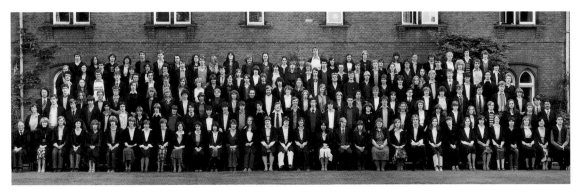

The first mixed intake, autumn 1979

In Girton, the opposite was true, in terms both of concept and realisation. The 'natives' were delightfully friendly right from the beginning, and on no occasion did I ever feel that we were other than equal members of a charming community whose whole intention was to make a success of the task of 'going mixed'. For this attitude the entire Foundation, College Officers, Fellows, scholars and students, are to be congratulated.

In particular, the then Mistress, Professor Brenda Ryman, and Dr (now Professor) Melveena McKendrick, then Senior Tutor, displayed praiseworthy wisdom. It was they who, as soon as the decision to go mixed was announced, set up a student committee to decide how this could best be achieved. Various options were considered including segregating whole wings of the College, or individual corridors, for men and women. But their far-sighted decision, particularly for those days, was to agree that, if they were to go mixed, they really would go mixed on all corridors, apart from one part of the College that would be reserved for those constrained by cultural or religious requirements.

Mixed Girton went from the first day that undergraduates were admitted (in October 1979). For the rest of 1977–8 the male Fellowship was developed, and in 1978–9 a few male graduate students joined the community. It was during this early period that I experienced for the first and only time the somewhat daunting experience of sitting down in Hall as the sole male in a gathering of some 200 'Old Girtonians'. I remember it well – not for any embarrassment I felt, but because, just as the first course was about to be served, someone there fainted and I spent the rest of the dinner in the Fellows' Drawing Room acting in a professional capacity.

But what of the first male undergraduates? It would be inaccurate to suggest that they had been selected solely on academic criteria, though this was a major part of the selection process, as it always has been at Girton. However, given appropriate academic ability, preference was given to those whose personality, it was hoped, was sufficiently mature to cope with the numerical inequality. They were few in number, but cope they did! Their attitude from the first day was that Girton was going to demonstrate best how to be mixed, and that the best of male characteristics should be demonstrated.

A clear memory is that, by the end of the first week of the 1979 Michaelmas Term, Girton had a men's team in rugby, soccer and squash, as well as an eight on the river – all taken from some twenty men who understood at least the principles of these sports, if not the finer points. This they achieved while at the same time satisfying their Directors of Studies and gaining tripos results that did not let Girton down.

Three enduring memories to conclude:
- Pleasant revision supervisions on sunny May days under the trees; impossible in central colleges.
- The men's eight winning blades for the first time and rowing back with flag flying and bagpipes playing in the bow seat.
- Perhaps the most striking, the changed atmosphere in College in the evenings. In 1977, College was empty in the evenings, with the women pursuing

their social interests in the men's colleges in the centre. By 1980 Girton had become a hum of youth enjoying life to the full – exactly what a community of youth should be, all in their different ways trying to put the world to rights.

John Marks graduated in 1946, came to Cambridge to do research and was subsequently appointed to a medical post in the University. From 1956 he spent twenty years in management in industry. He returned to Cambridge in 1976, was appointed one of the first male Fellows in Girton in 1977 and since then has held various College and University posts.

Roland Randall

I had been supervising Girton geography students for Dr Jean Grove since 1972, when I had returned to Cambridge from the University of Ulster in Coleraine. As I was initially living in Norfolk at the behest of the then Board of Extra-Mural Studies, I had not sought a college connection other than taking up dining rights at my old College, St Catharine's. In 1976 the Extra-Mural Board appreciated that I was servicing my subject rather than a geographical region, and asked me to live in the Cambridge area. Both Emmanuel and Girton invited me for interview, and both offered me a Fellowship. It was a delightful choice to have to make – a traditional older college in the centre of town, or a newer college embarking on a new era on the outskirts. My choice was immediate. Girton seemed vibrant, exciting and above all friendly. I was pre-elected to a Fellowship in the Spring Term of 1977 and admitted in the Michaelmas.

At interview I was surrounded by women, a situation that suited me and was to be the norm for several years to come. But at no time, then or later, was I made to feel unwelcome, though I was to discover that discussion about going mixed had been both long and heated. Once the decision had been made, however, no one appeared to disapprove of my presence. An early recollection was going in to the SCR after Hall after my interview, to be greeted by Gillian Jondorf. She sat down on the rug in front of the hearth, kicked off her shoes, patted the floor beside her and suggested I join her for a chat! My immediate feelings were positive. If this was the relaxed way in which Girtonians behaved,

then this was the place for me – though in those early days life could sometimes be a little confusing. The kitchen was not overly familiar with male appetites, for instance, and I remember the embarrassment of taking *all* the custard sauce on my apple pie, thinking it was an individual helping, not for all of High Table.

I was soon appointed to College committees. Chapel Committee met under the chairmanship of Brenda Ryman at 7.30am on Saturday mornings – not a time I had ever been called to committee before (or since!). Alternate Friday afternoons in term were for Council meetings. One of my first meetings saw all the important business steered through very quickly and efficiently by Brenda, followed by hours discussing the need or otherwise to have a cat-flap in the main doors for the College cat. I soon began to realise what a wily and able chairperson we had.

Those first years did not seem to have the frenetic pressures of later times. In the first few Easter terms and summers I remember many relaxing lunches in the Fellows' Garden with the Librarian, Marg Gaskell, and the Domestic Bursar, Margaret Hennessey, discussing how the College was coping with the influx of male graduates and then undergraduates. On the whole it seemed that the change took place remarkably smoothly. Alison Duke was a great help in the early years, telling me about the history of the College and filling me in on all those snippets of vital information not found in 'Morgan and Wood'.[1] She explained how to pronounce the names of our benefactors, and told me who created the hassocks in Chapel and how to sing the College songs.

Roland Randall supervises a class of geographers, 2005

Jean Grove was very keen that first-year geographers were primarily supervised 'in house', a tradition that we maintain to the present day. When supervisions included men for the first time, some of the women were wary of putting forward their points of view. However, a series of field trips in the Michaelmas Term soon served to prove that men were not a different animal – just a different gender, and often one that needed help in living away from home.

In most respects the watershed was crossed without difficulty. There was an inevitable loss of some of the best female geographers to downtown mixed men's colleges, and some early male applicants were not of a calibre worthy of consideration. However, some schools soon began to send their best male candidates for interview, simply because of Girton's tradition as a well-respected geography college where dissertation research in remote parts of the world was encouraged. Within three or four years the numbers of men and women reading Geography were often equal and the ranking across the colleges remained high. In 1977 I was delighted to join Girton, and as senior male Official Fellow I am still proud to have been part of this great change.

Roland Randall graduated in Geography from St Catharine's College, Cambridge, in 1966 and, after some years in Northern Ireland, returned to Cambridge in 1972 as a staff tutor at the Board of Extra-Mural Studies. He became one of Girton's first male Fellows in 1977, as well as Director of Studies in Geography, a post he still holds. He has also been a Tutor and Praelector at Girton, Director of Studies in Geography at Churchill College and is currently also Director of Studies at St Edmund's College, Cambridge.

The first men Research Fellows
John Davies

It seems strange to me now that there was a time when I did not know Girton College; strange that at Christmas 1973 – three months after I came from Australia to work with Malcolm Gerloch in the Chemical Laboratory – I passed Girton several times a day without knowing that it would become part of my life. I was helping Malcolm move house that Christmas, from Longstanton to central Cambridge, and, because the van he had borrowed from Trinity Hall was extremely small, many trips along the Huntingdon Road were required to complete his move. The trips were great fun: as always, Malcolm's conversation was wide-ranging and incessant, devoted to explaining the Cambridge sights. 'That's Girton College,' he would say every time we passed. 'It's a college for women.' I remember his voice, invariably hushed and tinged with awe and respect. The buildings, glimpsed through mature trees, looked impressive but somehow remote and austere, not part of our Chemical Laboratory world.

More than three years were to elapse before Girton came again to my attention. In 1977 Malcolm announced that Girton was soon to admit men, and suggested that I should apply for one of its recently re-advertised Research Fellowships. With characteristic honesty, he also explained his ulterior motive: if my application was successful, he could use my grant to support someone else! A short time later I found myself cycling under the Girton archway for the first time, delivering seven copies of a hastily assembled Research Fellowship application to the Porters' Lodge, less than one hour before the deadline expired. Later, when I learned that my application had succeeded, I was pleased but vaguely bemused and troubled: I had then no experience of Cambridge college life, no real idea of what would be expected of me.

During the months before I moved into College, several events heightened my concern. Sitting in the laboratory tearoom one morning, Malcolm and I were joined by Ralph Raphael, Professor of Organic Chemistry. Following a chance remark, the Professor suddenly realised that I was soon to live in Girton College – one of the first five male Fellows to do so. The effect was electric: his eyes boggled and he immediately quoted some lines from Kipling:

When the Himalayan peasant meets the he-bear in his pride,
He shouts to scare the monster, who will often turn aside.
But the she-bear thus accosted rends the peasant tooth and nail
For the female of the species is more deadly than the male.

It was an unnerving experience! I wasn't used to famous professors quoting poetry at me. Later, in the silence of the library, I studied the lines at leisure, an exercise that did nothing to calm my growing sense of alarm. Soon afterwards, in the offices of an insurance company, I found myself the only customer at a quiet row of teller windows. When I said that my new address would be Girton College, the effect was again dramatic: five pairs of eyes at adjacent windows all swivelled towards me in perfect unison, as if connected by some mechanical apparatus, and surveyed me with arched eyebrows. When I finally moved into residence at Girton – at the beginning of October 1977 – I was uncharacteristically nervous and apprehensive.

The climax of this apprehension occurred at the party given by the Fellows and their spouses to welcome new Fellows. Walking into the Fellows' Drawing Room for the first time, wearing a new suit that had impoverished me, I was confronted by a room full of people who all turned their eyes towards me. Even the insurance-company experience had not prepared me for this, and even now, more than a quarter of a century later, I never walk through those same doors without remembering. Mercifully, the discomfort was momentary: Christine McKie (the only person I recognised in the room; we share the same subject) detached herself from the throng, greeted me and began to introduce me to people who, without exception, would later become great friends.

There would be other uncomfortable moments. At Christine's beginning-of-term party for the Physical Science students, for example, I of course found myself the only man in a room full of women. As this had never happened to me before, I felt conspicuous and odd. But such moments were soon forgotten: it was like being in the army, making friends without the luxury of choice but with pleasant surprises.

A single, recent incident illustrates the strength of the bonds formed in that first year. Out of the blue, because I wanted advice about writing this piece, I telephoned Philip Davis, after lifting his number from the internet. We hadn't communicated for fifteen years, but we chatted as if the years did not exist and he reminded me of events that I had forgotten,

among them the Girton Fellows' cricket team, formed by Anthony McIsaac that first year. All five men signed up, even yours truly, who in 1973 had travelled 12,000 miles primarily to escape Australian football and cricket! In an early match, cricket novice Betty Wood was our star (she caught a ball at first slip, leaping into the air with right hand stretched to the limit while looking directly to her left; a ten-minute team-hug followed). In that same match I was paid the only compliment I ever received on my cricketing ability. Last man in (my talents had been expertly recognised by Captain McIsaac), my strategy was simple: take a huge attacking swipe at everything and hope to avoid major injury. The result was four, four, six, OUT! Sir Harold and Lady Jeffreys were spectators: 'We enjoyed watching your innings, John; it was very exciting,' said Lady Jeffreys. 'But we were lucky to catch it. It's a pity it didn't last longer.' This was high praise: Lady J did not hand out compliments lightly. I remember trying to calm poor Philip Davis with cups of tea after she had caught him splitting an infinitive at High Table.

That first year was very special. There hasn't been one like it since, and the Fellows' cricket team lived only very briefly. Now, in 2005, a spectator force of Life Fellows would probably not turn up if such a team played again. With hindsight, I think that everyone was nervous at first, wondering if a mixed Girton would succeed. In the end, I believe it worked quite simply because everyone wanted it to work – even those Fellows who had initially voted against the change. In that first year, Girton demonstrated that one of the best recipes for the success of any enterprise is for all participants to mutter continually, 'this won't fail because of me'.

I did my research. I read Muriel Bradbrook's '*That Infidel Place*', was astounded to learn about the history of women in Cambridge and was pleased and proud of the fact that I was part of the College at an important moment in its history. I particularly enjoyed the company of the Senior Fellows who provided tremendous support and encouragement. I looked forward to breakfast every morning with Alison Duke and her encyclopaedic knowledge of the College, its past students and its history. I assisted

Brenda Ryman (the Mistress) as she served occasionally behind the then-tiny student bar. I helped Lady Jeffreys pick the apples in her back garden, and was awed by her mathematical ability. I enjoyed countless lunches with Dame Mary Cartwright at the Wolfson Court cafeteria, and listened to her stories of Hardy and Littlewood. I sat by the fire in Muriel Bradbrook's house with Kathleen Raine, watching them consume at a single sitting the large box of chocolates I had brought with me in my bicycle basket. I talked about buttons and Russia with Dame Elizabeth Hill. Professor Raphael's warning had been unnecessary: I liked Girton.

Still at Girton many years later, I found myself, as Governor of a sixth form college in Rutland, attending the first meeting of a new committee chaired by a recently appointed Headmistress. She began by saying that she owed me an apology: 'I did not realise, when I set up this committee, that you would be the only man.' Looking around I saw that she was quite right – but I hadn't noticed. I felt comfortable! Memories of Christine's first student party flooded back and I realised in a flash the scale of my transformation. 'Please don't worry,' I replied. 'Girton College has trained me magnificently.'

John Davies is an Australian crystallographer who completed his PhD at Monash University, Victoria, in 1973. After post-doctoral work with Malcolm Gerloch in Cambridge and with Ray Bonnett and Michael Hursthouse in London, he joined Girton as a Research Fellow in 1977. He is now an Official Fellow at Girton. His wife, Cynthia, is also a Girtonian.

Anthony McIsaac

Girton was my home for three years from 1977. Outside the hectic activity of the undergraduate Full Term, we resident Fellows shared the long corridors with the other inhabitants of the College: teacher Fellow Commoners; an amateur operatic society rehearsing *The Gondoliers*; on one occasion a rat; and always the spirits of the founders and forgers of Girton keeping a watchful eye.

I suspect that little has changed (except for the rat). But some things were unique to that time. The first male Fellows were welcomed into a community that had decided, with whatever misgivings, that it wanted to change and wanted us to contribute to and influence that change. There was a sense of novelty and common adventure. The support of the whole Fellowship and a spirit of determination were certainly needed to build the SCR cricket team from the skills available. Thanks to a regular training programme, we were proud to record a draw against a much more experienced Sidney Sussex side. The team was not all male: Betty Wood distinguished herself with a spectacular slip catch, and eventually by obstinately blocking for long enough to deny Sidney victory.

Some things have changed for ever. A couple of years after men became members of Girton, Margaret Thatcher became the first woman Prime Minister. The associated political impact on British academic life led in the short term to job freezes and department closures. Since then, there has been a shift in the climate, and academics I have met have always been conscious of demands such as Research Assessment Exercises. Technological changes may ultimately prove to have more lasting effects than political ones. We were the last generation to have no choice other than to bash out our theses on typewriters, making corrections with Tipp-ex and throwing scrunched sheets on to the floor. Convenience aside, the word processor and e-mail have opened up academic communication. Ideas circulate in multiple snapshots of papers and technical reports, with several authors in different countries being able to fuse their contributions in a way that was impossible thirty years ago.

A Research Fellowship was an opportunity to develop ideas in peace. I appreciated the way the college system throws together people from different disciplines. I learned much about Wordsworth and Coleridge, as well as spending long days puzzling about the different degrees of infiniteness of mathematical structures. Later, for several years, I taught maths, mainly at sixth-form level (and was pleased that a number of my pupils went to Cambridge, though the Maths Tripos was the toughest of courses). I spent a short time doing research in

REFLECTIONS

It doesn't get much better than this

There we were, half the men's swimming team, sitting in a friend's room, waiting for her to come back and eating biscuits. Ian was sitting on the bed, calm as ever – he never said very much. Then he spoke: 'You know what? It doesn't get better than this, does it?' He went on: 'I mean, sitting here, friends, beautiful place to live, do some work, do some swimming, you know, just being here at College. It doesn't get much better than this.'

Silence! But fifteen years later we all say the same thing: 'He was right. It gets good, but it doesn't get much better than that.'

Neil Thompson (1987)

Returning to Girton after thirty-five years

They drew me back, those hallowed halls
Of blushing brick and ivied walls;
But, scattered by the bracing breeze
Of boys and booze and hairy knees,

Familiar students now are gone.
Miss Tranquil cedes her place to Fun;
Miss Modesty and sweet Serene
Are sometimes here but rarely seen;
And Chastity? Ah, who can tell.
It seems she may have left as well.
Sadly deceased, without confession,
Is Tutor to them all, Discretion.
And do nostalgic tears abound?
Well? No. Oh, and thanks, Mike, I'll have a whisky and dry
 ginger, as it's your round.

Helen Chown (Benians, 1968, 2003)

Longest-serving student?

I first laid eyes on Girton back in May 1993 when I came for a sixth-form open day, and was immediately struck by how friendly the College was. Not only were the students who had taken the time to help during the open day nice to me, but there was clearly a sense of community within the College.

Books in the Law Library at Wolfson Court

I came up in October 1995 and my initial impression of the College community has only been confirmed ever since. In between my undergraduate degree and my MPhil, I worked for a year in the College Development Office and was particularly responsible for relations with alumni and particularly young alumni, recent graduates of the College. I believe I might be Girton's longest-serving student; by the time I submit my PhD I will have been attached to Girton for ten years. I chiefly have Juliet Dusinberre to thank for this, as she stopped me running away to a Tibetan monastery in my second year.... Girton too far away from town? Not for me!

Lise Smith (1995)

I liked Girton as a place...
I felt we were taught a certain way of thinking, how to approach issues critically, how to make connections.... College staff and most supervisors took an unparalleled interest in students. There was a genuine commitment to students, to their intellectual development and their welfare. I liked Girton as a place – turning right on my bike on my way back from town and seeing the familiar red brick building with its tower in front of me, the gardens which always seemed to be especially lovely around exam time, the long corridors, Black Tie parties in Old Hall and the Stanley Library, Formal Hall, the Library in which I enjoyed working.... My years at Girton were a watershed. When I arrived, I thought that a new era would start for me: the beginning of a different and happier time than my teenage years at school in Germany. I was right, though of course I have learnt since that life is more complicated... and that Girton did not provide the answer to everything. However, Girton was the place where I feel I developed into an adult, where I was able to study fascinating things, where I had new and intense experiences, made life-long friends... and all within an exceptionally supportive and inspiring, as well as beautiful, environment.

Alexy Buck (1993)

Girton life – an MCR perspective
I got out of a taxi on Clarkson Road on a mild autumn day, somewhat disorientated after a twenty-four-hour flight from Australia, and walked into Wolfson Court – my first experience of Girton College. After finding my new room with the help of a friendly porter, I soon met my new housemates who immediately made me feel at home. With a New Zealander, a Singaporean, two Irish and an Ecuadorian on my stairwell, I quickly realised that my new life at Girton was going to be a truly multicultural experience.

This informal welcoming was followed by Freshers' Week, which demonstrated the wonderful role played by the MCR in welcoming new students and facilitating introductions. The social function of the MCR continued throughout my first year with weekly formal halls, MCR dinners and a host of other events.

Looking back now, I'd have to say that life as a graduate student in Cambridge, especially for someone living so far from home, could sometimes be socially isolating and alienating. Such a geographically dispersed population of students, many living up to six miles apart (which seems like cities apart in a place like Cambridge), only highlighted the MCR's function in providing a forum for establishing and maintaining College social links, offering support to fall back on and friends to share and relate experiences with. With many MCR members leaving after one-year MPhils, I also witnessed the vital role it played in sustaining College spirit, friendships and legacies over the longer term, as well as links with other colleges. I learnt what it meant to be a part of Girton, both as MCR president and as a College rower and tennis player. Through these activities I discovered the distinctive Girton identity of openness, friendliness and supportiveness. By helping to shape and be a part of this identity, I developed an enormous sense of pride in my College.

Alexander Mair (2002, MCR President, 2003)

theoretical computer science at Edinburgh, where I met my wife, who had worked in three different continents since her Linguistics department at St Andrews had closed in 1981.

I am now working in industry, applying mathematical logic to proving that the chips in mobile phones and digital televisions do what they are supposed to. I have been involved in several collaborative projects with universities, and there has sometimes been tension between the aims and values of the different partners. Direct application of academic research to industrial projects with deadlines can indeed be problematical. But the contribution of academic partners is vital, in taking a broader view and often explaining on very abstract grounds why one approach is likely to be more successful than another. I am grateful to the academic community for maintaining its distinctive values, and to my own research experience for enabling me to let them influence my everyday work.

Anthony McIsaac was a Research Fellow in Mathematics at Girton from 1977 to 1980. Since then he has taught Mathematics at Dulwich College and Richmond upon Thames tertiary college, and pursued research in theoretical computer science at Edinburgh and at Oldenburg in Germany. He is now working for the semiconductor company STMicroelectronics. He is married with two children and lives in Stratford upon Avon.

Philip Ford

Having been a research student at King's in 1972, when the College became one of the first three men's colleges to accept women, I was delighted to participate in the no-less-revolutionary change at Girton by joining the small group of male Fellows and graduate students admitted in 1977. However, there were other reasons for my delight. As a modern linguist, I had always looked at Girton with awe because of the presence on the Fellowship of such distinguished teachers as Alison Fairlie, Helen Grant and Odette de Mourgues, whose lectures on French Renaissance and neo-classical literature had been a source of inspiration to generations of students. A

younger generation of modern linguists now included Gillian Jondorf, Ruth Morgan – who had taught me when I was an undergraduate – and Melveena McKendrick. With such company, how could one fail to be inspired?

My year at Girton was a very happy one. The relatively large band of resident – mostly research – Fellows would meet every morning at breakfast, a meal presided over by Alison Duke, who accepted the invasion with good grace and made sure we behaved. Lunchtime saw the arrival of a much larger group of Fellows, including sometimes such figures as Mary Cartwright, Bertha Jeffreys and Muriel Bradbrook, whose careers summed up in many ways the challenges faced by women academics at Cambridge. Coffee in the SCR was always a chatty occasion despite the presence of newspapers, which acted as a stimulus for conversation rather than as a substitute for it, as happens in many formerly male institutions. I remember one such conversation that focused on the difference between girlfriends, mistresses and common law wives: the colour of underwear was considered to be the defining criterion.

During my first term at the College I was adopted by a black cat, who turned up in my room one day and brought me the occasional dead mouse as a sign of her esteem. I named her Ottilie, after the Ottilie Hancock Bye-Fellowship that I held, and she became well known throughout the College. She was clearly a lucky cat. At a Girton Christmas event I won one of only two raffle prizes I have ever won in my life, which turned out to be six cans of condensed milk. Needless to say, she was the one who reaped the benefit. She also shared with me the daily ration of milk doled out to Girton Fellows, always referred to by the gyps as 'dons' milk'.

My Research Fellowship at Girton came at a crucial time in my academic career. I had completed my PhD thesis in 1976, and spent the following academic year as a lector in Bordeaux. Since my research had been on the relatively unusual area (certainly at that time) of Neo-Latin literature, few Cambridge colleges were interested enough in it to offer a research fellowship. Girton was an enlightened exception, and allowed me

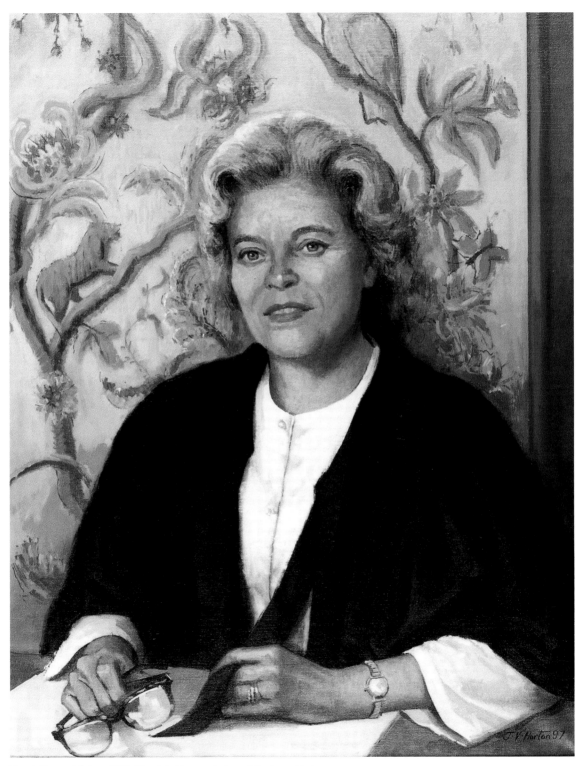

Brenda Ryman, Mistress 1976–83, painted from a photograph by James Horton

the opportunity to develop my research in the French Renaissance, to do some supervision in French literature and to flourish in the College's intellectual climate. When a post at the University of Aberdeen brought my time at Girton to a premature end, I left with some regret, but above all with a great sense of gratitude for the role Girton had played in helping me to establish an academic career.

Philip Ford left Girton in 1978 and took up a post as lecturer in French at the University of Aberdeen. He returned to the French Department in Cambridge, and a Fellowship at Clare, in 1982, and in 2005 was appointed Professor of French and Neo-Latin Literature. He is married and has one son.

The first men undergraduates
Jon Harbor

The invitation to an interview at Girton was almost thrown away: another of my older brother's jokes, I assumed, or an error in the system. A little checking revealed that Girton was indeed admitting male students, and Dr Jean Grove had seen something in me that my college of first choice had missed. I did not realise how lucky I was to be pulled out of 'the pool' by Girton's need for a few extra men.

Coming as I did from an all-boys grammar school, Girton was for me a whole new environment of social as well as academic challenges. After the initial awkwardness of being in the minority for the first time, and of being a teenage boy among so many women, I found Girton to be a far more supportive, healthy and welcoming environment than many other colleges. It was a place with lots of friends, many of whom were like older or younger sisters to me for some years; a place full of competition and fierce debate, of course, but full also of good nature and mutual support to help us all to succeed; a unique place to learn about gender issues, through the experiences of my friends; a time to find out that gender bias and injustice were very real. And it was a time when the strongest role models around me were successful women, ranging from the academic staff to my 'college mother'. In particular, Jean Grove provided limitless academic challenges, had a

genuine interest in all of the geography students and was an outstanding role model for combining professional and parental responsibilities.

As the first Girton men, we had no long-established traditions to constrain our creativity, and there were great opportunities to establish new clubs and participate in sports (even the athletically-challenged, like me, made it into the first boat and succeeded in the bumps). One of my fondest memories is acting as a last-minute sub for the women's first eight one morning when they were one short at practice. I had no idea what great rowing was like until that morning – all eight moving in unison and balanced, with focused power propelling the boat effortlessly. Other strong images of Girton include the woodwork and books atmosphere of the Girton Library, where many long days were spent on essays and exam revision, and the discomfort of the long bike ride to and from town on cold and rainy days.

Girton provided me with amazing opportunities to excel and experiment academically, with the support of my advisors and peers. Perhaps most memorable were research expeditions to the Indian Himalaya, Norway and Switzerland, each with scientific leadership provided by Girton students. A Cambridge education turned out to be a ticket into graduate school in Colorado and Washington, and an excellent preparation for life as a graduate student. After a short stint as an environmental consultant, post PhD, I ended up in academia for my long-term career, and continue to pursue research in remote parts of the globe. Like many others, I became a part of the brain drain. In fact, Girton geography has provided the universities of the State of Indiana with two of its current Associate Deans.

Some of the lessons learned at Girton underlie my own approach to teaching, scholarship and programme development at university and international levels. I work hard to maintain a diverse research group, and issues of bias and support for under-represented groups are important topics of discussion and action. Hard-working, collaborative and supportive groups are central to our research and learning, and are the foundation for much of our success. Is this the result of experiencing Girton 'in transition'? I suspect it played a significant role.

Jon Harbor grew up in Bishop's Stortford and, after his BA in Geography at Cambridge, completed an MA at the University of Colorado and a PhD at the University of Washington. He now serves as Professor of Environmental Geosciences, Associate Dean for Science Research and Co-Director of the Discovery Learning Center at Purdue University in Indiana. He has been a Fulbright Senior Scholar (in New Zealand), won his university's top teaching award and currently pursues research in environmental science and glacial geomorphology in the US, Scandinavia and China. He married Amy Orr, also a geographer, in 1985, and they have four children.

Ian Power

There were seventeen of us waiting outside the dark double doors. Despite the natural apprehension associated with the impending interviews, there was a surprising air of mild confidence. Rumour suggested that Girton usually took twelve or more Natural Scientists, so the odds of acceptance seemed strangely high.

The outer door opened and gave way to a well-proportioned study, carefully furnished and with an air of academe. The room belonged to Dr Christine McKie, the highly regarded Director of Studies for Natural Sciences. In the brief period between the entrance examinations and the arrival of the invitation for interview there had been little time to find out the details of this woman's significant contribution to the world of crystalline materials. She was a leader in her field, but also a first-class teacher and a pivotal figure in the life of her College.

The interview started promptly with the anticipated formality but also an overwhelming sense of warmth. Were we really the first male sixth form students to be interviewed at Girton? Looking back it is difficult to remember the precise questions that were asked, and anyway this was the general interview, the one where you could speak a little about yourself and what you thought you might offer a prestigious Cambridge college; the taxing academic interviews were still to come. This was the chance to discuss and reflect, as well as a genuine opportunity to spend some time with a notable Cambridge academic. But there was a key

question that was not asked. At no point during the interview was I asked why I had decided to apply to Girton. It was the obvious question… or was it?

Of course I had an answer prepared, of sorts at least. Barely six months earlier, I had been part of a small group of students from a large comprehensive school in Leicestershire who were visiting Cambridge for the first time. We had toured the usual 'historic' colleges – King's, Trinity and St John's – and then went on to Girton, for reasons that were fairly straightforward: the last student from the school to gain a place at Cambridge was a Girtonian, there was an Open Day and we had been given the time away from school to attend. It was as simple as that – no detailed preparation, no family connections and no real understanding of the significance of Girton and Girtonians in the emancipation of women earlier in the century.

If we had arrived at Girton by chance, then it was with real certainty that it became my first-choice college. On that first visit, that first drive under the archway, there was something special. I left with the impression that this was somewhere that I would dearly love to be. It was only much later that I realised the significance of Girton as a place, not just for now and the future, but for its unique past too.

But the question was never asked, and its absence from the interview and subsequent interviews said much about Girton and its view of the historic decision to admit male undergraduates. This was not a whim or fancy brought about by some kind of expediency. There was a real sense from that first interview that Girton had chosen to go mixed because it knew it to be right.

There must have been dissenters; there must have been those who could remember the battles that had been fought and were still being fought to gain women equal rights within the academic world. Was Girton about to sell out, when it could just as easily have stood firm as a bastion of female rights and opportunities within an all too male-dominated society?

By any standards this was a brave decision but one that – viewed from a male undergraduate perspective – was never questioned or in doubt. At that first interview and in subsequent meetings with Fellows,

COLLEGE SPORT

We are Girton, super Girton, no one likes us,
* we don't care*
We are Girton, mighty Girton, no one likes us,
* we don't care*

This song, sung to the tune of 'We are sailing' by Rod Stewart and borrowed from the Millwall football team, has become the theme song of College sport. No-one is very sure when it originated, although it has certainly been around since the early 1990s. It has become a song for all Girton students, often sung after the College Feast, and reflects the feeling that Girton stands apart from the rest of Cambridge. It is sung at sporting events too, and on one notable occasion – when Girton won the Cuppers football final in 1995 – the singers interrupted the song with a great shout 'wave to the Mistress' when they spotted Juliet Cambell walking towards the Grange Road stand. They all did just that, and then continued with the song.

The College always had excellent facilities for women's sport on site, and was unusual in having a swimming pool, which dates from 1900 – and is understandably more widely used now that it is heated! The early College planners were conscious that students needed the opportunity to exercise within the grounds and so established a hockey field and tennis courts. But when Girton went co-residential, sport took on another dimension. While the College had had its share of female blues, the advent of men resulted very quickly in College teams in all the (unfortunately still) more prominent men's sports. Early male Fellows and undergraduates have clear recollections of being pressed into service for the rugby and football teams and the first rowing eight, all of which were made up of the same participants regardless of ability.

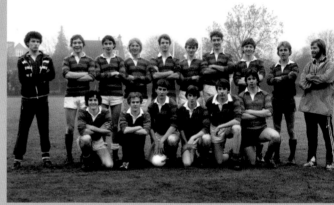

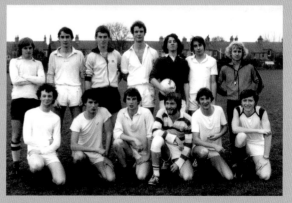

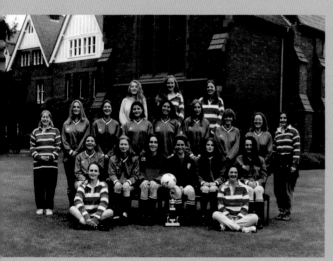

The 1994 women's football team

The 1979 men's rugby (top) and football (above) teams

Girton rapidly began to acquire male blues. There was an early blue football goalkeeper in graduate student Mike Power in 1979, and the College has had male football blues nearly every year since. The College men's team experienced a meteoric series of promotions, going from division 5 in 1984 to division 1 in 1990, and winning Cuppers (the annual knock-out competition) in 1995. The success of the College in football also extended to the women's team: founded in 1984–5, they were the first winners of the Cambridge University women's football league in 1985–6 and have never been outside the top flight. The team has won Cuppers and league several times, and has also contributed many players to the Cambridge University squad.

The College acquired a boathouse in 1979, in effect an extension of the Sidney Sussex and Corpus boathouse. In that year's *Annual Review* the Boat Club president wrote, possibly rather unrealistically, 'We hope to buy a new boat soon.' As a women's college Girton often did extremely well in rowing, despite for a long time only having one eight of its own, and was head of the river in women's rowing in 1978–9, the year before men undergraduates arrived. The Boat Club has managed to acquire more equipment over the years, and is now the largest of the College sporting societies. Contrary to popular belief, most of those who row at Girton have no rowing background, and the sport integrates people from all types of schools and nationalities.

In 1983, the College completed work on setting up a cricket pitch in Crewdson Field. Though it was to be some years before the cricket square had developed to its present high standard, the cricket teams were able to play on other grounds. The College dominated the University women's team in the early 1980s and won Cuppers in the 1985–6 season. The men's teams had more mixed fortunes, but in 1991 reached the Cuppers quarter-finals and boasted two blues players.

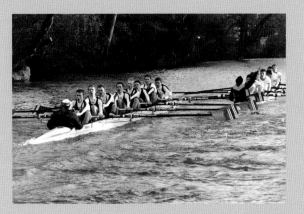

In rugby, both teams have had their share of success, with the women in particular often boasting blues players. The men's XV went into division 1 for the first time in 1991–2, but then dropped down for a while; they have only recently gone back up to division 1.

In hockey, the College was immensely successful in the mid-1980s, with the women's team winning the first University cup competition in 1982. The teams have had several blues players, especially among the women. The

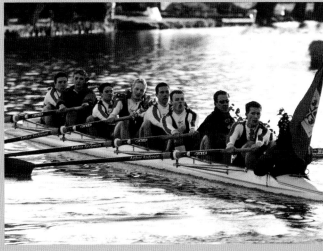

The men's first eight succeeds in the Lent Bumps, 2000 (top and above)

31

hockey team also held the first alumni and current student fixture, which has now become a tradition in rugby, football and cricket, with the addition of near-annual races between the old boy rowers (fittingly, in view of the title of Muriel Bradbrook's centenary history of the College, called the Infidel Boat Club) and the current first eight.

Many other clubs, such as water polo, badminton, tennis, lacrosse, pool, darts, table tennis and swimming have appeared and reappeared since the College went mixed. In the early days of co-residence, John Marks was instrumental in encouraging the men to set up new sports clubs and sport for all, seeing it as an important way for the College to integrate socially. It is perhaps no surprise that the first social society based on sport, the Unmistakeables, was founded in the early 1980s, followed soon afterwards by the Gymslips, the women's sports society, and many more 'sporting' clubs later.

The passion surrounding sport at Girton is certainly partly due to this social aspect, but it is also because College is special in having many facilities on site – swimming pool, tennis courts, football, rugby and hockey pitches and squash courts – by contrast with many other colleges which do not enjoy the luxury of this immediate access. At Girton participation in sport is accessible to all, whether in the playing or the watching, and is enjoyed by all College members. Staff have been involved in organising charity cricket matches against other colleges, and in the 1980s John Marks organised Fellows and staff v Cambridge University Women's Cricket Club matches. The College also has an annual five-a-side football competition during May Week that sees those who would never normally dream of playing (including the occasional scratch kitchen staff team) taking part.

Francisca Malarée, Development Director

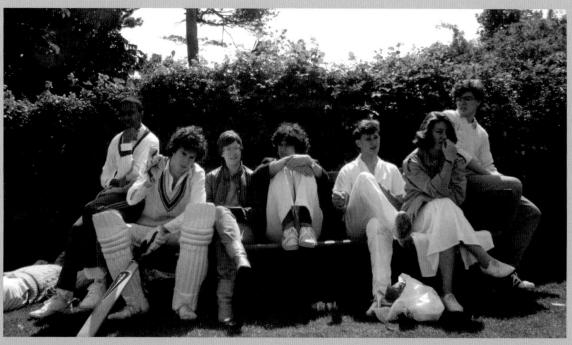

An early cricket match

senior undergraduates or admissions staff, there was always a sense that the whole Girton community was committed to co-residence. And of course, as a consequence, it worked.

The slight sense of confidence gained from that first interview was certainly misplaced. The two academic interviews that followed have left a lasting impression. Attempting to explain a casual interest in astronomy to a member of the Nobel Prize-winning team that confirmed the existence of pulsars was misjudged, to say the least. But the worst was yet to come: twenty minutes of organic chemistry with Dr Davies. If I had expected a lenient approach from one of the first male Fellows, I was badly mistaken. I left the room exhausted!

Certainly, if there was a desire to attract a good number of male undergraduates in the first year of co-residence, there was no obvious lowering of standards. That earlier confidence based on twelve places and only seventeen interviewees was wildly optimistic. When we came up that October, only three of the original seventeen had been offered places; the rest had been gleaned from the inter-collegiate pool. There was a steely determination to ensure that, for Girton, going mixed would be successful in the broadest sense. 'First-choice' male Girtonians were something of a rarity in that first year.

Looking back now, there is the danger of a rose-tinted view of what must have been a nervy period in the College's history. But the lasting impression, for me, is of a community that wished to embrace co-residence in its fullest sense. The right decisions seem to have been made, even at the most detailed level: opting for mixed corridors, choosing to reject potential male applicants who did not reach the mark, continuing with the 'college mother' system, moving the bar to larger premises after a term – all these decisions reinforced the view that co-residence was well thought through and here to stay. We first male undergraduates could have asked for little more.

Girton also maintained its essentially female qualities. Who could forget those supervisions in Barton Road surrounded by the essentials of family life: plumbers, heating engineers, young children and of course a liberal sprinkling of relativistic kinematics? Here were very successful women combining family and career in a way that at the time was revolutionary but has increasingly become the norm at the start of the twenty-first century. As men joining this community, we were never left feeling anything less than welcome and encouraged to bring the best attributes of masculinity to a community that had embraced change. Only towards the end of the second year was any antipathy felt and this, subsequent experience suggests, was quite natural. Those third-year undergraduates were the last of the 'all female' generations at Girton, and perhaps they were right to question and challenge the changes that had occurred. It was not all plain sailing, but then it was never meant to be.

It remains, thirty years on, crystal clear that the fellows of Girton made the right decision at the right time. Girton has an uncanny 50:50 male:female mix amongst its undergraduates, it has maintained its academic vision and it has also made inroads into the highly competitive area of male inter-collegiate sport. It is hard to imagine now that, during that first year, the College men's squash team gained promotion from Division 12 to Division 4 and that the football team won their first match against a Darwin XI. Who would have dreamed of Cuppers' success only two decades later? Times have moved on, but Girton has retained those essential qualities that not only attracted its first male undergraduates but also will enable it to continue to attract the very best in the future.

Ian Power left Girton with a degree in Natural Sciences and a PGCE, and started teaching Physics and Maths at Aylesbury Grammar School. After teaching posts at The King's School, Worcester, where he was Head of Physics, and Millfield, where he was Head of Science and a Houseparent, he became Headmaster of Lord Wandsworth College, a co-educational boarding and day school in Hampshire (famous for a certain old boy called Jonny Wilkinson!). Having been squash secretary at Girton, he has continued to play and coach squash at a respectable level and remains passionate about sport – a lifelong supporter of Leicester Tigers rugby and Leicestershire cricket. He is happily married and has two daughters aged fourteen and sixteen.

Elwyn Davies

I came to interview at Girton late in 1978. I'd abandoned a medical degree at another university after only ten days – homesick, disillusioned and wondering why I hadn't chosen a subject I was actually interested in. Girton seemed my last hope of studying zoology. I'd heard they were looking for bright students from a broader social mix than was usual at that period in Cambridge. They were also after men.

Coming as I did from a modern mixed Welsh comprehensive, I found the prospect of sharing my time with so many women neither mysterious nor worrying. The challenge for me was the idea of college life, the intimate business of waking, working, playing and dreaming in the cloistered company of a community outside family.

It took me six hours and six different trains to get to Cambridge, a place flatter than anywhere I'd ever imagined. There followed a bus journey, up the only hill for miles and then along a windswept road, until a dark line of trees and a looming tower signalled the end of the journey. It was Michaelmas break and only a few gloomy undergraduates were left to people the gothic maze of dimly lit redbrick corridors, smelling of wood polish and ancient dust. My fellow candidates were strange, competitive, intense individuals with whom it seemed I had little in common. I hated the place. I was defiant at interview. Later they made me an offer.

As it was, people and familiarity at Girton changed everything. The musty gloom began to generate a unique sense of enclosing warmth. It became noisy, mainly due to the men, who defied the mere numerical fact that women still made up the majority. Friendships formed and folded. It became a diversion to remember which of the people whom I now counted as intimates I had thought appalling at interview.

I remember learning to iron. I remember interesting encounters with towel-clad women in mixed bathrooms. I remember noisy debates in the JCR, deciding which of the acts on *Top of the Pops* were least deserving of our scorn. I remember my delight, in a room packed with England fans, when Wales kicked a penalty to win in the final moments of a Five Nations match. I remember multi-themed parties, and horrible experiments in cooking, and discovering that even the uncoordinated could play squash. I shudder at the memory of essay crises in the library on a Sunday night and summer revision to the sounds of tennis and cooing pigeons; but then there was always the reward of a drink later in the bar. I remember gowned dinners in the remote company of Dames, and of ancient women seemingly formed from the very fabric of the building, and of glamorous dons pausing between international degrees.

Most of all I remember talking and talking and talking, doubtless most of it rubbish, but, boy, was it fun at the time.

And now I've come full circle and I'm a doctor. Girton helped make that possible. The other thing I do is teach, and the way I teach is unquestionably influenced by my experiences at Girton. Because I also remember the supervisors who dedicated themselves, late in the evening, behind closed double doors, over coffee or sometimes sherry, to rectifying my inability to translate the stuff of lectures and textbooks into original thought. They may have failed in their primary objective but they succeeded spectacularly in teaching me the true and lasting value of the personal approach. I thank you. You know who you are.

Oh, and I can still iron.

Elwyn Davies claims to be Welsh but was in fact born in Manchester. He moved to Bangor just in time for Wales to become good at rugby and comprehensive education to be introduced. As a young man he returned to his birthplace to study medicine, where he lasted a mere week before deciding to throw himself on the mercy of the Girton selection panel and read Natural Sciences, this time managing the full three years. There followed a disastrous period as a scientific commissioning editor, before he once again opted to study the healing arts at King's College, London. He now works as a GP in Cheddar where he is happily married and has four children who just about tolerate his inability either to write or play the guitar and are mortified by his antics when Wales (now more frequently) win at rugby.

John Longstaff

There can't be many students who were awarded Cambridge scholarships in the late 1970s without ever having seen their college, or without being interviewed by anyone directly connected with that college; but this is what happened to me in September 1978. At the conclusion of the Organ Scholarship trials I learned to my astonishment that I was to be the first male Organ Scholar at Girton. True, I had actually applied for the scholarship, but although I was interviewed at three of the other colleges to which I had applied, there was never any whiff of a suggestion until the results were announced that I might be destined to spend three (actually four) years at the ladies' college built a discreet distance from the centre of Cambridge.

Some two months later I was invited to Girton to meet Dr Mary Berry (Director of Studies in Music and an old Girtonian herself) and Miss Duke, who was to be my tutor and needs absolutely no introduction from me! Arriving more or less outside the College on a dark and rainy Wednesday November evening, I felt as if I'd come to the edge of the planet. At the Porters' Lodge I met Dr Berry for the first time – a slightly forbidding experience as she is rather tall and I am not. I learned about signing for keys and she took me to my room for the night, a fairly functional affair somewhere along A corridor. I don't think anyone had given any thought to what bathroom I should use, something which bothered Dr Berry more than it did me (after all, a bathroom is a bathroom). Nonetheless, the following morning as I tried to find somewhere to shave, I got my fair share of doubtful looks from the young ladies currently in residence. Other than that, I learned during my brief visit that I would have to play the organ for prayers every other morning at 7.50am, I had my first experience of the College cafeteria and I discovered that the College bar was a dismal affair tucked away in a corner of the Post Room. The auguries were not especially promising, so I resolved to make the best of a bad job and put Girton out of my mind until the following October.

On arriving as a new undergraduate on a bright sunny afternoon I realised how wrong my first impressions had been. The College architecture was light and airy, with daylight flooding through the windows. There was a pleasant, informal atmosphere – people smiled as they passed you in the corridors. The staff, whether academic or domestic, took trouble to get to know you and address you by name. And if the men were not exactly welcomed by some of the older undergraduates who had begun their studies at an all-female college and would have preferred to end them at one, at least they were now behaving as though they knew what men were. That there was no attempt to provide men with their own bathrooms was actually a very good thing: given Girton's corridors, it would have been chaotic if the sexes had been segregated. It wouldn't have worked, and the resolution not to put it to the test was one of the most enlightened decisions the Fellows ever took about going mixed.

There was a brand new bar too – so well run that in no time at all friends from the town colleges were cycling up to sample well-kept IPA at 38 pence a pint! The film society did good business too after Formal Hall on Thursday evenings, the most popular films having two showings back to back. There was a refurbished swimming pool too, which was open virtually round the clock until one night a few weeks into Michaelmas Term when some drunken larking around in the water at three in the morning caused this liberal policy to be reviewed. But it was entirely typical of the atmosphere that there weren't going to be any more rules than were absolutely necessary, and if idiotic behaviour required stricter rules then the College Council would devise them, much as it would have preferred to believe it was nurturing a body of wholly sensible students.

Above all, Girton's relative isolation meant that there was no direct competition from the town colleges. As a music student, I had all kinds of freedom to organise and conduct some seriously over-ambitious projects: *Messiah* (twice), *The Merry Widow* (with the then Senior Organ Scholar and five of her friends doing high kicks across the stage of Old Hall), Carmen and Iolanthe (both in concert versions). No one in recent years had used the Dining Hall to put

on a concert, but when I asked permission the College authorities made it seem as if I'd asked for the easiest thing in the world.

I now realise, twenty-five years after going up, how lucky I was to go to Girton. If other Cambridge colleges are as friendly, then to study at Cambridge is indeed a special experience.

John Longstaff was the first man to be appointed Organ Scholar at Girton, a position he held from 1979 to 1983. He has held full-time posts as rehearsal pianist and conductor at the Opera House in Kiel, Germany, and with Northern Ballet Theatre. He was awarded second prize in the 1988 Leeds Conductors' Competition, and has been Musical Director of the Sheffield Symphony Orchestra since 1993. He is currently active as a freelance arranger and copyist, specialising in versions of large pieces for smaller ensembles, particularly ballet and opera scores.

Ward Crawford

We had just played (and lost) Girton's first ever men's Cuppers match in soccer. As we arranged ourselves for the photographer commissioned to record this historic event, he smiled in recognition: 'You were the rugby team last week, weren't you?' By and large he was right, as he would have been had he photographed any other men's teams at Girton that year. There were not very many of us to go around.

With such a small number of men going up as undergraduates in 1979 it was easy to believe that, although going 'properly' mixed would undoubtedly alter the place in time, Girton that year really was very much the same as it had ever been. Men in red and green rugby shirts or Girton scarves drew bemused glances, and the invitations to Freshers' balls at other colleges came addressed only to the women. For the rest of the University, the earlier graduate moves had clearly gone unnoticed.

I had come to Cambridge from a very traditional Ulster background, with little experience of anything or anywhere else; on my very first day I cycled into town to buy a kettle and coffee mugs, and offered myself up for a full body search to the first old man I found standing by the door of Woolworths. Northern

Ireland in those days was usually referred to as 'the Province', and in the 1970s (the worst decade of the modern Troubles) it truly was provincial. No doubt much of what I learnt during that first year was, and still is, typical for a late teenager moving away from home. But many Ulster teenagers had other things to learn too: how to distinguish between a consciously considered view and one lifted straight from a tribal religious background; and, especially, when to recognise and how to deal with one's own bigotry. I began those lessons in what I found to be an intensely welcoming and accommodating environment.

My overwhelming memory of that first year at Girton was of being 'brought in'. That risks sounding a bit trite, but it is how I remember it. From the porters at the Lodge to the Bursar in her office; the gyps and the ladies serving in Hall; Tom in the bar; even Mr Whitehead in his grumpy way accepting a falling-off in his bicycle maintenance work as gallant Girton men assisted the women; Dr Marks 'at home' pouring my first teetotaller's sherry; Miss Duke purposeful on her bicycle: they all represented the character of the place, and they all made me feel that I was now truly part of the College. It was inevitable that we students assimilated this spirit. And it probably contributed to the enthusiasm that brought twenty or so relatively sporting young men to try their hands (and feet) at more sports than would otherwise be sensible.

My contact with Girton continued after graduation. My wife, Sarah, was in that same 1979 matriculation year; we married in 1984,[2] and sharing many of the same friends has made keeping in touch with them easier. I am godfather to a 'Girton baby' and our own eldest child will herself go up to Girton in 2005. As a family we lived in Cambridge in the late 1980s, and at times the College became an important place of refuge from the busyness of the city.

Girton made one other fundamental impact on my life. I so enjoyed the social aspects of College life that I confess to spending less time on being a good engineer: so instead of returning to Northern Ireland, I embarked on a career that has led me on to a much broader and much more international path. And for that I am grateful indeed.

Ward Crawford's long-established habit of consuming a bar of chocolate while cycling back to Girton from the Trumpington Road Engineering labs made taking a job with Cadbury's a logical progression from Cambridge. He worked as a Control Engineer for a few years, before moving into different areas of business management. He is currently based in Tokyo, managing 400 Japanese and one New Zealander, and learning to communicate in both languages. He and his wife, Sarah, who was also at Girton, have four children, two girls and two boys, and have kept their family home in Devon since 1993.

Retrospect
Valerie Grove

Girton's girls-only, jolly-hockey-sticks, bicycling image held a certain perverse charm for me. Arriving from a co-ed state school in the mid-1960s, and having worked in my gap year on an evening newspaper, I found an atavistic satisfaction in the quaint and stuffy rules. Cycling home by midnight, farewells to male visitors outside the Portress's Lodge by 10.30pm, picnics on the Honeysuckle Walk, coffee and laughter after Hall in the tiny cell-like rooms of F corridor: what larks, eh? Never having been inside a girls' boarding school, and having only read about the sorority of dorm life in 'The Madcap of the Fourth' novels, I fell into the Girtonian milieu without resistance – while my ex-Roedean or Sherborne contemporaries were rebelliously climbing in and champing at the bit. I loved the fact that Girton had been the pioneering women's college, prudently located two miles from the town, and the men. I got by heart the letter to Miss Emily Davies, preserved in the College Library, from the novelist Charlotte M Yonge, declaring her 'decided objections to bringing large numbers of girls together'. I loved the Girton Feast when, indulging in happy self-parody, we lustily sang those College songs: 'Play up! All the college cried; Pass out to the wing, girls! That's the sort of thing, girls!', and the wonderful line, 'Then let us fill a teacup, And drink a health to those' – the Girton Pioneers.

When I went down in 1968, to be a 'Girton Girl' still had a rare resonance. The blue-stocking mocked in Punch cartoons and music-hall songs had not yet been erased from the collective memory. It was unimaginable that Girton would ever change: the romantic redbrick Waterhouse building, modelled on the Manchester Assize Courts, the overpowering aroma of beeswax, the portraits of College heroines (Miss Davies, Madame Bodichon, Lady Stanley of Alderley) along the gothic walls – surely all these were set in stone? But then came the day, in 1969, when Miss Muriel Bradbrook announced that Girton was entertaining the possibility of admitting members of the opposite sex. I was pole-axed with astonishment. I was in my first job, on the Londoner's Diary of the *Evening Standard*, and the Diary editor, Magnus Linklater, a Trinity Hall man whose sister Alison had been at Girton, suggested I ring Miss Bradbrook. Catching my tone of dismay, Miss Bradbrook said: 'I know how you feel. You feel amputated from your own past. But Miss Davies insisted that her ladies must always do exactly as the men did, hence their sitting the same exams as the men [even when most of the first applicants had hardly been to school], and if the men's colleges, led by King's, are going to accept women, then Girton must welcome men.' I was profoundly sceptical. Surely, I reasoned, women's colleges should wait a few hundred years (the length of time they had to wait for a college of their own) before disturbing the peace in this way. Perhaps eventually, when the men's colleges were all opening their doors to women, they might bow to the trend. It seemed to me an insanely generous gesture towards undeserving men who had locked women out for centuries and scorned Miss Davies's first valiant efforts.

But the Girton Fellows were prescient. They knew instinctively that many of the brightest and most ambitious girls would start applying to men's colleges once that possibility opened up, as indeed happened. And so, after another ten years had passed, there came the sound of heavy boots and basso profundo voices, and shaving points appeared in the bathrooms. Ten years after that, the then Mistress, the philosopher Mary Warnock, invited me back to College for a dinner to mark the completion of the first decade of co-residence, and suggested I might write about it for *The Sunday Times*.

And so, in April 1989, I found myself in the Stanley Library among Girtonians named Andrew, Nick, James and Bob. Bob was the one in the green baseball cap in a room full of dinner jackets. There were engineers, medics, biologists. There were no chinless, landed gentry hooray henrys among them – a genre of male undergraduate still rife in my day. Moreover, they had passed a rather severe test: they had had to be able to say 'I'm going to Girton' without a blush. Most of those I met had been to co-ed schools. They found Girton, with its 50:50 male:female ratio, a natural progression, 'just like the real world'. That's what they liked about it. True, they had not exactly chosen Girton. 'Girton chose me,' they said.

Only a few of the first intake of some fifty men had actually applied there. Crafty public schools, I was told, had told their boys: 'Apply to Girton, they'll take anything in trousers this year.' But Girton saw through that ploy, and turned instead to the pool, the supply of would-be undergraduates passed on each year by oversubscribed colleges. Baroness Warnock assured me that they got some very good people from the pool. I was struck by the unanimity: all the men I spoke to said that Girton was such a friendly, sociable place. Now Girton was to me a wonderful college in which to make lifelong friends, but 'friendly' was not the adjective that first sprang to the lips. Boarding-school girls used to say it was just like school, very cardigans-and-cocoa. At least two of my OG friends said they shuddered to recall a pervasive feeling while inside Girton that, whatever they did, someone would disapprove. So it was rather amusing to hear about how convivial and relaxed Girton now appeared to its students.

The men weren't particularly interested in the historical significance of Girton's foundation – until they sang those College songs, one of them told me. 'Girton served its purpose in the nineteenth century as a bastion of female education,' he said, 'but now it's different.' It certainly was. In that first decade of co-residence there were already ten pairs of inter-married Old Girtonians, which was some measure of the congeniality of the place. I have listened with pleasure to the mixed-voice Girton choir. And as a member of Mary Warnock's Task Force, charged with raising funds for the fabric of the College, I found it consoling to recognise that the modern Girton is as likely as any college to produce highly remunerated City men and women who might underscore their warm feelings for the College by generous gifts of cash. Which is, although I still feel glad to have been part of Girton's first century, a consoling factor for the future.

Valerie Grove (Smith, 1965) was born in South Shields and, since reading English at Girton, has been in journalism for forty years. She spent nineteen years on the Evening Standard, *followed by five years writing interviews for* The Sunday Times, *and is now a feature writer/interviewer and sometime columnist on* The Times. *She is married, has four grown children and has written two books of interviews (*Where I Was Young: Memories of London Childhoods; *and* The Compleat Woman*) and two biographies (*Dear Dodie: The Life of Dodie Smith; *and* Laurie Lee: The Well-Loved Stranger*). She is currently writing the authorised biography of Sir John Mortimer.*

1 A guide for senior College members first written by Ruth Morgan and Betty Wood in 1979.

2 The Crawford family featured in an article by Valerie Grove in *The Sunday Times* (30 April 1989) after Girton's first ten years as a mixed college.

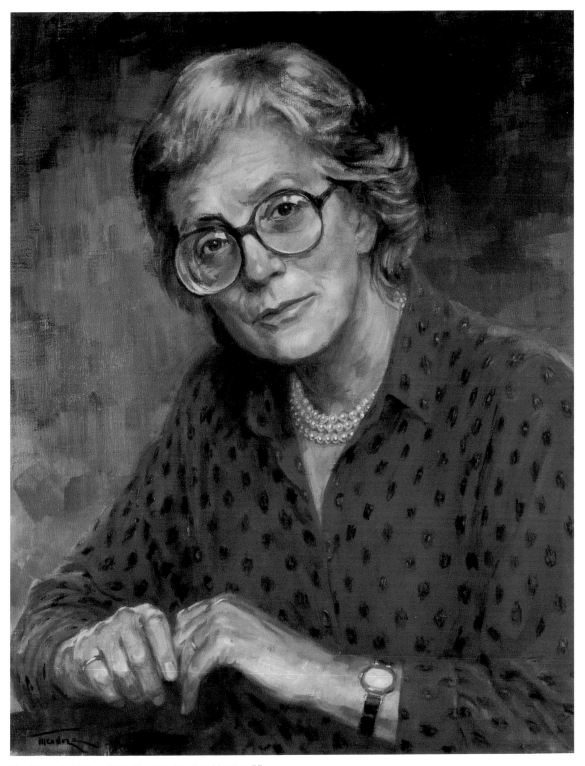

Mary Warnock, Mistress 1985–91, painted by June Mendoza RP

GIRTON'S GARDENS:
THE AFTERMATH OF GOING MIXED

Girton's decision to become co-residential made it essential to enlarge the JCR and MCR social facilities. An early priority was the provision of rugby and soccer pitches. Fortunately the College owned the field, known as Crewdson Field, that lay adjacent to the Girton Road beyond the northern boundary of the garden. The College took possession of the field, allowing the tenants to continue to graze sheep on the land until work began on levelling and draining the site in May 1980. A small number of sheep were then transferred to the New Orchard but the grazing proved to be unsatisfactory and no more sheep were grazed on College land. Unfortunately, Crewdson Field was not quite big enough to accommodate both pitches and so some apple trees near Grange Cottage had to be removed and telegraph poles resited. By the middle of November 1980 all but this area near the Cottage had been seeded, and the contractors later rolled and stone-picked the pitch before handing the site over to the College. A cricket pitch, carefully prepared by David Whitehead, was in use by May 1982 and the soccer and rugby pitches were ready by the following October.

The other major change to the grounds consequent on becoming co-residential was the landscaping of Ash Court after completion of a new squash court. The bank between the court and the back drive was regraded and the plants in the bed at the north-east corner of the court were chosen by the Head Gardener with the aim of linking the formal lines of the buildings to the more natural areas of the pond and its surroundings.

David Whitehead, the former Head Groundsman, retired in the summer of 1977 and Bill 'Mac' Stringer, the Head Gardener for thirty-two years, retired in April 1980 and was succeeded by Stephen Beasley. Financial stringency now required that the gardens and grounds become less labour-intensive. They had changed little over the previous twenty years and in some ways remained essentially an Edwardian garden. The kitchen garden still produced some vegetables, including asparagus and corn, and also provided cut flowers for resident members of the College, and the two orchards, known as the Old and the New Orchards, supplied apples, pears and plums to the kitchens, staff and students. During the 1960s and 1970s Mac Stringer won several Silver Medals for a display of apples at Royal Horticultural Society shows; his last was in 1979.

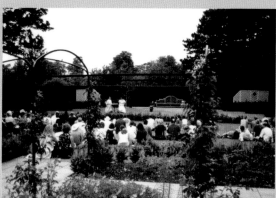

In March 1981, the Head Gardener reported that of the 2,465lb of apples sold that year, all but 350lb had been bought by the College kitchens, staff and students. Inevitably, such labour-intensive activities as apple picking and the production of flowers for cutting have had to be abandoned, but the College's Old Orchard still contains a fine collection of apple trees.

The winding path within a narrow perimeter shelter belt that surrounds the College gardens was a popular feature in Victorian gardens. Construction of the Northern Bypass (now part of the A14) involved the compulsory purchase of several acres of land in the northern area of the College grounds and the loss of part of the shelter belt in the northern area of the grounds. A severe storm in February 1978 led to the loss of twenty-eight trees, including some mature pines, and the subsequent survey of the shelter belt in 1980 revealed that few of the original trees had survived. Most of the closely spaced trees were rather weak and spindly, self-set seedlings of sycamore, beech, ash, elm (some of which had Dutch Elm disease),

hawthorn and yew. An ongoing programme of renovation and renewal using native or indigenous forest trees was introduced and the shelter belt continued along the boundary with the A14.

Unfortunately traffic noise from the A14 is clearly audible in the Fellows' Garden and so, while it is a popular place in which to relax, plays are no longer (see above) performed in the beautiful open-air theatre designed by Penelope Hobhouse.

Christine McKie

Girton's gardens have been the College's pride, protection and ornament since the earliest days. Emily Davies and Barbara Bodichon planned a wild garden, with trees that would screen the new college from the world, as is celebrated in the chorus of an early College song:

> …Girton's buildings, blushing red
> Behind a veil of green, sir

As Jane Brown records in her 1999 publication, *A Garden of Our Own*, the gardens and grounds flourished over the years in various guises. The Edwardian country house style, augmented by orchards and kitchen gardens – Girton was nearly self-sufficient in fruit and vegetables for decades, and farmed sheep and pigs too – gave way to serious husbandry during both World Wars and to changes in garden fashions. Gertrude Jekyll first discussed Girton's gardens with Barbara Bodichon in the 1880s, before drawing up detailed planting plans for Cloister Court and Emily Davies Court in the 1920s (some of which were revived in the 1980s). Chrystabel Proctor, in the 1930s, announced that Girton

was to have 'like Soviet Russia, a Five Year plan', and her vision and hard work resulted in the glorious gardens that were one of the splendours of Cambridge. After the Second World War, the planting of New Orchard and the careful nurturing of Old Orchard by Head Gardener Bill Stringer resulted in many prizes at County and Royal Horticultural Society Shows: 'Girton College virtually swept the board' (again), reported *The Times* in November 1979.

The 1980s saw a return to the earlier fashion for wild gardens, combined with new initiatives aimed at the conservation of both flora and fauna, put into practice by the new Head Gardener, Stephen Beasley, and continued by his successor, Robert Bramley. And of course, as Christine McKie records, the decision to become co-residential, as well as the construction of the A14 north of the College, had a major effect on the grounds. But despite these changes and intrusions, Girton's gardens continue to provide space for sport and relaxation, as well as the protective 'veil of green' originally envisaged by the Founders.

Chapter 2
Girtonians

Eileen Rubery and Kate Perry

We need tenacity to cling on against the odds:
Girton women in the public domain in the 1970s

The men were not coming to a new foundation: that had been women's experience 110 years earlier, as the pioneers found (see opposite). Girton's mark had already been made in many ways, illustrated here through the lives of Girtonians who were out in the world and in the public eye when the decision to go mixed was taken in 1976.

What were the graduates of Girton up to in the 1970s? Times were changing fast and opportunities widening, although many thought (and still feel) not fast enough. Irène Manton used the words quoted in the title to convey her scientific philosophy, but they could just as well be applied to the lives described in this chapter – the lives of twelve women who were pursuing successful and high-profile careers in the public domain during the decade when Girton went mixed. The pool to choose from is large, so we have chosen to focus on those who have had an obituary in the *Girton Review/Newsletter* or a national newspaper, who were undergraduates at Girton (so excluding postgraduate members of the College and those joining as Fellows) and who pursued the major part of their career beyond Girton. Within that framework, we have tried to illustrate the range of activities Girtonians engaged in, and some of the issues they faced.

The parents of our Girtonians came from a wide variety of walks of life. Delia Derbyshire's father was a sheet-metal worker; Alice Stewart's parents were both physicians in Sheffield; Anita Banerji's father was an Indian civil servant; Joan Robinson was an army major-general's daughter. Some followed in the footsteps of their parents (or at least built on their experiences) as Rosamond Lehmann did, whose father was an author and a critic; others struck out in completely new directions, such as Kathleen Gough, whose father was an agricultural engineer, while she became an academic – an anthropologist who studied populations in Vietnam and India.

Obituaries and published sources do not always yield information about the type of family responsibilities that our group had; public data can hide a variety of commitments to parents and relatives. But the data we do have indicate that eight of our group married or entered into long-term relationships. Some of course were also divorced, sometimes more than once. We noted sixteen children (seven boys and nine girls), which is probably about average for the period. Two of the children themselves became Girtonians, suggesting that Girton was regarded positively by these families. Most unusually, two of the women married while at university (Wootton and Llewelyn-Davies). The consequences were different, however. Barbara Wootton, marrying in 1917, moved out

The Girton pioneers: the first five students, Hitchin, 1869–70

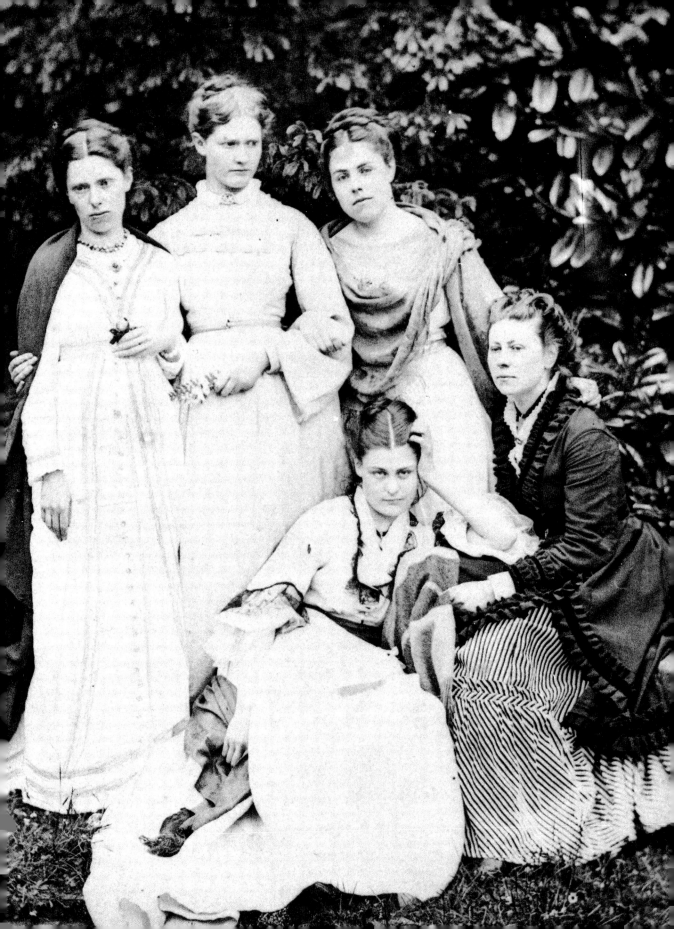

of College but continued to work for her degree, which she obtained in 1919. In 1935, when Annie Llewelyn-Davies became pregnant after marriage to her first husband, she left College in her second year and never completed her degree.

We assembled these 'brief lives' from obituaries, biographies, autobiographies, newspaper articles and other material in the public domain. We have not generally approached the family or friends of our subjects, but rather have tried to give a sketch of their uniqueness from the face they showed to the world.

Anita Banerji (1933–2001)
Eminent international scholar

Born in Allahabad, Anita Chakravarty was the daughter of an Indian civil servant, later Governor of Haryana. She was educated in Calcutta and gained a BA Hons in Economics from the Scottish Church College, Calcutta University, before coming to Girton in 1952 as an affiliated student to read Economics. A letter written to her husband after her death commented that 'she sailed through the Economics Tripos Part II at a time when it was one of the most exacting examinations in the University.' Back in India in 1955, she married Milon Banerji, a barrister and a friend from Cambridge days who was to become Attorney General of India, and they had two sons.

In the year after her marriage she was appointed as a lecturer at the newly founded Jadavpur University. As the only woman on the entire teaching staff, she had to overcome considerable resistance from both colleagues and students to achieve the recognition she deserved. Things became slightly easier when she was appointed a Reader, but it was not until 1980, when a High Court order secured her promotion to Professor, that her work was acclaimed at national and international level. She became Coordinator of the Centre for Regional Economic Studies at Jadavpur, specialising in public economics and the economics of public choice.

As well as the high regard in which she was held as an international economist, Banerji was equally in demand for her deep understanding of the problems of higher education. In India she served on the

National Commission for Teachers, the University Grants Commission and the executive councils of two universities, as well as becoming President of the University Women's Association of Calcutta. Internationally, she was actively associated with UNESCO and the International Federation of University Women. In 1982 she was the sole Indian delegate to the UNESCO meeting in Paris called to draft the convention on the recognition of degrees and diplomas, and throughout the 1980s she travelled widely to UNESCO and IFUW consortia on higher education.

Banerji returned to Girton in 1962–3 as Cairnes Prize Fellow, and in 1992 and 1994 came to Britain again, first as Visiting Fellow of Wolfson College, Cambridge, and then as Visiting Professor at the School of Oriental and African Studies (SOAS). She was now, however, seriously ill with diabetes. Despite this, she remained active on all fronts, and published her last book, *Women and Economic Development*, in 2000, shortly before her death. She is remembered by President K R Narayanan as 'a distinguished professor and intellectual, and above all, as a wonderful human being.' At Girton, an annual prize in her name is awarded for outstanding achievement in Economics.

Christine Elizabeth Cooper (1918–86)
Campaigning paediatrician

'Tina' Cooper's father was an analytical chemist and also a physician. From her mother she inherited an interest in child welfare, and after an education at St John's School, Bexhill, she spent two years qualifying as a nursery nurse before coming to Girton to read Natural Sciences in 1939. She completed her medical training at the Royal Free Hospital in 1945, winning a number of prizes and awards in the process. After junior posts, she stayed at the Royal Free to specialise in child health. In 1949 she was invited to visit the children's department of the Royal Victoria Infirmary, Newcastle upon Tyne, and was flattered to be shown round by Sir James Spence. She discovered afterwards that this was her appointment interview to become senior registrar to Sir James and, in 1952, consultant paediatrician at Newcastle General Hospital. On the

advice of Sir James, she focused her career on improving conditions for deprived children. Her unit was extremely family-friendly; one or other parent was always admitted with their child and was involved with their care management. She recognised the place of fostering and adoption in childcare, and was medical adviser to the Newcastle Adoption Unit.

In 1964 she was invited by the Government of Sierra Leone to advise on services for child health and nutrition. She spent two years in the country and was awarded the OBE for her work. On her return to Britain, she became involved in child psychiatric research, particularly on child abuse. She was a friend and pupil of Anna Freud and a member of the group of childcare workers who met regularly at the Freud house, as well as attending courses at the Ipswich Family Psychiatry Unit. She recognised the long-term damage of child cruelty and, with Alfred White Franklin, was a member of the 1970s Tunbridge Wells Study Group, succeeding him as President of the British Association for the Study and Prevention of Child Abuse. Her inspiration and teaching did much to break down the barriers between paediatricians and psychiatrists, as well as tackling the conspiracy of silence on child abuse. Her career as a whole demonstrates her early recognition of the lack of understanding of the needs of psychologically abused children, and her successful drive to obtain recognition and at least partial resolution of the issue.

Her obituary (*The Times*, 6 September 1986) recognised also the full life she led outside work: 'Despite never doing less than two full-time jobs, [she] somehow found time to share her passion for music, especially the opera, and all things Venetian.'

Delia Ann Derbyshire (1937–2001)
Pioneer of electronic music

Delia Derbyshire read Mathematics and Music at Girton from 1956 to 1959. Soon after getting her degree, she joined the BBC as a studio manager – although legend has it that Decca would not employ her because their recording studios did not employ women. She moved within the BBC to the newly formed Radiophonic Workshop in 1962, and was asked to work on Ron Grainger's score for the new science fiction series *Dr Who* (Grainger wrote the basic 'tune' and Derbyshire arranged it as an electronic piece). At that time there was no such thing as a synthesiser, and she created the eerie signature tune by using natural sources and electronic wave oscillators, and then endlessly editing and fine-tuning the result.

Though best known for the *Dr Who* theme tune (for which, thanks to the BBC's policy at the time, she received no recognition or royalties), she won most critical acclaim for her work in drama and features. Speaking about music composed for a documentary on the Tuareg people of the Sahara, she recalled, as quoted in her obituary, *Guardian*, 7 July 2001:

> *My most beautiful sound at the time was a tatty green BBC lampshade. It was the wrong colour, but it had a beautiful ringing sound to it. I hit the lampshade, recorded that, and faded it up into the ringing part without the percussive start. I analysed the sound into all of its partials and frequencies, and took the twelve strongest, and reconstructed the sound on the workshop's famous twelve oscillators to give a whooshing sound. So the camels rode off into the sunset with my voice in their hooves and a green lampshade on their backs.*

At the BBC she went on to work with Paul McCartney and Peter Maxwell Davies among others, and created many new works. After eleven years, she left to work with Brian Hodgson at his independent music studio (the second studio they had set up together), then did a variety of other jobs before meeting Clive Blackburn in 1980, who became her partner for the rest of her life. By now she had been discovered by a new generation of musicians – Orbital, The Chemical Brothers, Blur, Sonic Boom – and had become a cult figure. As her obituary also said: 'The technology she had left behind was finally catching up with her vision.'

Recognition continues beyond the grave. There is a Delia Derbyshire Discussion Group and there have been two plays about her life. Again, a comment in her obituary sums up her contribution to the field: 'I suppose in a way I was experimenting in psycho-acoustics.'

Kathleen Eleanor Gough Aberle (1925–90)
Internationally recognised academic anthropologist

Kathleen Gough's father was originally a blacksmith who became a dealer in agricultural machinery, introducing the tractor into the West Riding and becoming the first car owner in their home village. After grammar school, Gough read English then Archaeology and Anthropology at Girton from 1943 to 1946. She began doctoral work on the Nayars of Kerala (South India), which resulted in a PhD in 1950. Her first major publication was *Matrilineal Kinship* (1961), co-edited with David Schneider, which had its origins in a Harvard seminar. It was at this seminar that she met David Aberle, whom she married in 1955. They had one son in 1956. As her career progressed, she developed a long-term interest in problems arising from social exploitation viewed from a Marxist perspective. Further visits to India and Vietnam resulted in four further books, and many other articles became well-established anthropological texts. Her teaching positions included posts in England, the USA and Canada (most prominently, Brandeis University 1961–3, University of Oregon 1963–7 and Simon Fraser University 1967–70), and from 1974 until her death she was an Honorary Research Associate at the University of British Columbia. At the time of her death, she was planning a further extensive field trip to Vietnam.

She encountered a number of constraints in the course of her career – marriage and motherhood, and nepotism rules (from working in the same location and field as her husband) – but mostly arising from her strongly held and expressed principles, which incurred disfavour among university authorities. She was active in the Campaign for Nuclear Disarmament, the Civil Rights Movement and in opposition to war in Vietnam. As her obituaries said, 'She never joined a

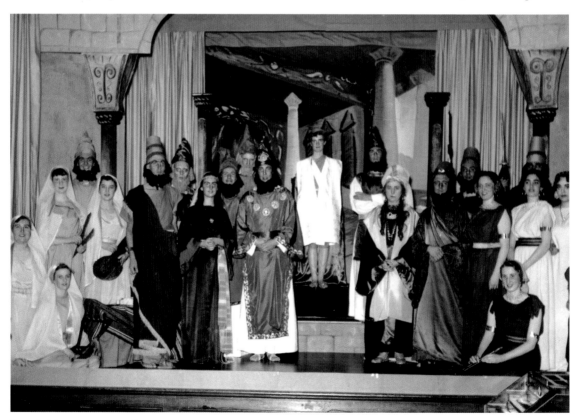

Handel's Athalia, performed by Girton College Music Society, 1954

political party but retained her socialist convictions and concern for the oppressed and exploited', and 'She fought oppression wherever she encountered it, often at risk and at cost to her academic career.'

Rosamond Nina Lehmann (1901–90)
One of the most distinguished novelists of the twentieth century

Rosamond Lehmann was born into a wealthy, well-educated family. Her charismatic father, Rudolf Lehmann, was an MP, author, editor and critic, while her great-uncle, an artist, painted the portrait of Emily Davies that hangs in Hall at Girton College. Educated privately, she read English then Modern Languages at Girton from 1919 to 1922, and wrote her first novel while still in her twenties. *Dusty Answer* (1927) drew on her experiences at Girton, and received immediate acclaim. The publication of her second novel, *A Note in Music* (1930), firmly established her reputation. Two more bestsellers followed, *Invitation to the Waltz* (1932) and its sequel, *The Weather in the Streets* (1936), both related to her first marriage (to Leslie Runcimann). Her books explore the sexual and emotional lives of women, and several of them have been dramatised. During the war she contributed short stories to *New Writing* (edited by her brother John Lehmann), and in 1948 won the Denyse Clairzouin Prize for translations of Cocteau and Lemarchand. She worked in international circles through the PEN club, and received a CBE in 1982 for this work. Four years later, she was made an Honorary Fellow of Girton.

Her personal life was turbulent, with a succession of romantic relationships, including two marriages (one son, one daughter), and a long association with Cecil Day Lewis. The death of her daughter Sally at the age of twenty-four in 1958 had a profound effect on her, causing her to become absorbed in psychic theory and an unorthodox Christianity. These influences were later reflected in *The Swan in the Evening* (1967).

As Muriel Bradbrook remarks, 'All her work was a transformation, although not a transcription, of her own life.' Bradbrook also remembers the College's reaction to *Dusty Answer*: 'Miss Hilda Murray told us not to read [it] as a true picture of Girton.' Bradbrook thought it was the first and best attempt to portray Girton from within, though she had no experience herself of the kind of intense emotional life it described. In the 1970s Lehmann published *A Sea Grape Tree*, and her major works were 'rediscovered', *Dusty Answer* being reprinted in 1978 after a gap of fourteen years. A few years later, the reissuing of her works by Virago Press revived her reputation as an early feminist writer. Anita Brookner characterised her as 'a novelist in the grand tradition… the first writer to filter her stories through a woman's feelings and perceptions.' Her philosophy can perhaps best be summed up in her own words: 'One can present people with opportunities. One cannot make them equal to them.'

Annie Patricia Llewelyn-Davies (1915–98)
Politician and Chief Whip

Growing up in north Wales, the daughter of a wealthy and a successful engineer and manufacturer, Patricia Parry read English at Girton from 1934 to 1936. She was an accomplished actor while at Cambridge, as well as a member of the Labour Club and the College cricket team. However, she married in the middle of her second year and left College at that point. Her subsequent regrets at her curtailed education made her a diffident public speaker, even at the height of her career. She joined the Civil Service at the beginning of the Second World War, ending up as Secretary to Philip Noel-Baker in the Commonwealth Relations Office. In 1943 she married her second husband, Richard Llewelyn-Davies. She combined her career as an administrator, and then as a politician, with family, saying that her three daughters accepted their working mother because 'they say it makes me more fun'.

Mary Warnock, in her obituary in the *Girton Newsletter*, described her as a 'natural politician' on the left of the Labour Party (a Bevanite), though she was initially defeated in three elections (in 1951, 1955 and 1959) in spite of memorable campaigns, including one conducted from a bubble car. In the following decade she directed the African Education Trust before being created a life peer in 1967. She then embarked on the most energetic part of her career:

between 1974 and 1979 she was Captain of the Gentlemen at Arms (Government Chief Whip) in the Lords, a post in which her tact made her highly successful and where she was hailed as the most outstanding servant of the Labour Party in the Lords.

In 1982, a year after her husband's death, she became Chairman of the House of Lords Select Committee of European Communities. She had a lifelong interest in health policy and was Chairman of the Board of Governors of Great Ormond Street Hospital and a member of two further House of Lords Select Committees – one on the Infant Life Preservation Act (set up to deal with problems following late abortions) and the other on Medical Ethics (considering laws on euthanasia). In both cases she was an outstanding contributor. She was made an Honorary Fellow of Girton in 1979.

Irène Manton (1904–88)
First woman President of the Linnaean Society

Irène Manton had a French mother and an English father. She read Natural Sciences at Girton from 1923 to 1926, gaining a first in both parts of the Tripos and continuing her research at Girton and the Botany School to complete her PhD in 1930. She soon moved to Manchester University as Assistant Lecturer in Botany, and established herself through her work on the cytology of chromosomes and the evolution of ferns. On the basis of this research, she was offered the Chair of Botany at Leeds in 1946. Here she built a second research career as a pioneer in plant electron microscopy, while running a demanding department. 'The story of the evolution of this second career from the first reveals the character of this remarkable woman' (Girton *Newsletter*, 1988).

A paper marking the beginning of electron microscopy in Britain had appeared in *Nature* in 1938. Manton recognised the potential of the method and, with some difficulty, gained access to the ultra-violet microscope at the National Institute for Medical Research to learn the technique. After several years of monthly visits, they offered her a set of Zeiss optics for sale – a purchase that took most of her savings. Many trials and tribulations later she had

her own microscope ready for use in 1949, leading to research on the sub-structure of plant cilia, and the publication of several papers in *Nature*.

Her successful career was marked by a string of international honours: she was elected a Fellow of the Royal Society in 1961, was President of the Linnaean Society from 1973 to 1976 and accepted an Honorary Fellowship of Girton in 1985. Though she devoted her life to science, she was also an accomplished linguist and musician (a violinist with her own string quartet), and built an extensive collection of Chinese and modern art. Leeds University named a building after her in 1998 and she and her sister Sidnie (Girton 1921 and 1927, and also a Fellow of the Royal Society) have a crater on Venus named after them.

Kathleen Raine (1908–2003)
Poet, critic and mystic

Kathleen Raine's father was a schoolmaster and the family were strict Methodists. As a child, she stayed with an aunt in rural Northumberland for the duration of the First World War, an idyllic period recalled in *Farewell Happy Fields* (1973). She read Natural Sciences then Moral Sciences at Girton from 1926 to 1929. While at Cambridge, she made long-term friendships with other aspiring writers and began writing poetry. A brief marriage to a fellow student, Hugh Sykes Davies, was followed by another to a fellow poet and sociologist, Charles Madge, which resulted in two children, a son and daughter; the daughter later went to Girton. But the relationship broke up in 1940: Raine felt uncomfortable with domesticity and led an unsettled life in London during her second marriage.

Her first volume of poetry, *Stone and Flower* (1943), illustrated with drawings by Barbara Hepworth, ushered in a prolific period of poetic writing that continued throughout her life. She also wrote scholarly and critical works, particularly on Blake and Yeats. In 1955, towards the end of her relationship with the naturalist and writer Gavin Maxwell (with whom she shared a love of Northumbria and a fascination for the occult), she returned to Girton as Research Fellow, working on Blake. This led to the Mellon lectures, *Blake and Tradition*.

In 1981 she co-founded *Temenos Review of the Arts of the Imagination* with the ambition to affirm 'at the highest level of scholarship and talent, and in terms of the contemporary situation, the traditional function of the Arts as vehicles of the human spirit', and soon became sole editor, with a devoted international following. Nine years later she established the Temenos Academy, a teaching organisation that received the patronage of the Prince of Wales. She received numerous awards and honours, including honorary doctorates from Leicester, Durham and Caen Universities, the Queen's Gold Medal for Poetry in 1992 and the CBE in 2000. She taught and lectured in the USA, India (which she loved) and Ireland, published four volumes of autobiography and saw her work translated into French, Spanish, Japanese and Hindi. A revised edition of her *Collected Poems*, which first appeared in 1956, was published in 2000.

In her work she attempted to bridge the divide between the rational and spiritual, and she saw herself as the last representative of the Platonic tradition. In her seventies, at an age when most writers might begin to retreat, she experienced an upsurge of creative energy, travelling, lecturing and publishing nine books.

Joan Violet Robinson (1903–83)
Eminent economist and humanitarian

Born in Camberley, Surrey, the daughter of Major-General Sir Frederick Maurice, Joan Maurice was educated at St Paul's Girls' School, London, and came to Girton as a Gilchrist Scholar to read Economics in 1922, choosing this subject in preference to History for its bearing on social problems. She married the economist E Austin Robinson in 1926, and they had two daughters. After three years in India researching Anglo-Indian economic relations, she returned to Cambridge and began lecturing in Economics, becoming a University Lecturer in 1937, Reader in 1949 and Professor in 1965. Her first major work was *The Economics of Imperfect Competition*, following which she became involved in Keynesian Theory, participating in J M Keynes' 'Circus' and working for the Labour Party.

Her move from exposition on the theory of imperfect competition in 1933 to involvement with Keynesian Theory marked a radical departure from conventional economics. In the early 1940s she turned her attention to Marx, and her *Essay on Marxian Economics* in 1942 was among the first from an economist to take Marx seriously. During the Second World War she was economic advisor to the Government, making official visits to China, the Soviet Union and Ceylon. In an article in 1953 she launched an attack against neoclassical economic theory that began a heated controversy lasting well into the next decade. In 1956 she published her major work, *The Accumulation of Capital*, which sought to extend the limits of Keynes' theories of growth and capital and which led to her later work with Nicholas Kaldor on the 'Cambridge growth theory'. Between 1962 and 1980 she wrote extensively on economic theory, her accessible style bringing her to greater prominence with a wider public.

In later years she was appalled at the prevailing economic view that inflation was determined by the excess of the supply of money, and that unemployment was a matter of individual choice. 'She perceived with increasing clarity that the problem lay in the methodology of economic theory... and proposed an alternative analysis based on studies of history' (obituary, Girton *Newsletter*, 1983).

For more than fifty years she played a central role in the development of economics and employed her enormous talent for social good. Her works (particularly on monetary economics) have maintained both relevance and inspiration. In 1962 she was elected a Fellow of Newnham College, and she became an Honorary Fellow of Girton three years later. In 1978 the Girton economics students formed the Joan Robinson Society in her honour, and the following year she became the first female Fellow of King's College, Cambridge. Colleagues are divided over her lack of a Nobel prize: some consider it 'one of the saddest "oversights" of the modern economics movement', others that it is 'a measure of her success as an opponent of orthodoxy'.

Alice Stewart (1906–2002)

Epidemiologist who changed medical practice

Alice Mary Naish's parents were both doctors dedicated to children's welfare who worked in Sheffield, where they had moved from Harrogate after being ostracised by other doctors for establishing a joint practice. She was educated at St Leonard's School, St Andrews, and came to Girton in 1925 to read Natural Sciences, completing her clinical training at the London School of Medicine for Women (later the Royal Free Hospital) from 1929 to 1932. She married Ludovic Stewart (they were divorced after the war), and they had a son and daughter. She never remarried, but had a long-term relationship with William Empson. During the war she studied the health risks of industrial chemicals, and in 1946 was one of the founders of the *British Journal of Industrial Medicine*. She then moved to the Nuffield Department of Clinical Medicine at Oxford, became a Fellow of Lady Margaret Hall, and began the epidemiological research that became her life's work.

In the mid-1950s she demonstrated a clear association between childhood leukaemia and exposure of the foetus to x-ray during pregnancy. This conclusion was met with strong hostility from the medical profession and others, especially the nuclear lobby. For two decades she gathered and refined her data, an analysis of thirty years of child health studies that became the Oxford Survey of Childhood Cancer. In the 1970s, the body of evidence she had amassed led to a recommendation by medical bodies that pregnant women should not be x-rayed unless there were compelling reasons. The research led her on to investigate the wider effects of low-level radiation. In 1974, having officially retired, she was invited to contribute to a US Government investigation into the health of nuclear workers involved with the Manhattan Project. Although the team's statistical methods were criticised, the findings provoked congressional investigations in 1978 and 1979. The nuclear accidents at Three Mile Island in 1979 and Chernobyl in 1986 led to her becoming a heroine of the anti-nuclear movement. In 1986 she was awarded the Right Livelihood Award, the 'alternative Nobel prize'. As her obituary said, 'Alice Stewart was a Girtonian of whom we should all be immensely proud.'

Rosemary Thompson (1934–2001)

Magistrate with a significant voice

Rosemary Edith Robertson Heggie grew up in Watford as part of a Scottish Presbyterian family. Her father was a railway clerk and her mother a nurse. She was educated at Watford Grammar School for Girls and came to Girton to read Modern and Medieval Languages in 1953. She was one of an outstanding group of linguists and graduated with a first, following which she taught for three years before moving to Montreal with her husband, whom she had married in 1958. They had a daughter, who later went to Girton, and a son. In Montreal, she did postgraduate work and lectured at McGill University.

On their return to England, Thompson became a research student at Reading University, working on medieval Icelandic literature, but gave this up when her daughter was born to become a full-time mother. Finding this role rather limiting, she moved into voluntary work, setting up a playgroup for deprived children, an English teaching centre for Asian women, and an adult literacy scheme. In the early 1970s she became part time tutor-counsellor for the Open University, with responsibility for students in Broadmoor, a post she held until 1996.

In 1971 she was appointed a magistrate and was elected to represent Berkshire on the national council of the Magistrates' Association in 1976. From the outset she showed a great interest in training and in the professionalisation of the magistracy. She rapidly rose to chair the training committee. In this capacity she worked with the police, travelled overseas and visited schools. She was a member (later Chairman) of Feltham Board of Visitors from 1981 to 1986, steering through measures aimed at achieving the transition from Borstal to young offenders' institution. In 1993 she was elected Chairman of the National Council of the Magistrates' Association. This was a period of legislative change, and Thompson spent time working with the Government, in particular senior civil servants and cabinet ministers, to steer the proposals through. She also worked to raise the profile of the lay magistracy by speaking to the media, becoming particularly adept at handling interviews with John

Eliza Baker Court

Humphrys and other presenters. In this way she raised public awareness, even persuading the Queen to visit her court at Maidenhead and take part in a training exercise. In 1992 she launched the Association's schools project, designed to give children an understanding of the court system.

After retirement from office in 1996, she became a non-executive director of the Prison Service, and later also of the Probation Service. In 2000 she was appointed as an expert consultant to Lord Justice Auld for the review of the criminal courts. She was made an OBE in 1991, a CBE five years later, and received an honorary doctorate from the University of Central England in 1995; in 2000 she became Deputy Lieutenant of the Royal County of Berkshire. She was a significant force in improving the training and professionalism of the lay magistracy and raising its profile, she was influential in the education of the public (particularly the young) in the court system, and she had a passionate concern for improving the treatment of prisoners, especially women. Her particular concern was the reintegration of offenders into the community, and her work overall was informed by her belief, inculcated at an early age, that life should be lived within a framework of ethical standards.

Barbara Wootton (1897–1988)

A 'Woman of Our Century'

Barbara Adam was the daughter of two Cambridge classicists. Her father was a Fellow of Emmanuel College; her mother was a Girtonian who had lectured in Classics for College and became a Research Fellow in 1920, the same year that her daughter became a lecturer and Director of Studies in Economics at Girton. She never got on with her mother, and looked to her nanny ('The Pie') for affection and stability. She married John Wootton in 1917 and lived as an out-student from 1917 to 1919. Initially it seemed she would follow her parents into academia, but a series of personal tragedies may have caused her to change course. Her father had died when she was ten, and her husband died of war wounds only weeks after their marriage. She also lost a brother in the First World War. Her second husband was George Wright, whom she married in 1934.

She came to Girton to read Classics in 1915, but changed to Economics. After her degree, her focus was on social administration, criminology and the law. She took a job as a researcher for the TUC and the Labour Party, and then became Principal of Morley College for working men and women. She was later Reader in Social Studies at the University of London before finally being appointed Professor at Bedford College in 1948. In 1952 she relinquished this post to take up a Nuffield Foundation Research Fellowship, which led to her major publication, *Social Science and Social Pathology*, in 1959.

A lay magistrate for almost fifty years, sitting for sixteen years as chair of the juvenile courts in London, Wootton was an acknowledged workaholic, but one who was 'endlessly and untiringly engaged in practical matters' (obituary in *Psychiatric Bulletin*, December 1988). She published widely on social sciences, was a member of innumerable committees, was a Governor of the BBC, and served on four Royal Commissions. She campaigned particularly on issues of juvenile crime, firearms and drugs, especially the legalisation of cannabis.

In 1958, she became one of the first four life peers, an honour she accepted while remaining a rebel, seeking to abolish 'this creaking contrivance' (*The Listener*, 26 July 1984). She was the first woman to sit on the Woolsack as Deputy Speaker. She was made an Honorary Fellow of Girton in 1969, a Companion of Honour in 1977 and received an honorary Doctorate from the University of Cambridge in 1985.

Wootton was an acknowledged leader throughout her career. In 1926 *Everywoman* stated: 'This is an age when women are coming into their own and we can get inspiration by following the remarkable career of Barbara Wootton. She is even now only twenty-seven years of age, yet she is a considerable figure in the national life, and is, in a sense, the standard-bearer of the new generation.' In 1971 she was hailed by the *London Illustrated News* as 'a sociological legend in her own lifetime', and in 1984 she was one of six remarkable women chosen for the BBC2 series 'Women of Our Century'.

Postscript

So what do these particular women tell us of Girtonians in public life in the 1970s? The overall impression is of gregariousness:

> Her room in the House of Lords was always full of people, and of flowers, and of supplies of white wine from the refrigerator. (Llewelyn-Davies)

linked to persistence:

> Her success stemmed from a mixture of single-minded determination in pursuit of clearly defined ends and the ability to utilise the merit of chance observations. (Manton)

plus a willingness to fight when necessary, as when Banerji used the courts to obtain her promotion to a Professorship:

> Politics is not the art of the possible, it is the art of making the impossible possible. (Wootton)

A further feature was a pragmatic and 'down-to-earth' perception of one's abilities, as is evidenced by Raine's exclamation when faced with the possibility of being chosen as poet laureate: 'God forbid' (*Daily Mail*, 1 July 1972), or Philip Larkin's comment (reported in *The Times*, 8 July 2003) on the publication of Raine's *Collected Poems*:

> I can think of few recent poems as free from jargon, vulgarity and smartness as those in this book.

These Girtonians were resourceful, but also possessed of a lively, if somewhat mordant, sense of humour. They clearly did not take themselves too seriously just because they had achieved public success: Manton called Mondriaan 'him of the bathroom tiles', and Robinson once said:

> I was innocent of mathematics and so I had to think.

And on a final note, they exhibited a desire to improve the lot of others even if that ambition was likely to adversely affect their own careers:

> Her aim was 'to do a little good here and there and fit the scales against all the harm' and 'Her fierce independence of spirit led her to espouse humanitarian causes without regard to prevailing prejudices or fashions'. (Robinson)

> Children need clear standards of right and wrong, to learn to respect other people and their property, and to respect themselves. (Thompson)

> An iconoclast whose formidably critical mind challenged many conventional wisdoms by posing often embarrassing questions. (Wootton)

Eileen Rubery qualified in Medicine at Sheffield University Medical School in 1966 and came to Girton to do a PhD in Biochemistry in 1967. She became a cancer specialist and then managed Public Health issues in the Department of Health for over eighteen years before returning to Cambridge to do research at the Judge Institute of Management. She is a Senior Research Fellow and Registrar of the Roll at Girton.

Kate Perry started her career as a teacher in a school in the Welsh borders. Several moves later and after a five-year break to have two sons, she decided to change direction completely and to become an archivist. She first came to Girton to catalogue the papers of Bessie Rayner Parkes and was appointed College Archivist (a Foundation appointment) in 1987.

Chapter 3
New grounds for equality

Girton was not alone either. This chapter opens with an historian's description of what was happening elsewhere in the UK, and the development of sex discrimination as a national issue. Here we find a Girtonian at the heart of national reforms, anticipated by the College in the enabling decision taken under Muriel Bradbrook. Echoes of debate at the time reverberate in the still lively issues that face many women's colleges in the US today – a comparison that also brings home the unique character of 'Collegiate Cambridge'. Girton was always part of a larger body.

The national context
Carol Dyhouse

It would not be much of an exaggeration to suggest that in Oxford and Cambridge common rooms over much of the last century men and women were regarded as entirely separate species; indeed one college Bursar, gloomily contemplating the admission of women to a previously all-male college in the 1970s, is said to have likened the idea to 'the letting of cats into a dogs' home'. Women were an unknown quantity to many traditionally minded male dons, and, once admitted as 'co-residents', they would demand bathrooms, long mirrors, unspeakable forms of sanitary equipment and other feminine paraphernalia in place of the spartan facilities of the decent male. Co-residence, it was feared,

would usher in immorality and destroy academic standards and fellowship. Segregation by sex was seen as normal and healthy, the taken-for-granted condition of many elite institutions of higher education, particularly Oxbridge colleges, high-ranking public schools and most of the London medical schools.

Historians are trained to look for continuities as well as signs of change, and both are apparent in the educational history of the 1950s and 1960s. In 1958, a number of women's organisations petitioned Winston Churchill to suggest that the new college in Cambridge that was to be founded in his name should admit both sexes. The Open Door Council, the British Federation of University Women, the Women's Freedom League and other groups all made the point that more women scientists were needed in the post-war world and that Churchill College might make an important contribution in this respect. Churchill himself appears to have given the issue more than a passing thought, although his private secretary, Jock Colville, intervened swiftly with a warning that 'a proposal for a co-educational college would be like dropping a hydrogen bomb in the middle of the University'.[1] But in the meantime a number of developments in the University of London heralded a new mood in which single-sex colleges were increasingly viewed as anachronistic.

Priding itself on having been the first British university to allow women to graduate (in 1878), the University of London had long been embarrassed by the obduracy of its medical schools in denying access to women. In 1944, backed by the Report of the Goodenough Committee on Medical Education, the University required all of its associated medical schools – including the Royal Free Hospital School of Medicine for Women – to admit students of both sexes. Queen Elizabeth College decided to admit men from 1953. Royal Holloway had been considering admitting male students since the early 1940s, on the grounds that the college needed 'invigorating' and that 'segregation at the university stage [was] now becoming out of date'. This question of whether segregation had become anachronistic was put to the heads of the three remaining women's colleges by Sir Douglas Logan, Principal of the University of London, and Sir Keith Murray, heading the University Grants Committee, in 1958. Neither was slow to see the possibilities of the women's colleges expanding to accommodate the post-war demand from male applicants. The response from Westfield was somewhat equivocal: its Council was divided on the desirability of going mixed, although the idea of 'experimenting' by admitting men to newly established science departments gained more support. Bedford's response was to state that the College still thought it necessary to uphold the principle for which it was founded.

'I am not making much headway with the problem of the admission of men to the [London] women's colleges,' Sir Douglas confessed to Sir Keith in the spring of 1958. But what strikes the historian now is just how quickly change came about. There were arguments to be resolved, practicalities to be faced, charters that needed amending: indeed, alteration to Royal Holloway's Trust Deed called for an Act of Parliament. Royal Holloway was enabled to admit men in 1962; Westfield in the following year. Bedford too decided to 'go mixed' in 1963, although the issue of admitting men had caused intense controversy: indeed the College was almost torn apart by the bitter disputes and recriminations of 1958–63. Almost all the arguments in favour of and against retaining separate women's colleges, later rehearsed by those in the women's foundations of Oxford and Cambridge, were articulated in these years.

The first 'serious' proposal on the part of a male college to admit women at undergraduate level in Oxbridge came from New College, Oxford, one year later, in 1964. For a variety of reasons (including opposition from the women's colleges and, in the event, a failure to secure the requisite majority among the Fellowship to allow for a change in statutes), the proposal came to nought. The pattern of what the student press of the day referred to as 'sexual apartheid' persisted through the 1960s, and it was not until the following decade that colleges mixed at the undergraduate level became a reality. In Cambridge, Churchill, King's and Clare began admitting women in 1972. In Oxford, after tortuous discussions and negotiations, a group of five colleges (Brasenose, Jesus, Wadham, St Catherine's and Hertford) embarked on a 'limited experiment' in admitting a restricted number of female students in 1974. In both universities there were attempts (ultimately unsuccessful) to phase and control the process of change in what were represented as the interests of the women's colleges, anxious lest they lose their best students to the wealthy and prestigious male foundations. Controversy and endless political manoeuvring both preceded and were intensified by uncertainties about the legality of arrangements in the context of the Government's proposals for Equal Opportunities legislation in 1973–5, as Shirley Littler describes below.

To those involved in the controversies around co-residence during those years, the discussions and debates seemed interminable. But seen through the longer lens of history, events moved with extraordinary rapidity. Once a few male colleges decided to admit women, it quickly became apparent that their popularity increased among male students and the academic quality of their entrants improved. A centuries-old tradition of segregation collapsed in a flash as colleges vied with each other in what Anthony Sampson described as a competition 'to grab the best girls'. Women students, once an embarrassment, had become both resource and bait. By 1988, when

Magdalene admitted its first female students, there were no all-male colleges left in Cambridge. Oriel was the last of the men's colleges to admit women in Oxford, in 1985. Of the women's colleges, Girton was the first to decide to admit male undergraduates, which it did in 1979. St Anne's and Lady Margaret Hall in Oxford accepted male students in the same year. St Hugh's admitted male undergraduates in 1986; Somerville, after much-publicised disputes with its student body, went mixed in 1994. In this new century, Newnham, New Hall and Lucy Cavendish Colleges in Cambridge continue to admit only women. In Oxford, St Hilda's is the only all-female college to have survived.

Social and cultural changes in the post-war period were important in underpinning the growing acceptance of the mixed college, undermining the taken-for-granted pattern of sexual segregation characteristic of Oxbridge society from the 1870s to the 1950s. Students became increasingly intolerant of what was often regarded as the inappropriate 'paternalism' of university authorities who saw themselves as *in loco parentis*, and the 1960s were a decade of escalating conflict over what were deemed to be 'antiquated' and 'petty' rules, regulations and 'gate hours' designed to govern personal and sexual relationships. The ending of National Service, and a trend towards co-education at the secondary-school level, brought a new community of experience between young men and women. Together with the new mood of 'permissiveness' in social and sexual behaviour, this often served to accentuate clashes in values between old and young. The lowering of the age of majority from twenty-one to eighteen years of age, following the Report of the Latey Committee in 1967, released university authorities from any pseudo-parental obligation. Discussions on the feasibility of co-residence in the early 1960s had often been characterised by tutors' anxiety about their perceived responsibility for policing student morals in the context of shared corridors and steamy study bedrooms; by the 1970s they had (just about) given up.

Even more pertinent than changes in the social status of the young in bringing about the reshaping of college life were changes in expectations around women's opportunities and lives, both reflected in and facilitated by the Equal Opportunities legislation of the 1970s. Pressure from feminist groups had been evident from the late 1960s, and there was widespread support for the idea that the Equal Pay Act of 1970 needed to be complemented by some form of 'anti-discrimination' legislation that would tackle employment, training, education and social and political life. The form that legislation should take was referred to Select Committees of both the House of Commons and the House of Lords between 1972 and 1973. One of the most difficult issues faced was the position of single-sex schools and colleges. Government draftsmen were charged with formulating exemptions, as neither Conservative nor Labour Governments wanted to eliminate parental choice at the level of schooling, or see elite institutions made illegal. However, the position was extremely complex. No one was quite sure how provisions for safeguarding equal opportunities in employment would affect college appointments and fellowships, for instance, even if student intake could continue as before. Another problem concerned those male colleges that had recently begun to admit restricted numbers of women, in the interests of 'regulating and ordering change': if 'quotas' were to be illegal, how would these strategies (adopted in both Oxford and Cambridge) fare?

These uncertainties (and many more) were to continue for some time; and it is evident with hindsight just how effective these very uncertainties were in speeding up and expediting the process of change. Few of the colleges knew exactly where they stood at any particular time, and ministers, civil servants and draftsmen, who received requests for advice, were often themselves equally perplexed. Faced with such complexities, some colleges decided to jump. Something of this applied to Girton's decision to admit men, for instance. A change to the College's Statutes had been procured in 1971, described by Muriel Bradbrook as 'a prudent precaution' that would enable the College Council to admit men on the basis of a simple vote, should they decide at some point in the

future that change was expedient. As Girton's Statutes no longer prohibited co-residence, there was uncertainty, later in the decade, about the precise legal position: would an 'Enabling Statute' prove to be a 'compelling' one? The ambiguity of the situation appears to have weighed in on the side of the majority vote in favour of co-residence in 1976.

What, in the last analysis, did the near complete breakdown of single-sex colleges achieve? Most straightforwardly, many more women were able to study in elite educational institutions, particularly Oxford and Cambridge. In both universities, the proportion of women had been kept 'artificially' low before the 1960s: both universities operated 'quotas' restricting the numbers of women entrants. The Robbins Report on higher education in 1963 found that women represented 15% of Oxford's student population and only 10% of Cambridge's: in other British universities, women averaged 25% of the student body. Today the proportions of men and women students in both Oxford and Cambridge are roughly equal. It is hard to see how this might have been achieved if colleges had remained single-sex.

Some women dons welcomed the initiative taken by the first men's colleges to admit women, seeing this as the only feasible route to equality. Others demurred. There was strong opposition from women principals and fellows, in both universities, to what they feared would spell the end of the women's colleges. The fear was that the more richly endowed men's colleges would be sure to 'skim the cream' of applicants (there was rather less talk of 'widening participation' forty years ago). The issues led to heated controversy, many recriminations and much bitterness, in addition to generating some very odd political alliances. Unregenerate misogynists were suddenly fired with chivalric protectiveness towards the poor women's colleges. The heads of the women's colleges found themselves in an unenviable position: in Oxford, John Vaizey castigated them as 'Uncle Toms', accusing them of defending narrow institutional interests above the claims of women generally. But it is not difficult to understand the defensiveness of women dons, nor their concern that men's colleges that admitted

women would remain, in essence, men's colleges with some women students, but with very few women in any position of authority.

Preserved in Girton's Archives is a tape recording of Muriel Bradbrook reflecting on the College's decision to 'go mixed' at the end of the 1970s. She vividly recalled the 'Titanic' sense of shock that she had experienced at the news that Churchill, King's and Clare were to admit women: 'I felt... this great liner had struck an iceberg, because we had lost our monopoly...'. The voice is infused with a sense of loss and regret; the sentences are punctuated with sighs. But the speaker briskly composes herself, with a marked change of tone. Emily Davies, she reminded her interviewers, had never faltered in her conviction that 'what they did, we did', and 'if the men went mixed, we must go mixed'. This was the College's 'real tradition', and in the end 'it worked out splendidly'.

Bradbrook's vision of the mixed college, where men and women could work together as colleagues on an equal footing, was indeed a splendid one, wholly consonant with the vision of Emily Davies in the 1860s, at a time when even a college for women could be described as a 'wild dream'. A century later, there were still many who responded to the idea of co-residence with horror and dismay. A feminist – or egalitarian – concern that institutions with a centuries-old tradition of patriarchy would scarcely be likely to transform themselves overnight was entirely defensible. Indeed, the slowness of some of the former male colleges to appoint significant numbers of women to senior positions has disappointed many, and it might be argued that the former women's colleges have implemented a policy of equal opportunities more wholeheartedly and with rather more success than their male counterparts. Even so, we may conclude that, in the specific historical context of late twentieth-century Britain, the triumph of the mixed college was a necessary – though not yet sufficient – condition of a move towards equal opportunities for both men and women.[2]

Carol Dyhouse is Professor of History at the University of Sussex. Her publications include Girls Growing Up in

Late Victorian and Edwardian England *(1981)*, *Feminism and the Family in England, 1880–1939 (1989) and* No Distinction of Sex? Women in British Universities, 1870–1939 *(1995). She is currently working on gendered patterns of access, provision and student experience in twentieth-century British universities for her next book,* Students: A Gendered History.

The 1975 Sex Discrimination Act
Shirley Littler

When I joined the Home Office in 1972 my division listed fifty-eight responsibilities, including royal and church matters, summertime, London taxis, sex discrimination and miscellaneous hazards otherwise unallocated. Sex discrimination was a relatively new Home Office issue, and it was going, surprisingly fast, through the usual series of Home Office responses:

1 there is no problem
2 perhaps there is a small problem but no Government action is appropriate
3 the problem is being carefully monitored and may require action in due course
4 urgent legislation is needed for a new regime with its own quango

The Conservative Government was at stage two in 1972, but reached stage four by 1974, with proposals for legislation building on its Equal Pay Act 1970 and confined to aspects of employment and the establishment of an Equal Opportunities Commission (EOC). Between March 1974 and November 1975, the Labour Government completed its much more ambitious legislation, covering employment, training and related areas; education; housing; the provision of goods, facilities and services, and advertising in all these areas; and strengthened enforcement. The legislation did not affect social security, pensions, taxation, small employers or personal or private relationships, and was 'not money-spending', the strengthened EOC being the main cost.

In 1974 I began working full time on equal opportunities and led a small team of Home Office officials who, with colleagues in other departments, saw the Bill through Parliament.

One early decision rejected 'reverse discrimination' and 'quotas'. Evidence from the USA suggested that these provisions could operate in arbitrary ways and that injustice and inefficiency had resulted. The UK Government felt that what mattered was equal access to opportunities, buttressed by provisions to stop 'indirect discrimination' and by appropriate information, training and enforcement.

Another key decision on employment was that there would be few exemptions for whole occupations, but rather criteria – 'genuine occupational qualifications' (GOQs) – for excepting particular jobs. Somewhat embarrassingly, the three main Home Office services privately sought exemption: the fire service, which existing legislation required to be all male, and the police and prisons services, which had arrangements to protect and enhance the position of their women officers. Roy Jenkins rejected these requests, though the strength requirements for firefighters could remain, provided they did not amount to 'indirect discrimination', and some of the GOQ criteria would be important for police- and prison-service work. Conversely – and controversially – the Government opened the profession of midwifery to males, with certain provisos. In the end, underground mining, ministers of religion and the armed services were the only occupations exempted. The GOQ criteria included authenticity or physiology (as in modelling or acting), mixed-sex teams in social or personal work, employment in certain single-sex establishments, and decency or privacy.

The Bill prohibited sex discrimination in educational establishments and placed a duty on public-sector bodies to provide equal treatment. It did, however, permit single-sex establishments (as Girton then was) and boarding accommodation. Most interestingly for present purposes, it prohibited the co-educational quotas then obtaining in some schools and colleges: a single-sex establishment could become mixed gradually but could not stop at quotas of, say, 40:60 or reverse the process once begun.

In its third main area, the Bill prohibited sex discrimination in the provision of goods, facilities and services to the public, and in the disposal of premises.

Because the potential scope of this part of the legislation was so wide, the discussions about appropriate exceptions – for example, for sports, charities, insurance and accommodation – were particularly fascinating.

The enforcement machinery combined the right of individual access to industrial tribunals or the courts with the strategic functions of the EOC. The EOC could represent individuals in suitable cases but its main tasks would be wider policy: to identify and deal with discriminatory practices and to promote equal opportunities. It could issue enforceable non-discrimination notices and follow up court and tribunal proceedings. It could require information, conduct general enquiries and research, advise Government and educate and persuade public opinion.

The Bill was an elegant tapestry of complexity – a tribute to the political and administrative thought that had gone into it, and the artistry of Parliamentary Counsel. It concerned all Government departments to varying degrees, and various aspects were controversial in Parliament. The Bill team faced exhilarating challenges. Our documents went to over 100 recipients in Whitehall, and I remember vividly the night before Report Stage, when we worked until midnight revising, copying and collating over eighty notes on amendments selected by the Speaker. Various changes were made as the seventy-six-clause Bill went through Parliament to become an eighty-seven-section Act, and some of the debates would have delighted medieval schoolmen, but its structure remained intact.

The Bill broke new ground and had some unexpected effects. Shortly before introduction, our team suddenly realised that the Bill would prohibit the women's seats on the TUC Council and the Labour Party's National Executive Committee; the political advisers had missed this! We pointed it out, deadpan, to Roy Jenkins, who replied, equally deadpan, that after introduction his junior minister should have early discussions with other political parties. Suitable exceptions were agreed, giving rise to the first UK legislative definition of a political party.

Overall, the legislation attracted widespread support here and, as it coincided with International Women's Year, gave the UK Government much kudos abroad. It was radical but fair, not too far ahead of public opinion, and was effective in changing practice in the areas covered. It became the model for the 1976 Race Relations Act and, at least until human rights legislation created new complexities, I believe it stood the test of time.

Shirley Littler (Marsh, 1950) read History at Girton and subsequently joined the Administrative Civil Service. She worked in the Treasury (where she met her husband, Geoffrey) and other Government bodies before joining the Home Office, her favourite department, in 1972. There she headed the Broadcasting Department and the Immigration and Nationality Department before joining the Independent Broadcasting Authority in 1983, later becoming its Director General. She chaired the Gaming Board from 1992 to 1998.

Clearing the way
Christine H McKie and Dorothy J Thompson

'Guys at Girton' read the headline in the *Sun* on 29 November 1976, following Girton's decision to put into effect the Enabling Statute agreed over five years before, and so to admit male undergraduates from October 1979. In one respect this vote marked the end of a challenging process for the College, which had started in November 1968 when Churchill College, followed shortly by King's and Clare, announced its intention to admit women. In other respects the vote of the Governing Body on Guy Fawkes' Day 1976 marked the start of a new phase in Girton's history. It is the process of 'going mixed' with which this section is concerned. For when Cambridge (and Oxford) colleges changed their constituency, they reflected changes in society, so it is within a wider national context that this local history may be viewed.

In 1969 Girton celebrated its centenary as a women's college with 370 undergraduates and sixty-six graduates in residence. The Mistress, Muriel Bradbrook, published '*That Infidel Place*' as a short history of the college. She also made history by initiating discussion in Augmented Council and

(later) the Governing Body of a possible amendment to the College Statutes to allow the admission of men. Different possibilities were canvassed, with some favouring a 'cooperative federation' with a male college. In February 1970 the decision was taken to amend the Statutes in such a way as to allow the admission of men at an unspecified date in the future if at least two-thirds of the Governing Body voted in favour. By May 1970 the enabling clause was drafted, and in October it was voted upon, only to be delayed, as prior change was needed to a University Statute (GI, On the Obligations of Colleges). In March 1971, before any of the men's colleges had actually changed their constituencies, the new Statute was finally adopted. It was four-and-a-half years before it would be acted upon.

This step-by-step approach took the majority along. The greatest fears were over a possible decrease in academic posts for women, but the most memorable feature of discussions of the time was the absence of personal animus or entrenched positions. Throughout, the debate was characterised by good argument, with much of the leadership coming from our Life Fellows. No one resigned, no one bore grudges; the winning arguments involved the continuation of our pioneering role, and the best setting for women's education in the later twentieth century. Once the decision was taken, whatever their prior individual stance, members of the Fellowship united to make it work.

The Sex Discrimination Act of 1975 had reflected and affected changes in social attitudes. Girton's decision in 1976 was to proceed to appoint male Fellows almost immediately, to open Girton to men as graduates from October 1978, and to admit men undergraduates from 1979. And so it happened – without problems.

Looking back to the debate, two features are striking. There was a constant concern, unfounded in the event, that sufficient numbers of suitably qualified women would not come forward to fill the increased number of places now available in Cambridge, with the result that Girton might lose out. Secondly, the focus of the debate that took place, as indeed of the final announcement, was in terms of co-residence rather than co-education, which after all to some degree was already in place.

Christine H McKie (Kelsey, 1949) read Natural Sciences (Physical) at Girton. After working for her PhD under Dr Helen Megaw in the Cavendish Laboratory, she spent two years as a post-doctoral Fellow at the National Research Council in Ottawa. She returned to Cambridge in 1958 as a member of the Department of Mineralogy and Petrology (now part of the Department of Earth Sciences) and was elected to a College Fellowship. She has held a variety of College positions over the last forty-seven years.

Dorothy J Thompson is Wrigley Fellow and Director of Studies in Classics at Girton, where she has spent most of her working life, acting also as Tutor and Senior Tutor. Her published work is mainly on Hellenistic Egypt. She is a Fellow of the British Academy and currently President of the International Association of Papyrologists.

Comparisons: women's colleges in the United States
Leslie Miller-Bernal

Both in the United States and in England, women's colleges[3] were important historically for women's access to higher education. In contrast to England, however, the first undergraduate college in the US that enrolled women was actually a small, private, religiously based co-educational institution: Oberlin College in the Midwestern state of Ohio. In 1833 Oberlin became the first college open to both women and black Americans. The women's colleges in the Eastern and Southern states were associated with ideals of 'true womanhood' and gentility, while colleges and universities in the Midwest and West usually admitted women to reduce the cost of building separate institutions. However, they generally established 'ladies departments' or 'coordinate programmes' to separate women as much as possible from men students.

As early as the end of the nineteenth century, a majority of women students in the US were being educated in co-educational institutions of higher

FIFTY YEARS OF FULL MEMBERSHIP
FOR WOMEN AT CAMBRIDGE

On July 4, 1998 (see opposite) some 900 women who had been at Cambridge in 1948 or earlier processed to the Senate House to the ringing of church bells and the cheering of crowds. They came from Girton and Newnham in three instalments, being too many for a single ceremony. With an audience of University grandees they were addressed by the Vice-Chancellor and University Orator before going on to a champagne reception on the Senate House lawn. All this was to mark the fiftieth anniversary of women's full membership of the University.

It was an ambiguous anniversary. Cambridge, where Emily Davies launched her campaign for the higher education of women, was just about the last university to give them recognition as full members. To make amends to those who had been short-changed, today's University celebrated their achievements with its finest pageantry. The day was a wonderful success. But what did the pre-1948 women feel about their own time at Cambridge?

There was no strong sense of grievance among the undergraduates of those years. On the contrary, the main feeling was pride in having been able to study at the University. The competition for the limited number of places at Girton and Newnham meant that getting there was an achievement, and in those pre-PC days women were conscious of new opportunities. Individual experiences varied, of course, but the three remarkable women who replied to the Vice-Chancellor on behalf of their colleagues (Nora David, Beryl Platt and Margaret Anstee) were typical in rejoicing in the cup being half-full rather than regretting the part left empty. They even spoke of the practical advantages of not wearing gowns as their male colleagues had to when the Proctors were rounding up undergraduates at night. It did not loom large that until 1948 Girton was not itself accepted as a full college of the University.

By the time Cambridge got round to giving women full membership female students had long been able to use University libraries, laboratories and so forth, and were awarded the titles of degrees – even if their degree certificates were sent by post! Those who had suffered most were the dons who, even after the appointment of the first woman Professor in 1938, were excluded from University administration and ceremonial functions. Helen Cam spoke most movingly about this at the College Feast at Girton in 1948.

Summer 1998 was my last term in Cambridge and, for me personally, supervising these celebrations at the request of the Vice-Chancellor was a wonderful finale. They were part of a programme of events, including a conference on the history of higher education for women and the photographic exhibition 'Educating Eve', which left us many fine portraits on the walls at Girton. But July 4 was the heart of it all. I will never forget the pleasure of welcoming so many splendid vintage Girtonians back to lunch in College nor the numerous wonderful letters, now in the Archive, that they wrote about their memories and about the day itself.

Juliet Campbell, Mistress of Girton 1991–8

education. However, many women's colleges, particularly the 'Seven Sisters' (Barnard, Bryn Mawr, Mount Holyoke, Radcliffe, Smith, Vassar and Wellesley), were still a prestigious educational option through the 1960s. The Seven Sisters were considered the female version of the eight Ivy League colleges (Brown, Columbia, Cornell, Dartmouth, Harvard, Princeton, University of Pennsylvania and Yale), most of which enrolled only men. There were also many other private secular or Protestant women's colleges, including those in the South such as Agnes Scott (Georgia) and Sweet Briar (rural Virginia); those in the Northeast such as Connecticut College for Women, Skidmore and Wells (both in different areas of upstate New York) and Wheaton (Massachusetts); and a few in the West, notably Mills College (California). Another large group of women's colleges were Catholic, and, in addition, there were a few relatively large state universities – Mississippi University for Women and Texas Women's University, for instance.

The decline of single-sex colleges in the late 1960s

The popularity of single-sex higher education decreased markedly during the decade that began in the late 1960s and continued into the mid-1970s, at a time when cultural, demographic and economic factors combined to favour increases in the number of co-educational institutions in the US. The cultural ferment of the 1960s, especially the Civil Rights Movement and later the Women's Movement, stressed integration, with the result that separate institutions began to be seen as anachronisms. Women's enrolment in institutions of higher education was proportionally lower than men's, but was increasing at a faster rate. While the 1960s was a boom period for higher education, with federal government and foundation money enabling many institutions to expand, the 1970s was a time of high inflation. Administrators, worried about how they would be able to maintain numbers, saw co-education, especially for men's colleges, as the perfect solution. The decision of Yale and Princeton – two Ivy League universities that had no nearby sister or coordinate women's college – to become co-educational in 1969, broke the historic link between high prestige and men only. For men's colleges, the gains were clear: academically gifted women were eager to enter, so they not only gained in enrolment but were also able to become more selective and academically rigorous. At Yale, 2,850 women applied for 240 places in the first year that women entered as matriculating undergraduates. The trend for men's colleges to admit women continued, so that by the 1990s there were only a handful of men-only colleges remaining, notably Hampden-Sydney in Virginia, Morehouse (an historically black college) in Georgia, and Wabash in Indiana.

Many leaders of women's colleges recognised the threat posed by prestigious men's colleges becoming co-educational. They realised that they might lose academically talented women students, and so decided to become co-educational themselves. The most famous women's college to do this was Vassar, which was like Girton in being both one of the earliest colleges for women and one of the first to admit men, about 100 years later, in 1969. Connecticut College, Skidmore and Elmira, all in the Northeast, were other 'first wave' women's colleges to make the transition. Many women's colleges resisted the trend, however, especially since the women's movement gave them a new *raison d'être*: research showed that many co-educational colleges had 'chilly climates' for women and that graduates of women's colleges were more successful in later life than women graduates of co-educational colleges. Other women's colleges did not survive the increased competition and folded or merged with other institutions. Of 233 women's colleges in 1960, only ninety remained single-sex by 1986.

The second wave and beyond

The struggle to attract students and to maintain healthy finances did not lessen as the number of women's colleges declined. This surprised some people, who thought that the remaining women's colleges would have a niche market among all the young women who wanted single-sex education.

Instead, market research showed that very few high-school girls – only 3% or 4% – said that they would consider a women's college. It became commonplace to say that young women attended a particular college not because it was a women's college but rather despite its single-sex character.

Several prominent women's colleges gave up the struggle and admitted men about fifteen years after the first group of women's colleges had become co-educational. Wheaton (Massachusetts) and Goucher (Maryland) made the decision at about the same time. But by then, the late 1980s, the political atmosphere was different and the protests of the students were greater. Wheaton's experience was particularly difficult, as it had made a name for itself in promoting its 'gender-balanced' curriculum, and it had just completed a financial campaign based on being a college for women. Students and alumnae were organised in opposition to the change, and alumnae donors sued the college. Nonetheless, the Trustees stood firm and eventually settled out of court, with the result that the college had to give back only $150,000 of the $25 million raised in the campaign.

Mills College in Oakland, California, is famous for its resistance to becoming co-educational. When College Trustees announced in 1990 that Mills would admit men, students and alumnae protested vehemently and gained the support of students at other women's colleges. The Trustees changed their minds and agreed to keep Mills as a women's college, provided that undergraduate enrolment increased to 1,000 by 1995. This number had not been achieved by 2003; however, the graduate programme, open to men and women as it legally must be, has grown.

Fewer and fewer women's colleges have survived. In recent years, such colleges as Elms, Lassell, Immaculata, Chestnut Hill and Hood have announced that they are admitting men. Other women's colleges have been absorbed or taken over, for example Mount Vernon College by George Washington University, Mundelein by Loyola (Chicago) and Southern Virginia Women's College by the Church of Jesus Christ of the Latter Day Saints. Large state universities, in particular Texas Women's University and Mississippi University for Women, have been required by the courts to admit men students. These two universities remain predominantly female, however, and are often listed as women's colleges. Currently, across the US fewer than sixty women's colleges remain.

Survival mechanisms

Women's colleges today are very different from their past stereotypical image in the US – institutions where privileged white women got lessons in being proper wives for successful men. The struggle for numbers has led to greater use of financial aid, which in turn has meant that more students in recent years have come from families of limited means. At Wells College, for example, about 50% of the students are the first in their families to attend college. Associated with this trend is the relatively high proportion of minority students, even at a women's college like Wells, which is located in a rural area in the Northeast. Fewer applications have led to increased acceptance rates or lower selectivity: over 80% of applicants to Wells College have been accepted each year since 1969. In general, the academic credentials of students admitted to women's colleges today are not as strong as they were thirty or forty years ago.

Many women's colleges are no longer traditional private liberal arts colleges for full-time residential students. Depending in part on their location, women's colleges without a large endowment have typically survived by one of two methods. The first is by developing programmes for students other than their traditional full-time women students. Graduate programmes, often with evening classes, for part time older students, or weekend colleges with intensive instruction, are some of the methods used to generate further income. Mills College is an urban example. It enrols fewer full-time undergraduate women than it once did, but it generates income from its graduate students. Wilson College, located in a rural area in southern Pennsylvania, has many applied programmes, including 'equestrian studies'. In addition, 50% of its 739 students are part time (and 14% are men). Catholic women's colleges are not

exempt from this trend. The oldest Catholic women's college in the country to award the AB degree, the College of Notre Dame (CND) in Baltimore, has 652 full-time and 1,039 part time students, 4% of whom are men. CND has developed many special programmes to attract students, including a weekend college, graduate programmes and a programme for adults of fifty-five years and older.

The second survival mechanism is available only to some women's colleges – those physically close to a co-educational or men's college, which allows them to function in many ways as co-educational colleges. Spelman in Atlanta, an historically black women's college, has what can be described almost as a coordinate relationship with all-male Morehouse; it is also very close to several other historically black institutions that together form the Atlanta Consortium. Similarly, the College of St Catherine in St Paul, Minnesota, is a Catholic women's college in close association with the co-educational University of St Thomas. Bryn Mawr (near Philadelphia) probably benefits from being sufficiently near Haverford that its students can attend classes there or even live in co-residential dorms.

One of the few women's colleges to have survived by neither of these two methods is hampered by its rural location in central New York State. Wells College, located on the eastern shores of Cayuga Lake, is very small – only about 400 students – and is located in a village of fewer than 1,000 people, twenty miles from a small city. Wells continues to be a private liberal arts college for mainly residential, full-time students, but it is struggling with enrolment and finances. About every five years, special committees are set up to examine what the college can do to ensure its survival. Past solutions have included a dramatic 30% reduction in tuition and a short-lived women's leadership institute. The college has occasionally considered co-education, but loyalty to Wells' long history as a women's college (it opened in 1868) has so far blocked this proposal. Moreover, a large monetary gift to the college is tied to its remaining single-sex; and a further factor in recent years has been the development of a strong lesbian,

bisexual and trans-gender community. As a small women's college, Wells is felt to be a safe environment for the expression of alternative sexualities, one that some students fear would not be maintained were it to admit men. And yet Wells may not be able to survive in its current form. None of the initiatives has enabled the college to sustain numbers, and in recent years its annual expenditure has outrun its revenue.[4]

Former women's colleges compared to former men's colleges

Women's colleges improve their enrolment when they admit men undergraduates. This may seem an obvious outcome, but it has often been predicted that men would not want to apply: 'What kind of a man would want to attend Wheaton, Vassar or Hood?' is the rhetorical question. But among those willing to attend formerly women's colleges are often men interested in sports. They know that the college will be forming new teams and that they will have a good chance of actually playing rather than sitting on the bench. However, the greatest increase in applications at formerly women's colleges comes from women. The college moves from being in a category that only 3% or 4% of high-school girls will consider, to a category that almost all will.

The increase in applications and enrolment has not related only to the period when women's colleges first admitted men undergraduates, nor has it decreased with time. Vassar, Skidmore and Connecticut College, for example, increased their enrolment after they admitted men in 1969, and so did Wheaton and Goucher in the late 1980s, and Chestnut Hill and Hood in the twenty-first century. Vassar enroled 1,601 women in 1965, but 2,164 in 1995 and 2,411 in 2004.

However, women's colleges 'going co-ed' are not flooded with male applicants. This is in marked contrast to the deluge of women applicants to former men's colleges. The numbers of men applying to former women's colleges seldom reach parity with the numbers of women applicants, even after many years. Connecticut and Vassar, for example, are still only around 40% male, even though they have been co-

educational for more than thirty years. Sarah Lawrence, another former women's college that made the transition to co-education at about the same time, was only 26% male in 2003.

Another difference between former women's and former men's colleges is in the expectations for the academic qualifications of applicants of the formerly excluded gender. Former men's colleges expect and do get many very highly qualified women applicants, including those who used to attend the Seven Sisters colleges. The converse is not entirely true: the new men applicants to former women's colleges are not as academically weak as many people fear. When Wells discussed co-education in the late 1980s, it was predicted that new men students would have to receive special academic assistance. However, the experience of former women's colleges indicates instead that, with increased applications, colleges can become more selective for both men and women.

Given the different past histories of former men's and former women's colleges, it is not surprising that, as co-educational institutions, the gender composition of faculty and administration is different. Men's colleges historically hired very few women, and so they have had to struggle to overcome the dominance of men in their hierarchies. Women's colleges, by contrast, tended to have a relatively even mixture of women and men in both faculty and administration, particularly from the 1970s on, and so it has been easier for them to preserve a good gender balance. A comparison of nine former men's colleges with nine former women's colleges found that almost half of the full-time faculty at the former women's colleges were women, whereas less than one-third of the faculty at the former men's colleges were women.

There are other differences. Former women's colleges are more likely than former men's colleges to have female role models, as many of their past presidents or other leaders are likely to have been women. They also do not have to contend with the problems associated with Greek-letter fraternities, such as sexual harassment and date rape. American football – a male sport that dominates many co-educational colleges – is seldom established at former women's colleges. The sports for men at these colleges are usually soccer, basketball, track and field, swimming and tennis.

One issue at former women's colleges that received early negative publicity was how much men students dominated classrooms and campus leadership positions. It is easier to document whether men tend to take more than their share of key positions than it is to find out about classroom dynamics. In both cases, however, the evidence seems to indicate that men may dominate in the early years of co-education, but that, after about a decade, leadership is shared and men and women participate relatively equally in class discussions. It has been more difficult for women to achieve this sort of equality on campuses where historically men have dominated. Duke University (a former men's institution) recently released a study focusing on such concerns. Women undergraduates were found to lose status in campus hierarchies over their four years at Duke, while men students gained. The investigators did not find 'widespread gender issues in the classroom', although men and women agreed that men talk more in classes and are less concerned about appearing unintelligent in front of their peers. A notable aspect of the Duke study is that it was careful to distinguish among different sub-groups, finding, for example, that the concerns of students of colour were not always the same as those of white students. A major conclusion of the study is that women students are under 'intense pressure' to conform to norms of femininity, apparently effortlessly, while at the same time attempting to achieve academically.

Disappearing?

Women's colleges seem in danger of disappearing in the US, with the exception of a small number of very prestigious and exceptionally well-endowed institutions such as Wellesley, Smith, Barnard, Bryn Mawr and perhaps Agnes Scott and Simmons. On the face of it, this would seem a loss for higher education. Not only would their disappearance reduce the diversity of institutional types, and hence student choice, but it would mean that places where women are supported,

given the opportunity to be the leaders of diverse types of activities and quite protected from sexual harassment and homophobia would cease to exist. All-girls' private secondary schools, on the other hand, are flourishing. Some researchers argue that it is more beneficial for girls and boys to be separated in adolescence than in early adulthood, given their different rates of development and the difficulties teenagers have concentrating on academic work when they are distracted sexually.

While most high-school senior girls today only consider co-educational colleges, a hopeful development is the desire of many former women's colleges to preserve the best aspects of having been a women's college – in other words, to establish themselves as models of gender equity, where women are taken as seriously as men. They do appear to be a different sort of institution from former men's colleges: they have more favourable gender ratios among faculty

and administration, and women seem as likely as men to be leaders of student clubs. Moreover, some former women's colleges are establishing mechanisms to maintain a positive environment for women, such as Vassar's 'watchdog' committee to keep track of gender-equity issues. Wheaton is attempting to make itself a 'consciously co-educational' college, with a leadership institute that focuses on supporting women leaders and annual awards for the male and female student who has done the most to promote gender equity. A major challenge facing higher education today is how to institutionalise gender equity while flourishing in an increasingly competitive academic environment.[5]

Leslie Miller-Bernal received her PhD from Cornell University in 1978 and has taught Sociology at Wells College, NY, since 1975. Her research, which focuses on women's experiences in women's colleges, former men's colleges and former women's colleges, has included a comparison of Girton and Newnham.

1 Correspondence Jock Colville to Winston Churchill, 16 June 1958, Churchill papers, Churchill College Archives, CHUR 2/568B/167.

2 For more extended discussion, and detailed sources, see C Dyhouse, 'Troubled identities: gender and status in the history of the mixed college in English universities since 1945', *Women's History Review*, vol. 12 no. 2, 2003, and the same author's '"Apostates" and "Uncle Toms": accusations of betrayal in the history of the mixed college in the 1960s', in *History of Education*, vol. 31 no. 3, 2002.

3 While Oxbridge colleges are constituents of the wider University, 'college' in the USA refers to a total teaching establishment, i.e. the educational equivalent of 'university'.

4 The Trustees of Wells College voted in October 2004 to admit men, beginning in the autumn of 2005. By February 2005 applications were more than double the level they had been a year before.

5 For further information, see Leslie Miller-Bernal and Susan Poulson (eds), *The Challenge of Coeducation: Women's Colleges since the 1960s*, Vanderbilt University Press, forthcoming.

COLLEGE DOMESTIC LIFE

A vital part of College life is represented by its administrative and domestic staff – those who keep the College going year on year, in the offices, the kitchens, the workshops and the grounds, and maintain it day in and day out. The office staff, the cleaners, kitchen staff, works and maintenance staff, gardeners, groundsmen and porters are an essential part of Girton, particularly in the last twenty years since activity on the domestic side at both College and Wolfson Court has increased hugely. This is partly due to the growth in the conference trade but also because the more diverse and enlarged community necessarily causes greater wear and tear, and new legislation on health and safety and accessibility demands a higher standard and new elements of maintenance.

Girton is fortunate in having had the services for decades of loyal, dedicated staff whose contribution to the general ethos and 'feel' of the College has been immense. The splendid set of photographs taken by Anne Crabbe between 1995 and 1997, published in *Girton People*, captures many of these members of the community,

including the then Clerk of Works, Basil Few, and his successor, Michael Pocock, then one of the painters. Long service seems to be the norm at Girton. As Christine McKie records elsewhere, 'Mac' Stringer was Head Gardener for thirty-two years from 1948 until 1980, and David Whitehead, the Head Groundsman, worked at College for over forty years from the early 1930s until 1977. And as Maureen Hackett also records, one member of the Wolfson Court cleaning staff has been there since the building first opened in 1971, and three members of the kitchen staff can rack up over seventy years service to the kitchens there between them.

One of them is Graham Hambling, who started as a chef in 1979, rapidly becoming the chef/caterer and then, in 2001, the overall Girton Catering Manager. Since 2004 he has also taken on the management of the conference business, an activity that started as one conference a year at Wolfson Court during the long vacation but is now almost a daily event at both Girton and Wolfson Court. In common with the other Cambridge colleges, Girton has expanded its conference, meeting, party and wedding business hugely in the last twenty years. These events are now an essential and significant contribution to revenue, and Girton is particularly fortunate in having a large site at its main building with ample parking, which means that daytime conferences can take place even in term. There is rarely a day when Graham and his staff don't have to provide accommodation and catering for some function or other, an activity that has become considerably easier since the redevelopment in 2000–1 of the College kitchens, which now have modern facilities and offer a much more efficient service for all their customers. There is a new bar and conference area in the old kitchens too. New projects include the renovation of Tower Wing and new en-suite rooms in Pear Trees. Dinners, parties and other functions are also on the increase, especially wedding receptions. Girton does not yet have a full

Michael Pocock, Clerk of Works

Tom Durkin, Girton's first barman

wedding licence, but anyone attached to the College can get married in the Chapel if a special licence is obtained, and the extensive and beautiful grounds, combined with the excellent catering now available, make it a very desirable venue for receptions.

All those who worked at Girton during the era when the College went mixed comment that the change had one very fundamental effect: the place got friendlier and less formal, for students and staff alike. Whether it was the advent of men, with their differing needs – including the necessity of providing a bar in College for the first time – or just the effect of a better social life within College, Girton became more relaxed. The nature of the place means that there will always be a certain hierarchy, but barriers and formalities have increasingly broken down and interdisciplinary bonds have grown. Tom Durkin – 'Tom the barman' – was important in that process. Right from the establishment of the new bar in 1979, Tom was a permanent fixture there and, despite officially 'retiring' in 1999, he continued to work in the bar and to decorate

many College rooms in his spare time until his sudden death in 2003. The bar began in what is now the JCR, but was moved down next to the wine cellar in the mid-1980s and has recently undergone a refurbishment.

Wolfson Court has played a vital part in this increased informality. Its offer of somewhere in town to meet and eat during the day, for Fellows and students alike, and the relaxed and welcoming layout of its cafeteria, help to foster friendliness. Florrie Buck still works there two days a week, extending into the future her forty-five-plus years at Girton. Residents of the Grange in the 1960s will remember her well – she is still in touch with several of them – and she has had an unbroken association with the College since then.

She has clear memories of the impact of 'going mixed'. Some of the older gyps were a bit embarrassed at having to cope with young men, and some of the female students were a bit shy, particularly at having to share bathrooms. One or two of the older Fellows, too, took a bit of time to get used to the change. But the atmosphere soon

Darren Turpin mowing the lawn

Florrie now comes and goes in both College and Wolfson Court as she wishes; she is part of the place, and is not unusual in loving it. Jill Brayley has been the telephonist and receptionist at the Girton Porter's Lodge since 1987, and has thoroughly enjoyed her time at Girton (she retired in May 2005). 'When I arrived it was just a job,' she says. 'But it was so agreeable that I stayed on long after I intended to.' She loves interacting with Fellows, staff and students, and being at the hub of the College. It is, she says, a pleasure to help the students, and there is hardly a dull moment.

Things have changed since her arrival. A large part of her job used to be taking messages, but mobile phones have stopped all that. Security is tighter now, and communications at all levels of the College have got better: the staff are now consulted and listened to much more than was the case, and she feels very much part of the College community. Conferences and functions have had their impact on her working day too, with the need to provide a reception service, and the layout of the Lodge is about to change in response to the changing 'business' of the College and the increased security needs. Jill remembers too that gas fires in some of the students' rooms were still the norm until the early 1990s; modernisation always takes its time, but it happens eventually.

The staff member who has perhaps seen most change during her long career at Girton is Valerie Biggs, who recently retired as Admissions Secretary. Aged only seventeen and straight out of secretarial collage, she joined the Admissions Office in 1959 as assistant to the formidable K M Peace. She later worked for Marjorie Docking, sometimes part time when her children were small, and eventually took over the office in 1986. She has seen at first hand the changes necessitated by the decision to admit men, and has also witnessed the end of

lightened, and the new young men brought the girls out and encouraged them to socialise in College a lot more (the new bar helped, of course!). But Florrie also has fond memories of the earlier era, when important guests would come to College for major occasions and their chauffeurs would stay with her at her home in Girton Village.

the entrance exams and the advent of admission offers made on the basis of predicted A-level results, which made it necessary to interview all those who applied. She too loved working at Girton, and she too believes that the men changed things. Although academic standards were never compromised, she is sure that the first men offered places had to demonstrate their all-round social skills as well as their academic powers. And while she worked in the Admissions Office, the College realised that a great deal more effort had to be put into contacts with schools. Valerie revelled in arranging and running open days, and she understood very early on that, in the new mixed Cambridge, Girton – two miles out of town – had to do an extra job in selling itself.

When Valerie first came to Girton the Fellows were a daunting and formidable presence at the edge of her working life there. But they were also kind: 'Peacey' even allowed her to receive letters at College from her boyfriend, of whom her parents disapproved because he was in the army. Her long and happy marriage has justified KMP's trust, and Valerie's long and happy career at Girton is one of many testaments to the community feel that the College engenders in everyone connected with it.

All staff members, past and present, are part of Girton and many remain connected with it long after they leave. Those mentioned here are only a few of the many who have worked at the College over the decades, and stand for all the others whose contributions to Girton life have been so valuable. College remembers and cherishes them all.

Graham Hambling, Catering Manager

Jill Brayley, receptionist

PART TWO: EXPECTATIONS

Chapter 4
Numbers – putting the house in order

In the year that College went fully mixed, the then Senior Tutor reflects on how Girton set about putting its house in (new) order. This chapter is about governance: where College takes things into its own hands, where it acts in concert with others, where it responds to outside pressure. Broad comments about the Government's presence in university affairs are followed by a detailed account from today's Bursar who could not show more clearly what dealing with external events, planned and unplanned, means. A Professor of Accounting, adding a personal note as one of the 1979 Girton graduate cohort, puts this in the context of the changing culture of academic professionalism and accountability.

Organising ourselves
Melveena McKendrick

[*Edited text of a speech given by the then Senior Tutor at the 67th Annual Meeting of the Roll at Queen's College, London, on 19 January 1980*]

Girton is a co-residential institution! That statement is rich in implications and, in its way, momentous. But the lived reality is not momentous; on the contrary, it feels so natural, right and obvious that, whereas until October we were struggling to imagine what it would be like, we shall, I am sure, soon be struggling to recapture the flavour of what it was like before.

I doubt if anyone in College would now wish it to be other than it is, but twelve years ago the way forward was fraught with uncertainty.

In that year, 1968, Churchill announced its intention to admit women in 1972. King's made a similar announcement in 1969, and Clare gave indications that it would probably do likewise. It was quickly realised by these colleges that they would, in the early years at least, need the goodwill and cooperation of the women's colleges, particularly over admissions – and, of course, our graceful cooperation and our brave faces hid very real misgivings. The prospect of fierce competition for the crème de la crème of academic women brought painfully home to us how spoilt the three Cambridge women's colleges had always been.

The men's punctiliousness in consulting us, and the concern they expressed for our future, did nothing to lessen their determination to proceed, and all our discussions achieved was not a moratorium on going mixed, such as was negotiated at Oxford, but a non-binding agreement to phase the men's colleges' lemming-like rush towards the sea of co-residence.

At Girton, however, the feeling was strong from the start that a policy of 'wait and see' wasn't good enough, and in late 1969 and 1970 discussions about the future began in earnest. A considerable number of

79

Fellows were committed already to the idea that co-residence was not only advisable but preferable, but there is no doubt that expediency was a major issue in these discussions. On the one hand we feared that, of the three women's colleges, Girton stood to lose the most, as more central colleges opened their doors to women. The spectre of a severe decline in the College's academic standing haunted us all. On the other hand, we were deeply aware of the College's proud role in women's education, and we felt an allied conviction that the new mixed colleges might not be the promised land for aspiring women academics that they were certainly going to be for aspiring women undergraduates.

Over the months that followed, this issue was the major preoccupation of the College's Governing Body. By 1971 a substantial number of its members were convinced that, in the face of a mountain of imponderables, the only sensible precaution we could take was to put ourselves in a position where we could act quickly if and when we felt we ought to. It was therefore agreed in March 1971 that we would go ahead and apply to the Privy Council for an Enabling Statute.

The academic success of co-residence in the first three men's colleges to admit women was soon borne out by the way in which they began to shoot to the top of the Tripos league tables. And it is increasingly clear that the motives of the second and third waves of men's colleges in admitting women have, on the whole, been purely practical, in spite of ideological pressure from their undergraduates. They have decided to admit women not because they believe in equal opportunities, not because they want a healthy, normal collegiate society, not even because they want their share of the good women around, but in order to continue to attract good men. One outstandingly able applicant to a still men-only college put it succinctly: 'I would no more contemplate going to a college that excludes half the human race, than I would contemplate going to one that excluded any particular race.' Among those young men who come from mixed schools, this feeling is, naturally, widespread.

It was also an awareness that this feeling was shared by many young women that led Girton in the mid-1970s to start thinking actively once more about the future. We had by then taken many applicants whose first preference had been a mixed college and who had settled happily in Girton, learning very quickly that, because Girton was not co-residential, it did not mean that their lives in Cambridge would not be co-educational. But we felt it keenly that these girls – bright, able and an asset to the College – had clearly preferred the idea of a mixed college, and we respected their judgement. We felt that our applicants were being pre-selected, academically and personally, in a significant and unfortunate way.

A sense began to grow too that the women's colleges couldn't hold out for ever. The justification for our existence lay in the opportunities we offered for women, but those opportunities were growing year by year. Our very pride in Girton's pioneer role in women's education began to give the prospect of another pioneer stage in our history its own attraction. By now, in any case, the Equal Opportunities Act was in force and it looked as though our Enabling Statute was going to prove a compelling one. When the vote came, in November 1976, some voted against, but the majority in favour was very decisive. Even those who voted against accepted the decision with excellent grace, and have since thrown themselves into the task of making a success of co-residence with as much enthusiasm as those who voted for the change. This is, in my experience, typical of the College, which is a College of consensus not conflict – one of its greatest strengths.

The Rubicon crossed, the Augmented Council began immediately to make plans and took two important decisions. The first was that, although we would hope to achieve the sort of balanced community that has unfortunately [in 1980] not yet materialised in most of the other Cambridge mixed colleges, where women are still substantially in the minority, we would not make academic concessions to achieve it. Although we anticipated that it might take us up to ten years, or even more, to achieve a good

balance, we were nonetheless committed to admitting on ability, not sex. We are only at the beginning of this process, but the decision has so far proved more than justified. This year's intake totals 167, and fifty-eight of them are men – some of whom applied direct to Girton, while others came from the pool. This means that men constitute something over a third of the year. Moreover, we have achieved a good balance, among both the men and the women, between the arts and the sciences. And even more encouraging, our applications from men for next year doubled, and our female applications went up too. We have offered places to eighty-eight women and seventy men for next year, so it looks as if we will have our balanced community in three or four years rather than ten. We are, however, determined to do our best to keep attracting able women, and we will continue, through our very active Schools Contact programme, to maintain our links with girls' schools as well as developing our contacts with mixed and boys' schools. We shall not renege on our past.

Our other important decision was to tackle co-residence in two stages and to admit men first at Fellowship level. We felt strongly that our first male undergraduates should come into an already established environment: as a women's college admitting its first men, it was important for us to be able to show the schools that we were aiming at a thoroughly integrated community.

In the event, a large and highly competitive field of applications for the College's Research Fellowships in the spring of 1977 enabled us to appoint eight men as Research Fellows and Research Bye-Fellows for the autumn, as well as four women. The College already had a number of male lecturers and Directors of Studies, and from among them we thus acquired our first male Official Fellows. Two further elections to Official Fellowships brought our total number of male Fellows at the beginning of that first full year of co-residence to twelve.

One concern was that, by the time we admitted our first male undergraduates, we should have at least one male Undergraduate Tutor. In January 1978, accordingly, one of our first male Official Fellows, Dr John Marks, became our first male Tutor. As a medical doctor, a man of mature years and the father of a grown family, he seemed eminently cut out for the task, and guaranteed to still the wildest parental imaginings about women students and male moral tutors. Our undergraduate tutorial team is now made up of four women and three men, each with a mixed panel.

Of our twelve new male Fellows, no fewer than seven had chosen to live in – and after we women had recovered from our gratified amazement at their intention to live two miles out of town, we forgot all about it. October came and went, and we were halfway through term before we realised that we had lived through the momentous moment without even registering its passage. The men had moved into their sets, scattered through the College, and had settled down without fuss to life and work. Girton had always welcomed Fellows' guests, female or male, with an unusual degree of ease and generosity, and the presence of men at High Table and in the Combination Room struck no new note in our community life. Only at the breakfast table was there a noticeable break with tradition, and here it seemed that the change was unequivocally for the better: cheerful young male company at 8.30 in the morning makes a good start to the day! And although in that first year I never failed to experience a jolt of surprise, a curious momentary sense of dislocation, whenever I saw our new Research Fellow in Mathematics, Anthony McIsaac, striding through town with his Girton scarf flung proudly round his neck, even this seems normal now that the town is scattered with Girton scarves draped round male necks.

The advent of the first male undergraduates and the tutorial situation apart, the two next main areas of decision-making were residence itself and sports facilities. In order to supply the committees with as much information as possible, I interviewed the Senior Tutors of all the mixed colleges about their experiences of co-residence in the hope that, if there were problems or pitfalls, we could avoid them. It seemed, however, that there were none to speak of, and I gradually learnt that every college had proceeded differently. We decided therefore to go our own way and hope it would be sweet.

The unanimous views of the undergraduates on residential matters were, however, initially surprising. They insisted that the College must have the courage of its convictions and avoid not only single-sex corridors or wings but also single-sex bath and washroom facilities (apart from the public ones). But to my total consternation, it was seriously suggested by one girl that the gyps would have to be told to make the men's beds. Another, to my consternation and amusement this time, said that the men couldn't be expected to live in the rooms that had long ago been bedroom halves – because their feet were so much larger than women's! Needless to say, I sat firmly on these stirrings of female treachery, pointing out that equality worked both ways and that a bedroom half for years now had been, and would always be, part of the experience of being a Girtonian.

The prospect of a thoroughly integrated community held no fears for us. We had already abolished guest and gate hours, and overnight male visitors were commonplace. Our first male undergraduates now live in clusters scattered through the College, after we had decided on this formation and then taken views on what a cluster might consist of; the consensus was a minimum of three. People are entirely happy sharing facilities, and there have so far been no problems – or at least almost none. One man did complain that his wardrobe was not big enough to accommodate all his OTC uniforms. We have not given him a bigger one. Another man did keep leaving his shaving tackle in the bathroom on D Corridor, much to the irritation of the Vice-Mistress, Dr Jondorf, whose room is nearby. In exasperation she eventually left a note saying that if he didn't remove them, she would throw them away. He didn't and she did. And while it has been known for the girls sometimes to cook omelettes for the men, it has also been reported that the men reciprocate by doing the girls' ironing; these days, it seems, young men are deeply into ironing and do it all the time, even to the extent of ironing jeans and socks.

The new Girton men are not, however, a special breed. Our fifty-eight first-years are a splendidly mixed bunch and include a large number of sports enthusiasts, for whom we have had to cater. Having come to the conclusion that, initially at least, we would have to negotiate shared facilities with other colleges, we persuaded Trinity Hall to share its cricket and rugby facilities with us for three years, and – in the case of rowing – have thrown in our lot with Corpus Christi and Sidney, paying for an extension to their boathouse to accommodate our boats and contributing to the cost of the boatman.

We are already aware, however, that we must press ahead with our own facilities for field sports, particularly after our new rugby team, to their and our absolute amazement, won their very first fixture – against Trinity Hall itself – and after we also acquired our first soccer blue, one of our graduates. We are conscious that – unlike the residential side of the new arrangements, which involved us in very little expense – these new sports facilities are costing the College a great deal of money. We are, however, convinced that it is money we have to spend. We have no ambitions to become a sporting college, but we know from our contacts with the schools that good sports facilities are an important attraction for many able young men, and, if we advertise ourselves as a co-residential college, we must live up fully to that image.

Our new male Girtonians are taking an extremely active role in College, and are determined that Girton should generate its own social life in a big way. There is a new spirit in the air in College at present, the sense of a new beginning, a more vital future. Long may it last!

Melveena McKendrick came to Girton to do her PhD in 1963. She has been a Fellow since 1967, and has served as College Lecturer, Tutor, Senior Tutor and Director of Studies in Modern Languages. She is now Professor of Spanish Golden-Age Literature, Culture and Society and Pro-Vice-Chancellor for Education in the University, and a Fellow of the British Academy.

Directed change
Dorothy J Thompson

In a paper written on the alteration of Statutes for the Governing Body of 11 November 1970, the Mistress, Muriel Bradbrook, introduced the question by

considering current pressures for change. The first she identified was that of 'the increasing national direction of university policy'. The Department for Education and Science was projecting roughly double the number of qualified entrants for the universities by 1980. Cambridge, already planning some increase, countered (as did Oxford) with a proposal to increase by some 30% over the next ten years; Wolfson Court, which opened in 1971, was part of this plan. Changes in the length of degree courses were also being discussed, and the substitution of loans for grants. Such was the background to our more immediate concerns. Central direction of university policy is, therefore, nothing new, but over the last thirty years the detailed workings of universities and colleges have become more and more subject to Government requirements.

The two main ways in which Girton, like other colleges, has been affected by central direction are in the control of student numbers and changes in the funding structures; a third area of Government interest affects more intimately the life of students and Fellows alike.

The trebling in 1980 of university fees for non-EU overseas students, combined with the introduction of differential fees, was the first major change in the period we are covering. Girton had always enjoyed a significant number of overseas members, but with this increase in fees – from £770 in 1979–80 for all overseas students, to £2,000 for Arts courses, £3,000 for Sciences and £5,000 for Medical Sciences in 1980–1 – the essential internationalism of the Girton experience seemed under threat. It was only through the imaginative and highly successful efforts within the University of those who saw the need for action that the formation of the Cambridge Commonwealth and Overseas Trusts (joined in 1995 by the Cambridge European Trust) served to counteract the threat. More recently, the Gates Scholarships have raised the number of talented students from round the world who – to the benefit of all concerned – have joined the University. At Girton in 2003–4, out of 483 undergraduates in residence, twenty-two (4.5%) were from the EU and forty-six (9.5%) from elsewhere

overseas. No college can be viewed in isolation; the constituent parts of the University benefit immeasurably from their joint membership.

A year after this increase in overseas students' fees, a directive in October 1981 from the University Grants Committee decreed that, given a decrease in demand for university places, the numbers of home (including EU) undergraduates admitted to the University should be cut by 2% overall, on the base of three years previously. A similar cut in funding would follow. Given the recent foundation of Robinson College, 2% overall meant 6% for the other colleges. For Girton, a drop of forty-eight students was required in three years. The financial implications seemed appalling and we finally agreed we would have to sell the Grange. Over the next few years, however, the picture slowly changed. When Greece joined the EU, the base figure was raised a little, in 1983 Cambridge was granted forty more funded places for science and in 1985 the ceilings suddenly became targets as the pressure to cut diminished. The sale of the Grange fell through; the College was still solvent. Since that

Wolfson Court, the 'Airport Lounge'

period, we have become accustomed to living with sudden changes of Government policy and, amid a stop-go rollercoaster of directives, we have concentrated on providing the best education we can for the mix of students that suits us best.

The Education (Student Loans) Act 1990, and the introduction of student loans towards maintenance costs, highlighted the changes that were taking place in Government funding for higher education. The need for bursaries and scholarships became yet more urgent, and, as so often, the colleges benefited from Trinity's generosity through the Newton Trust and other University initiatives. And in 1998, for the first time since 1962, undergraduates had to meet a proportion (as yet, a small one) of their fees themselves, besides the cost of maintenance. The figure (and proportion) will rise in the future and the loans system is again being changed. 'Development', a new term in its current usage, is here to stay.

In 1986, following some political demonstrations, Section 43 of the Education (no. 2) Act was drafted to 'ensure freedom of speech within the law'. An Education Act was, in effect, being employed to control public meetings. As the Girton *Students' Guide* reported: 'It is a paradoxical result that the recent legislation, the object of which is to safeguard freedom of speech, forces the College to institute a process of codification which must inevitably limit to some degree the freedom and discretion of organisers of meetings.' The Code of Practice (on the conduct of meetings) that followed was soon joined by many others, reflecting changes in the law and social pressures: a Code of Practice on Discipline, another under Section 22 of the Education Act 1944 (on democracy and accountability for the JCR and MCR), a policy on harassment, and so on. More recent central concern for what is involved in education is to be charted in the rash of assessment exercises: the quality of university research and teaching is now subject to outside measurement and audit. As elsewhere, Girton feels the added pressure to be seen to perform, and the requirements of central Government play an ever-increasing role in our lives.

For biography, see chapter 3

Directing change
Debbie Lowther

Over the year 2003–4, I researched the history of the College's trust funds in order to ensure that they were correctly categorised in the new form in which the College would be producing its accounts from 2004. In the process, I read my way through the complete Council minutes of the College since it became a Chartered Corporation in 1924, including the Bursars' annual reports to Augmented Council, as well as wills, trust deeds and correspondence with benefactors. I discovered some interesting, surprising and useful facts about the trust funds, but what fascinated me most, and distracted me from the task in hand, was deciphering the changing approach of successive Councils to financial decision-making. This change has been continuous. Girton seems never to have felt itself to be a rich college, but the Council's sense of relative poverty and the appropriate response to it has been variable. There has been nothing special about the last thirty years in that sense, but there is no doubt that it has been easier to understand where Girton was financially thirty years ago in terms of the continuum of eighty years. Fifty years after receiving its Charter, the College was well established and mature but more dependent on public funding than at any time since its foundation. The significance of that change is more obvious now than it appears to have been then.

General changes in the financial environment over thirty years

Thirty years ago, the College was operating in a quite different financial environment from the one we find ourselves in today. The 1970s were a period of successive national economic crises, and the College, as investor, employer and property owner, was as badly affected as any other institution. Inflation was a particular problem. Unanticipated surges in inflation led to running deficits, as the College had to set its fees well in advance of each academic year, and the increase in fees was frequently overtaken by the increase in costs in the course of each year.

Students at Cambridge are, and were, charged fees both by the University and by their college. The

Cambridge system of education, which involves both lecturing (the University's responsibility) and small-group teaching (the college's) is necessarily expensive. In the 1970s, large fee increases were necessary to keep up with inflation, but were regarded by the College Council as politically unpalatable. College fees were then, as now, controversial, and the fees for home students were paid by local authorities, which meant that it was the rate-payers who would ultimately suffer the increase in cost. Council also wished to avoid increasing fees because this was a time when it was believed that the best way to encourage equality of access to higher education generally, and to an Oxbridge education in particular, was to keep the level of fees and charges as low as possible.

It was a period in which financial planning was particularly difficult. The stock market was volatile, and although the yield on College investments of 9.16% mentioned in the 1976 annual Bursar's report to Augmented Council is one that any investor might envy today, it was not enough, in the short term, to compensate for the increase in the College's costs due to inflation. The College was not in the habit of producing budgets, and it seems that the deficit of 1974–5 came as something of an unwelcome surprise. In the light of it, fees were eventually raised, but only by enough to halve the deficit in the following year.

The Bursar of the day foresaw hard times ahead as well as behind, and used her annual report to remind Augmented Council that she had continually preached the need for economies, and that the College should be adding to its reserves each year rather than spending every penny of income. It seems, however, that Council was unable to agree on a coherent strategy for reducing expenditure. One senses that, although the College had rather more autonomy than it does now, the Council felt that the College was not alone in what it was trying to achieve, that it was operating in an essentially benign environment where it was understood that excellence of results was more important that financial efficiency, and that it would ultimately be protected from financial failure because of its important role in the past, present and future of higher education.

With the paint barely dry on Wolfson Court, the College was still in expansionist mode and looking to increase student numbers. No doubt it was expected that growth would bring economies of scale. It was also a time when it was felt to be important for the College to broaden the scope of its academic activities so that, in addition to teaching undergraduates, it wished to support increasing numbers of graduate students and Research Fellows, and to establish Visiting Fellowships to enrich the academic community.

The general economic environment in which the College operates today is in some ways an easier one. Inflation has been well under control for most of the last decade, and although annual pay awards are invariably higher than inflation, this is at least predictable. On the other hand, low unemployment (and very low to non-existent unemployment in Cambridge) is driving up costs relentlessly, while the collapse of investment returns and low interest rates since the turn of the millennium has constrained expenditure on all fronts.

Landmark changes

Thirty years ago, the College was able to decide for itself both the level of its fees and its student numbers. It appears to have exercised its discretion in these matters responsibly. However, within ten years its autonomy in these respects was almost completely eroded by Government. From 1978, the budget for college fees paid from public funds had to be negotiated with the Department for Education and Science (DfES). The colleges had hitherto charged different fees, but there was an agreement between them to move gradually towards fee equalisation.

At the point when it lost control over the level of fees it could charge, Girton was well aware that its fees were considerably lower than they might (and arguably should) have been, and that it would now be extremely difficult for fee income to catch up with cost increases. Margaret Thatcher's Conservative Government came to power in 1979 and immediately began to cut public spending, including grants to universities. This quickly led to compulsory

reductions in student numbers, and by 1982 the College had also lost control of the number of home students it could admit. With numbers effectively restricted, the College, in common with many others in Cambridge, was able in the mid-1980s to commit to housing all its undergraduates throughout their (mostly) three-year courses. Prior to that, it had been usual for second-year students to live out of College.

A decade later, the Conservative Government under John Major decided on a major expansion of higher education, with the aim of a 50% participation rate. This target was also, apparently unquestioningly, accepted by the Labour Government of Tony Blair, which, in 1997, inherited the responsibility for achieving it. This Government also inherited the recommendations of the Dearing Report into higher education, which called for a review of the Oxbridge college fees. In 1998, the Government and the Universities of Oxford and Cambridge came to an agreement that, in future, support from public funds for college fees would be provided by means of a block grant from the Higher Education Funding Council for England (HEFCE) to each university, and that the value of this would be reduced in real terms by 21% over ten years. For Girton, this would mean the loss of about £350,000 per annum by 2009. Before this college fee settlement had even been negotiated, however, the Labour Chancellor, Gordon Brown, had announced the phased loss of Advance Corporation Tax (ACT) relief on the investment income of charities. This was estimated at the time to be likely to cost the College about £150,000 per annum.

The combined effects of the college fee settlement and the loss of ACT relief (between them responsible for the loss of half-a-million pounds' worth of annual income to the College) have been far-reaching. The consequent financial crisis has triggered a sea change in the way in which Girton views its responsibilities for supporting students and broadening access. The College can no longer afford general subsidies and must instead target its financial support at those who are most in need. This may be more effective in the long run.

Consequences of Government policy

While successive Governments over the last decade have had a policy of unprecedented expansion of higher education, it has been clear from the start that the taxpayer would not be willing to pay the full economic cost of the additional places. So the per capita resource coming into institutions has declined, and the grant support formerly available to individual students has been gradually replaced by loans. From 2006–7 it will all change again, as variable fees funded by student loans are introduced.

Government legislation has had obvious and intended consequences for higher education, but universities and colleges have also been significantly affected by other legislation that has no direct connection with higher education policy as such. The withdrawal of ACT relief announced in 1997 was met with concern in the press about the impact on pension funds, against which it was primarily aimed. The impact on charities was noted, but as a large part of the charitable sector raises funds only to spend them on its charitable objectives, and has no endowed funds, there was relatively little protest.

The pension-fund sector as a whole has since then run into enormous financial difficulties. Girton's endowment has suffered in the same way as pension-fund investments have, not only from the withdrawal of ACT relief but also from the dismal performance of global stock markets since 2000. Girton is not only dependent on investment income from its own endowment, but is also responsible as an employer for contributions to the Universities Superannuation Scheme (USS) and for the adequate funding of its share of the Cambridge Colleges Federated Pension Scheme (CCFPS).

The burden of compliance with legislation has increased dramatically over the last thirty years, and affects almost every aspect of College life. In common with other employers, the College is constrained by the vast amount of health and safety and employment legislation that has appeared at an ever-increasing rate in recent decades. The Data Protection and Freedom of Information Acts affect our relationships with students, employees, alumni, benefactors and

FACTS AND FIGURES

Melveena McKendrick speaks of how quickly it looked as though numbers of men and women would reach parity. In fact, between the two years 1982–3 and 1983–4 the total numbers of undergraduate women and men switched from 246:234 in favour of women to 213:244 in favour of men. That numerical bias was to remain for a decade or so. If one just looks at the fresh intake each year, over the first four years that men were admitted Girton was taking some nine women to every six men. This figure reversed to seven women to nine men throughout the rest of the 1980s and early 1990s.

There was another swing in 1994–5, when women first-years once again exceeded men, and established a pattern that was to hold for over a decade. But the margin between the sexes had become much closer. So from 1994–5 until 2003–4, and averaging for the decade, the proportions have been eight and a half women to eight men. For College as a whole, including students out of residence (e.g. on overseas courses), in 2003–4 there were 266 women undergraduates and 241 men.

It has taken all this time for the University itself to reach parity. It seems hard now to remember the days when only 10% of the University undergraduate population were women. When the first men's colleges went mixed that proportion became 20% in 1976 and 27% in 1979. The proportion has risen in fairly regular steps since then, and over the last four years (since 2001) has hovered around 49%.

Other things have been happening. The University has expanded from roughly 8–9,000 undergraduates and 2,000 postgraduates in the mid-1970s to 11–12,000 undergraduates and more than 5,000 postgraduates thirty years later. At the same time Girton, like many other colleges, has kept its undergraduate intake steady while growing in postgraduate numbers. Indeed its first-year target of between 150 and 160 is almost identical to what it was when men were first admitted; there is a small increase in undergraduate totals but this is due to students staying on to complete four-year courses. Its postgraduate population, on the other hand, has kept pace with the University and grown by two and a half times.

candidates for admission. Our ability to maintain and develop our historic buildings is restricted in so many ways by building regulations, planning consents, listed-building consents and the Disability Discrimination Act. Thirty years ago, the College had no Health and Safety Officer, no Data Protection Officer, no Development Officer and no Personnel Officer. These new posts have been paid for by economies in other areas. Other posts that did not exist thirty years ago are the Computer Officer and the Webmaster. College employed its first Computer Officer in 1993. There are now three, plus a part time Webmaster. Despite the important role played by eminent Girtonians in the development of computing, the College was slow to install computer systems for administrative use. The College's accounting system was first computerised in the mid-1980s, and was upgraded again in the early 1990s.

Now that we have management accounts and budgets, has the quality of decision-making improved? Thirty years ago the Bursar thought that the College needed to make certain kinds of economies and financial decisions, but the then Fellowship was unable to agree to implement them. Now, having a proper budgeting process has empowered Council to make those kinds of economies and decisions, and – although it is difficult to be sure – my guess is that the College is in a much better state than would otherwise have been the case. With the devolved

budgeting system now in place, all budget holders are required to consult their relevant constituencies before making a reasoned budget proposal to the Budget Sub-Committee. It is difficult to imagine how the College could otherwise have found the will to pay, for example, for the investment it has made in Ethernet cabling throughout the last decade to enable students, Fellows and staff to access the Internet. The all-pervading use of the Internet is something that the College Council of thirty years ago could not have foreseen. Ten years ago, it was clear to those knowledgeable enough about technology that it was necessary to plan for the kind of use we now take for granted, but there were no additional resources available for it. Without a devolved budgeting system and a strategic plan against which to assess applications for budgets, it is difficult to see how this project could have been undertaken.

Access – who pays?

Present Government policy stresses the need for equality of access to higher education and for widening participation among the lower socio-economic groups. Universities will not in future be allowed to charge higher fees unless they can satisfy the access regulator that they are making sufficient progress on access.

Girton's admissions policy of thirty years ago was already an inclusive one. Having succeeded in its mission to create places in higher education for women, it was preparing to go mixed and to extend its support for equal opportunities to men. Girton today does not need to be told that it must offer equality of access, and, fortunately, donors and benefactors have been generous in their contributions to hardship and bursary funds. Girton is still a college in which less well-off students can reasonably expect to receive adequate financial support to enable them to complete their degree courses.

Nevertheless, it is necessary to question the Government's assumption that increasing participation in higher education to 50% of the age group is necessary to improve access for non-traditional applicants. In the 1970s the public purse financed tuition fees for all eligible home students, and paid full maintenance grants to those from poorer backgrounds. At that time it was possible for working-class students to come to Girton at almost no cost to their parents. The expansion of higher education, without proportionate expansion of public expenditure on higher education, has necessitated the replacement of maintenance grants with loans, followed by the introduction of the £1,000 tuition fee for all students in 1998, shortly to be replaced by variable fees funded by loans if the institution can satisfy the access regulator. For students from the lower socio-economic groups, who are notably averse to taking on debt, this can hardly be seen as encouragement to participate in higher education.

A Cambridge education is expensive because of the University's and colleges' uncompromising commitment to excellence. It is astonishing that, despite the relentless decline in support from public funds over the last thirty years, the quality of teaching, learning and research has not markedly suffered. One cannot help feeling that there will soon come a time when it is simply not possible to avoid taking actions that undermine the College's commitment to excellence, such as reducing the number of teaching Fellows, the number of supervisions students may have or the number of computers in the College's computer rooms. The collegiate system has, of course, been underpinned by the generosity of benefactors, who are also unswerving in their determination to preserve excellence in higher education. However, the University, the colleges and Girton in particular, are still a very long way from having adequate private funds to be sure of being able to protect the quality of teaching and research in Cambridge, regardless of Government policy.

The use of endowment income

Clearly, the College is not able to spend as freely as it could thirty years ago, and although the teaching budget has been largely protected, and a policy of removing general subsidies of rents and charges has partly plugged the funding gap caused by the college fee settlement, not all academic activity has escaped the need to cut costs. Thirty years ago, as now, the College was regularly in receipt of generous bequests and

benefactions. Thirty years ago, the College's buildings were sound and thought to be fit for their purpose. The earliest buildings on the main site were only just over a century old, had been built to last and were doing it admirably. New Wing, by comparison, was only about forty years old, while Wolfson Court was brand new. The College was well established, teaching was comparatively well funded from fee income, and the place of women in higher education was secure. As the College contemplated going mixed, it was also conscious of a responsibility to broaden the scope of its academic activities and to use bequests and other windfalls to enrich its intellectual life.

Between 1968 and 1984, therefore, the College founded two Visiting Fellowships and a Visiting Fellow Commonership. From 1968, over several years, funds for the Helen Cam Visiting Fellowship were raised as a memorial to Professor Helen Cam, largely by the American Friends of Cambridge University. This was to be a Visiting Fellowship in an arts subject. The Brenda Ryman Visiting Fellowship was established by Council in 1984, in memory of Brenda Ryman, to provide the same for science subjects. The Mary Amelia Cummins Harvey Visiting Fellow Commonership was also founded in 1984, using the unrestricted bequest of M A C Harvey herself, and designated by Council to provide funding to allow non-academic members of the professions, civil service or performing arts to spend sabbatical leave in the College.

In addition, the College's Research Fellowship Funds were generously augmented with frequent additions of capital from the sale of properties left jointly to the College and the London Library by Mrs Rosamund Chambers. This policy quickly built up substantial amounts of money to fund three-year Research Fellowships in the arts and the sciences. The Bursar of 1982 was proud to report to Augmented Council that Girton had ten Research Fellows, and that only King's and Trinity had more, with twenty-one and thirteen respectively.

The 1980s were also a time when opportunities arose to augment funds that could provide support to Girton graduates undertaking professional training. The precedent was the already long-established Sybil Campbell Fund, founded in 1946 by an anonymous donor to provide grants for postgraduate professional training, other than teacher training (which was already provided for). In 1980, the Harry Barkley Fund for Clinical Medicine was founded by the then Mistress, Brenda Ryman, in memory of her husband, and the G K Williams Fund for Law was founded by Mrs C M Williams in 1981. The Council also had a policy at this time of designating smaller bequests for the use of the Library.

It is clear that there was a strong view in the College and on Council that it was the duty and responsibility of the College to make provision for what, in the first decade of the twenty-first century, we have learnt to call non-core activities. It is not that there were not competing claims for expenditure on improvements to the buildings, but it was the very clear view of the Bursar at the time that the academic mission of the College took priority. The decision of the Council to use these funds to make such generous provision for expanding the academic reach of the College also indicates that, although Girton has never regarded itself as a rich college by comparison with others in Cambridge, poverty is relative. Clearly, the basic activities of the College were felt to be well funded, and the belief was that, as a mature college within the Cambridge system, Girton now needed more research posts and visiting academics to enhance its standing, improve its competitiveness and enrich the community.

Today, priorities are less clearly defined. The College buildings are, after all, the physical environment in which the academic objectives of the College are pursued, and they must meet the expectations of students, Fellows and staff. Thanks to health and safety legislation, fire safety regulations, building regulations, the Disability Discrimination Act and greater prosperity generally, these are somewhat higher than they were thirty years ago. And, improvements aside, the cost of basic maintenance is higher than ever before, thanks to a competitive local labour market, the burden of legislation, VAT and the standard required of any work done to a Grade II* listed building. Far from being able to support expansion of the academic mission, the College must now manage a conflict between

maintaining the quality of education of its students and maintaining its buildings.

Although essential in the interests of financial efficiency and the survival of the College as a permanent institution, this narrowing of the focus of the use of endowment income is regrettable in so far as it reduces the diversity of the academic community and the opportunities for creative and fruitful contact between academics from different institutions and at all stages of their careers.

Operating deficits then and now

Something that has remained unchanged over the last thirty years (and for four decades before that), but has now changed radically, is the form in which Cambridge colleges produce their annual accounts. From 2004, the majority of Cambridge colleges, Girton included, have moved away from the '1926 format' of accounting and produced their accounts in a new Recommended Cambridge College Accounts (RCCA) format, which conforms to Accounting Standards and is intended to show a 'true and fair' view.

The RCCA format includes all four of the conventional primary statements of account (income and expenditure account, balance sheet, cash-flow statement and statement of total recognised gains and losses) missing from the 1926 format. When the Bursar of thirty years ago described a surplus or deficit on any of the many separate accounts that made up the 1926 format, it was necessary to define this as before and/or after any number of apparently arbitrary transfers between accounts. For the last ten years, we have had a 'management' income and expenditure account, the surplus or deficit on which was capable of being reconciled to the overall deficit on the General Capital Account, making it possible to speak of an annual surplus or deficit for the College.

The biggest change, however, as we moved to producing audited accounts which comply with accounting standards, was that we would in future be obliged to charge depreciation to the income and expenditure accounts. The surpluses and deficits we have spoken of hitherto have been essentially cash surpluses or deficits, i.e. before depreciation. A cash surplus or deficit is an important indicator of the ability of the College to remain solvent in the short term. In the long term, however, the institution needs to be able to provide fully for the depreciation of its buildings if it is to survive in perpetuity. The Bursar of thirty years ago urged the College Council to aim to make small (cash) surpluses each year that could be added to capital to provide for the future. The Bursar of today will report that any apparent cash surplus has already been absorbed by a methodical depreciation charge, which is intended to do transparently and systematically what was previously vague and discretionary.

The inclusion of operational buildings in the balance sheet at their depreciated replacement cost (which itself is a radical innovation for college accounts), and the commensurate depreciation charge, will quantify for the first time the extent to which a college is unable to provide for the eventual replacement of its buildings from current income. In Girton's case, a substantial deficit on the income and expenditure account will reveal what we in any case already know, that it is impossible to provide fully for depreciation from current income, and that we are therefore net consumers of our inheritance.

Does this matter? Thirty years ago it probably did not. The College buildings were understood to have been a gift, there to be used, and if necessary used up, for the furtherance of the College's charitable objectives of teaching, learning, research and religion. Fee income was understood to be partly available for repairs, as was endowment income. The College was responsible for the upkeep of its own buildings, but they had been built using funds raised from donors, and it was assumed, it seems, that they would be replaced, if and when ultimately necessary, by further appeals to donors and benefactors. These might have included other, richer, Cambridge colleges, partly through the mechanism of the Colleges Fund. It was expected, possibly not unreasonably, that fees for home students would continue to be funded at an adequate level from the public purse, and that the College would be able to continue in perpetuity by a combination of public funding for the teaching of undergraduates and private benefactions for other purposes.

By the mid-1980s, however, the Bursar was warning Augmented Council that 'the College must look out for itself' because no-one else was going to help it. It was becoming clear that the College could not rely on Government policy and public expenditure to ensure its continued existence. Once Margaret Thatcher had famously declared that there was no difference between income and capital (despite Harold Macmillan's equally famous warning against selling the family silver), the writing was on the wall. The fabulous gift of Girton's early benefactors – its buildings – in so far as it was used for the benefit of home students funded by the British taxpayer, would be consumed as income rather than conserved as capital.

In 1993 Council took matters into its own hands by appointing a Development Officer to establish a professional fund-raising office within the College. By diverting funds from current educational expenditure to this new office (but not completely new activity – the Mistress and Fellows have always, it seems, fund-raised), Council was displaying a strong awareness that the future of the College really was its responsibility and no one else's. Girton thirty years on has lower expectations of general public support and a rather higher dependence on its alumni and private supporters.

It has taken arguably too long for the Cambridge colleges to start producing their accounts in conformity with Accounting Standards. That it has finally happened reflects the general sense among the colleges that there has been a change in what is regarded as responsible stewardship. Colleges have always required administration, but now they require management too. This means making use of management tools developed in the business world. The Bursar of thirty years ago strongly refuted the idea that the College was a business. The present Bursar is inclined to agree, but even though we are not a business, we can be businesslike. Even if there is no possibility of persuading the British taxpayer to cover the full cost of the education we provide to home students, we must know precisely how much this education costs in order to plan to cover the subsidy from endowment and further fund-raising. The new form of accounts will require colleges to include allocated and apportioned overheads in their education accounts, something not required by the 1926 form of accounts, which recognised direct costs only. Similarly, by including a charge for depreciation in the calculation of the cost of providing accommodation, the College can start to recover the real cost of its buildings through charging unsubsidised rents to students, while using donated funds to prevent hardship among those who cannot realistically afford the higher charges.

Conclusions

The financial landscape has changed dramatically in thirty years. The present era of low interest rates, low inflation and low investment returns provides an operating environment in complete contrast to the experience of the 1970s. Despite what many regard as benign economic conditions, however, the College faces a difficult challenge in maintaining its educational standards in the face of Government policy, which increasingly dilutes the impact of public expenditure on excellence in higher education. Many of the choices made by the College Council of thirty years ago are ones we cannot afford to make today, as resources have become even more constrained. Furthermore, the College's own priorities have changed, as the threat to the independence of the institution posed by over-dependence on public funding has come into focus. The Council's awareness of its responsibility for the future of the College has increased, and has led to an acceptance of the need to invest in fund-raising which was not anticipated thirty years ago. It has also led to an enhanced willingness among the Fellowship to cooperate in the interests of efficiency, economy and effectiveness, and to take a more businesslike approach to managing the College's affairs where necessary and appropriate. Girton's continued ability to adapt will be a key factor in determining its fate in a future in which it seems clear that only the fittest will survive.

Debbie Lowther read Natural Sciences and Engineering as an undergraduate at Selwyn College, Cambridge, before qualifying as a Chartered Accountant with Coopers & Lybrand (now PricewaterhouseCoopers). She worked for a number of years in the venture capital industry with 3i plc before becoming Bursar of Girton College in 1994.

Unanticipated demands

Michael Power

In January 1984, having spent four very happy years as a graduate student at Girton College and in the Department of History and Philosophy of Science, I was approved for the PhD degree. Twenty years later I supervise three doctoral students in the Department of Accounting and Finance at the London School of Economics (LSE). Then, I used to meet my supervisor regularly to discuss pieces of written work. Whether I made any progress was largely up to me, although her advice was invaluable, and I had the impression that any risks were mine as the student. Now, in 2005, it feels as though the risks have changed sides and followed me. I now make detailed notes of meetings with doctoral students and there is a formal progress evaluation by the Department twice a year. 'Getting PhD students through' is important. Completion rates are monitored by the LSE Graduate School, which is monitored by HEFCE, which is in turn monitored by the UK Government.

In addition to these pressures on institutions to ensure completion, the training component of doctoral work is increasingly emphasised. In the early 1980s the process felt primarily like one of apprenticeship, and I was free to choose my topic; the main ambition was to be around high-quality minds and absorb something. The need to publish was implicit and the Research Assessment Exercise did not exist. In 2005 the process feels like one of grooming. Assisting students with a publication strategy is expected and it is not unusual for colleagues to publish with students, although it is often unclear which party is the major beneficiary of this strategy. There is now a supervisors' code and students have a right to expect a certain standard of support. The risks of litigation for universities failing to meet these expectations are real.

Of course one should be wary of anecdotal and impressionistic contrasts. After all, between 1984 and 2005 I changed field, institution and, importantly, role. Yet there is also little doubt that the world of higher education in the UK changed very dramatically over this twenty-year period.

It can be argued that the world I experienced in 1984 was one of great privilege for a few, in which academics and universities operated in an environment of limited public accountability, and in which injustices and waste were rife. This was a world of highly informal professional self-regulation, whose rules and rituals were far from transparent and whose members enjoyed freedom from external scrutiny. It was, it should also be said, a world in which academic salaries had not yet lost touch with comparable positions in the public sector. Indeed, when I joined a firm of accountants in 1984, my starting salary was below that paid by my research studentship at Girton. And when I joined the LSE in 1987, my starting salary exceeded that of the private-sector accounting firm, a situation unthinkable today.

Few people seriously regard the academic world of 1984 as a 'golden age' (although it was my own personal golden time); there was much wrong with that world and much that needed reform. Yet few can also doubt that many of the changes since then, in the name of transparency, accountability, efficiency and value for money, are at best ambivalent and at worst counterproductive. A target and audit culture has been created in the world of UK higher education and public services generally. Specifically, the advent of the Research Assessment Exercise (RAE) and of quality-assurance mechanisms for teaching has profoundly altered the culture within which academics operate.

On the face of it these reforms seem reasonable enough, but this is to assume that auditing and the systems of control that it demands are simply neutral in their operations. This is far from being the case. The behaviour of academics has changed in response to efforts to measure and monitor performance. There is a new instrumentality in which assessment systems are gamed in skilful ways. The creation of dense procedural systems, whose relation to real quality is questionable, not only involves an enormous distraction for academics and other professionals, but also alters incentives. One effect of the RAE as it has developed over the years has been that certain activities that are the lifeblood of academic communities, such as reviewing, supporting interview boards and

committee work, literally don't 'count' in the new world of performance appraisal. In addition, notwithstanding attempts to correct for this in the next RAE in 2008, public policy engagement is valued much less than publishing in highly rated specialist journals.

Accordingly, the modern academic is a less public person and volunteers less of her time to activities that fall outside the scope of formal appraisal systems. However, it must be remembered that the process of disengagement from public policy issues by social scientists started long before an audit culture took off. According to David Marquand, this was the result of a shift in the concept of professionalism from a commitment to the public good to that of technical expertise. In the case of academia, it resulted in research efforts increasingly directed towards specialised peer groups and small scientific communities. The RAE has exacerbated this turning away from public culture. This growing elitism has been accompanied by a decrease in trust, and, paradoxically, the growth of professional ethics in many different fields has been accompanied by growing demands for accountability.

The effect of all this is a downward spiral in which efforts to recreate trust via audit and other mechanisms are essentially counterproductive. In its early manifestations, it seems as if a world of external checking had been created in the UK; an 'audit society' comprising multiple agencies for inspecting and monitoring. In 2005, this legacy lives on in the regulatory state, but there is a notable difference: auditing is now something that organisations increasingly do to themselves. External checking processes have become normalised and internalised. The role of Government and its regulatory agencies, such as HEFCE, is to check these self-checking arrangements.

In 2005, audit has also mutated into something else: risk management. UK universities are now required to adopt the ideas of the 'Turnbull' report, a set of principles for internal control and risk management targeted primarily at the directors of large companies, but which has become a blueprint for organisations in the public sector as well. Risk committees have been created and risk analyses have been undertaken in an effort to demonstrate implementation. As the need for risk assessments is passed down to sub-units and departments, documentation and process increase yet again. Universities must monitor themselves in the name of risk, and must begin to think of themselves as organisations that are at risk and 'manage risk'. But this immaculate image sits uneasily with the messy and contradictory nature of universities, pulled in different ways by teaching and research and by the need to demonstrate both excellence and access.

The theme of risk has much to do with the constitution of a new 'professional academic self': more caution, less innovation. The new breed of academic is acquiring defensive managerial skills, takes notes after meetings with students and colleagues and creates a trail of documentation 'just in case'. Aware of students' rights and demands, to which she is sympathetic, the modern academic is concerned above all to manage personal reputational risk, withdrawing from public roles and being increasingly careful in the appraisal and evaluation work that characterises a legalised world of small print and disclaimers.

These changes are symptomatic of a more general crisis of professional opinion in which experts previously trusted to give judgements are seeking to manage and transfer the risks associated with doing so. Employers do more of their own assessment, often hiring a new breed of employment-risk consultants. A risk industry feeds on itself as each part of a chain of opinion formation seeks to manage its own risk, and is increasingly without content. A climate exists in which skilled individuals hesitate to venture an opinion. Why has this happened?

The last twenty years in the UK have seen an acceleration of individualism and an associated shift of power from institutions to consumers. We have designed a society in which individuals have increasing claims over abstract legalised organisations. Individuals in those organisations seek to manage the risks this creates but also withdraw from personal responsibility. Rights inhere in real

people, but duties are increasingly the function of abstract entities called organisations, which are subject to accountability processes. Public professional judgement is a major casualty of this individualisation process.

Academics in 2005 operate in a very different environment from that of 1984. Mechanisms of accountability have changed the internal landscape of universities. Laudable attempts to work with the grain of existing practices have nevertheless had profound unintended consequences. System density has increased, creating internal compliance industries within higher education organisations. Academics have learned to game evaluation systems for research and teaching, making first-order quality issues invisible. In the UK, the emergence of research ethics monitoring outside the medical sciences domain is likely to have a considerable impact on the kind of social scientific research that is done. There is a real prospect that, as researchers find interactions with human subjects too risky, they will withdraw even more to their private offices, to the formal modelling of possible worlds inhabited by abstract people and to the examination of standardised data sets and cool calculations.

The problem may have moved far beyond the question of public trust in professional judgement; individuals themselves have lost trust in the environments in which it is safe to venture an opinion. All this is worrying because it leads to the normalisation of 'safe' teaching and research in a private, professionalised domain that is the very antithesis of the university ethos.

Michael Power is Professor of Accounting and a Director of the ESRC Centre for the Analysis of Risk and Regulation (CARR) at the London School of Economics, where he has worked since 1987. He was educated at St Edmund Hall, Oxford, and Girton College, Cambridge. He is a Fellow of the Institute of Chartered Accountants in England and Wales (ICAEW) and an associate member of the UK Chartered Institute of Taxation. He has also held visiting Fellowships at the Institute for Advanced Study, Berlin, and at All Souls, Oxford. His research focuses mainly on the changing relationship between financial accounting, auditing and risk management. His major work, The Audit Society: Rituals of Verification *(1999) has been translated into Italian, Japanese and French. Recent publications include* The Risk Management of Everything *(2004).*

ΑΙΩΝ ΠΑΝΤΑ ΦΕΡΕΙ

IN MEMORIAM
CAROLINE PENROSE
BAMMEL

1940 1995

Chapter 5
New kinds of disciplines

What is being taught and learnt has hardly stayed still. A long-time Graduate Tutor in Science talks of combined College and University efforts to develop opportunities (especially for women) in SET – science, engineering and technology. Her own initiatives have been pioneering here. What College support has meant in personal terms informs an engineer's reflection on his international experience. Three medics reveal their commitments to a vocation. Another teacher from the professions is prompted to more general ethical reflections. Finally, a voice on the passing of certain disciplinary expectations, and their transformation into others, speaks in medieval French but could be speaking for academics everywhere.

Initiatives in science and technology
Nancy Lane Perham

Girton has, from its conception, been concerned with the whole spectrum of academic endeavour, so science has been taught in College as it evolved into a range of different specialities over the years. There were subjects, however, that did not make their appearance in the University's Natural Science Tripos until later – mine, cell biology, did not exist as a distinct discipline until the techniques now used to study the component parts of cells had been devised.

In the last third of the twentieth century, science became ever more important to the economy and Government, to clinical medicine and the populace, and hence to educational establishments. Women gradually became part of the scientific workforce, both in academia and in industrial research. Yet women are present in only small numbers at professorial level in science departments or in senior management, and the higher one goes the fewer women there are, not just in Cambridge but throughout the UK and internationally. At Girton, before it became co-residential, women held all posts, senior and junior. But the Girton Fellows teaching science did not necessarily also hold senior University positions.

In the broader, UK-wide scientific community, recognition of eminence and success in science in the form of election to the Fellowship of the Royal Society (FRS) – the UK's national academy of scientists founded by Charles II – was awarded to very few, and in particular to very few women. As the first women FRS were not elected until the 1940s, those who 'made it' in this respect tended to come from the Oxbridge women's colleges. In the early 1970s, although only a tiny percentage of FRS were women, nine of them were Girtonians: not just Dorothy Hodgkin, Nobel Laureate, who was an Honorary Fellow of Girton, but also the likes of Dame Honor Fell, Mary Bishop, Dame Mary

Cartwright and Marthe Vogt, all of whom were College Fellows, or, in the case of Dame Mary, Mistress. Perhaps tellingly, with the exception of Dorothy Hodgkin, most of them chose not to marry. This presumably reflected the difficulties at that time in trying to run a scientific laboratory while bringing up a family. Dorothy Hodgkin, as Georgina Ferry's admirable biography of her informs us (*Dorothy Hodgkin: a life*, 1998), had home help throughout so never had to concern herself overly with childcare for her three children.

In the latter decades of the past century, the issue of childcare became one of the major problems confronting women who wanted to practice science, in an age when nannies became increasingly expensive and hard to come by, and when childcare centres or crèches were rare. Moreover, Girton, in 1970, did not offer maternity leave to its Fellows, so those few of the Fellowship who wished to return to continue with their science and College teaching after having a child had to take unpaid leave at the time of childbirth. In addition, the pressure was on to bear one's offspring in the summer months, out of full term, and if one was unlucky enough to produce one's babies when Michaelmas Term began in October, as I did, one risked being unpopular with one's colleagues. Those of us with another University job were able to get maternity leave from those quarters, which helped one survive the three months' unpaid College leave, and it was not long before Girton recognised that this was a clear oversight and changed its policy. By the mid-1970s, maternity leave became available, though this was not in time for the births of either of this scientist's two children. Interestingly, if one did at that time return to the lab a few months after childbirth, one had to face the disapproval not of men but of other Cambridge women (though not the Fellows of Girton), who made it quite apparent that they felt a mother's place should be at home. It was easier then, as a new mother, not to mention that one was a scientist. Nowadays, of course, it is entirely acceptable to return to science soon after the birth of one's children.

Many of us thought that, in an all-female establishment such as Girton was in the early 1970s, it was important to have women scientists teaching our undergraduate scientists, thereby acting as role models for them. This was easier in the biological sciences than in subjects such as engineering, given the dearth of women in that field. For many years in the 1970s and 1980s, biology at Girton was fortunate in fielding a particularly strong contingent of Fellows in a range of subjects from plant sciences to physiology, entomology and cell biology, and the physical sciences were led by a few exceptional women material scientists whose fields were crystallography, maths and astrophysics. Not all these College teachers held University teaching posts, however, which led to some disquiet and an occasional sense of inequality. In all cases, moreover, women teaching science had to have a lab in which to practice their research: so no lab, no Fellowship. This made life difficult for College teaching officers and as a result few of them were scientists. Coincidently, Veterinary Medicine in College flourished during this period: Girton became the only college for women vets, with all the female candidates coming to Girton rather than being scattered in small numbers through the other women's colleges. This demonstrated the importance of 'cohorts' in giving women confidence in their ability to flourish in a scientific field, through strength in numbers. Nowadays women make up about 50% or more of the undergraduate veterinary medics, as they do in medicine also. There are, however, much lower percentages of women in other science subjects, such as maths and physics.

When men were admitted to Girton, the situation gradually began to change. Men began to take up Fellowships in disciplines, especially engineering, where the College traditionally had few women Fellows. Initial anxieties of all kinds about the influx of men proved unfounded. This was especially so in the natural sciences, where strong friendships developed between the scientists in the same year, as well as between years, based on the College policy of second-year undergraduates supporting first-year novices.

Towards the end of the millennium, when the University became overtly concerned about the relative dearth of its academic women scientists, Girton was involved in its resultant action. One of the Fellowship

(myself) was instrumental in producing the 1994 report, entitled *The Rising Tide*, for the then Government's Cabinet Office, and also in the somewhat later establishment, in 1999, of the Athena Project backed by HEFCE (Higher Education Funding Council for England). These initiatives aimed to increase the recruitment of women into science, engineering and technology (SET) at higher education institutions, and to improve their retention, progression and promotion in both universities and industry.

In 1999, the University, similarly concerned about the small numbers of women University Teaching Officers (UTOs) in science, engineering and technology, announced the establishment of WiSETI (Women in Science, Engineering and Technology Initiative). Its precursor since 1993 had been a University Committee concerned by the small number of women in SET, following on the heels of the University's membership of Opportunity 2000 (renamed Opportunity Now in the year 2000). As a Fellow of Girton, I am the Director of WiSETI, and it has involved a number of Girton students from time to time.

Among the initiatives that have been put into place by WiSETI are the provision of e-mail mentoring for all undergraduate women; the Springboard Programme, which aims to build the confidence of young women in SET; recruitment officers, who act as 'head hunters' to encourage women to apply for University teaching posts in science and engineering; and an annual lecture given by role-model women scientists with associated networking opportunities for female undergraduates and graduates.

The evaluation of WiSETI events by questionnaires, together with numerical data from the University, suggests that women in SET posts appreciate the networking events and that the number of women undergraduates at Cambridge in science has increased over the years. However, the highest numbers of women researchers in SET at Cambridge are the contract research staff (CRS), who occupy short-term post-doctoral positions that tend, alas, to have no long-term possibilities. Numbers of women UTOs in SET also remain low, especially in the computer sciences.

For this reason, in 2003, the Department of Computer Studies formally asked Professor Ursula Martin, an old Girtonian, to work to increase this number and to join in with the WiSETI initiative.

Given that contract research staff often have no college links, the Girton Graduate Tutors and other Fellows (John Davies, Rex Godby and myself) set up a 'Research Associates' scheme in 1992, whereby post-doctoral researchers can partake in Girton graduate community activities. This has flourished, especially for those in SET disciplines, where there are many CRS who crave the 'Cambridge collegiate experience'. Several other colleges have followed suit.

The number of women doing MPhils and PhDs in science subjects has increased over the years. Notable improvements began in the late 1970s and early 1980s, when Professor Brenda Ryman, a biochemist, became Mistress. She was a strong supporter of science, and encouraged the research activities of both Fellows and graduates in SET in College. During her reign, Fellows with doctoral degrees were for the first time allowed to refer to themselves in College as Dr, rather than Mrs or Miss as had always previously been the case. This helped enormously in allowing Fellows in SET to be recognised as scientifically qualified for their work. It was a great loss when Brenda died in office from cancer at the early age of sixty.

Particularly important for science graduates is the way the life of the MCR has improved over the past thirty years. Dining at Formal Hall with Fellows on Thursday nights has become a regular, and very popular, occasion. A well-organised and varied social programme has supported a diverse range of graduates and Research Associates from all over the world, and has become a feature of Girton graduate life. These activities have served as an example of best practice to other Cambridge colleges, many of whom have emulated them.

Girton's Emily Davies Fora, which began when Baroness Mary Warnock was Mistress and continued under Juliet Campbell, ran annually for several years, with enormous success. Not only Girton scientists but also graduates and practitioners of other subjects took immense delight in meeting at a central venue in

London to discuss different aspects of issues that impact on all women, such as the problems associated with ageing. This provided useful links between College and successful Girton graduates, who were often inspired to become reinvolved with College life. A recent new development, building on such possible links, is the 2004 WiSETI pilot project whereby successful senior women in science, technology, engineering or finance come to Cambridge to talk about their experiences and careers to female undergraduates. Supported by Citigroup, women speakers from Schlumberger, Qinetiq, Rolls Royce and the Garland Press have thus far been involved, with Pfizer, Tesco and BP in the wings, and the feedback from the undergraduate women has been most enthusiastic.

An important aspect of the new Girton Archive will be to keep records of some of its more remarkable female scientists.[1] The papers of such recently retired Fellows as Professor Enid McRobbie FRS, an outstanding Girton plant biophysicist, Dr Christine McKie, author of one of the major University texts on crystals and for many years Director of Studies in the Physical Sciences, and Dr Janet Harker, who was responsible for recognising the potential and overseeing the admission of generations of biological scientists, are important archival materials for the emergence of science in the latter part of the twentieth century. These, together with the records of recent Girton science graduates who have been elected FRS – such as Professor Frances Ashcroft, now in Oxford; the early Girton pioneer scientists; and others such as Bertha (Lady) Jeffreys, Vice-Mistress, then Senior Fellow, who for years supported both students and Fellows in science at Girton – could provide an incomparable archive for posterity. This will demonstrate the impact that the Fellows and students of Girton have had on the scientific community, and indeed on the development more generally of scientific ideas and technology.

Nancy Lane Perham OBE is a scientist in cell biology. She came to Girton as a Research Fellow in 1968 and has since served as Official Fellow, Lecturer in Cell Biology and Graduate Tutor for Science. She currently directs the University's project on Women in Science (WiSETI) and serves on the UK Resource Centre to improve the position of women in SET. She has lectured widely to raise the public awareness of biology, edits journals and is the recipient of a number of honorary degrees.

Engineering: taking Girton with one
Mark Spearing

I came up to Girton in 1983. I was quite lucky to get in, and in truth I was not a very good engineer as an undergraduate. Cambridge had too many distractions, or at least alternative attractions, and I must have exasperated my supervisors and Director of Studies. My academic focus became sharper only in my final year (Engineering was then a three-year course; it now takes four years), largely due to my carrying out a research project as part of my coursework. I found that I thoroughly enjoyed the process of research, and the possibility of staying on to pursue a PhD became far more interesting than any of the other options open to me.

My PhD turned out to be even more fun than I had expected, and has led to a career largely spent in engineering academia. Thanks to an offer of a post-doctoral research position in Santa Barbara, California, I have spent most of the past fifteen years in the USA, the last ten in the Department of Aeronautics and Astronautics at the Massachusetts Institute of Technology. This has provided an interesting perspective on my academic roots at Girton, and on the cultural differences between engineering education in the US and the UK.

Perhaps the most important effect of spending six years as a student at Girton was that it immersed me in a working environment where half the population was female and about 25% of the engineering students in the college were women. This compared with a quite dismal 8% in the University Engineering Department, and an even lower percentage in the engineering workforce at large. However, in the subsequent twenty years the engineering workforce has gradually become more diverse. At MIT I regularly teach undergraduate classes with over 40% female students, and I have even taught a graduate class made up of over 60% women. Cambridge does not quite match

these numbers, but the same trend applies. I am eternally grateful to my female contemporaries at Girton for making me aware (often in no uncertain terms) that they were every bit my equal intellectually, and that they had every right to an equal voice in the future of science and technology. It is clear that many of my male contemporaries, educated elsewhere, have still not had the benefit of these lessons, and that we still have a long way to go as a profession.

A second key effect of going through Girton as an undergraduate was the strong ethos of teamwork among most of the engineering students, within each year and between years. Part of this was built into the engineering curriculum, with its significant requirement for laboratory work completed in pairs. However, engineers at Girton seemed to work together to a greater extent than students at other colleges, in the form of mutual instruction and mutual preparation for supervisions and exams – cooperative habits that are absolutely essential in both academic and industrial settings. A few years ago I attended a workshop organised by Boeing, the aerospace company. A senior vice-president made the comment that he had never seen a US-educated engineer fail due to a lack of technical skills, but that many failed as a result of other factors, particularly the inability to work as part of a team and to communicate effectively. In academia, research funding is increasingly directed towards multidisciplinary projects or interdisciplinary fields that require multiple researchers to pool their expertise. This recognises that many of the key challenges for the future of engineering, e.g. bioengineering, information engineering, nano-technology, environmental engineering and dealing with the complexity of modern engineered systems, require skills that stretch far beyond those of any one individual. Unfortunately, academic engineers of my age or older have usually reached their positions on the basis of individual excellence in pursuit of their doctorates and have often not had to work as part of a team. This can lead to tragicomic failures where interdisciplinary teams are concerned, and, as a result, formal teaching of teamwork and communication skills is now being introduced into engineering curricula in both the US and the UK.

As I reflect on the past twenty years, I am very grateful for the environment that Girton provided during my undergraduate and postgraduate education. Whether intentional or not, it prompted me to adopt attitudes and behaviour that have proved to be very important in my subsequent career. I do not think that I am alone in this: of the half-dozen Girton engineering graduates with whom I have remained in contact, all are employed in technical fields, suggesting that we have collectively retained the enthusiasm for engineering that originally brought us into the discipline, and all have been relatively successful within it. I was honoured to be able to spend 2002–3 on sabbatical at Girton as the Brenda Ryman Visiting Fellow, and delighted to see that the essence of the environment that my contemporaries and I enjoyed as undergraduates seems to have been preserved, while many of the details have been updated. Long may this continue!

Mark Spearing has recently been appointed Professor of Engineering Materials at the University of Southampton, following ten years as a Professor of Aeronautics and Astronautics at the Massachusetts Institute of Technology. His teaching and research interests include aspects of materials used in aerospace structures and micro- and nano-systems. Together with his wife, Elnor, he enjoys an active lifestyle, including walking, skiing and various recreational sports.

Medicine: views from a professional discipline
Medicine business
Thomas Sherwood

As Voltaire said, 'When critics are silent, it does not so much prove the age to be correct as dull.' Universities run no risk on this score; there is no shortage of attackers in the twenty-first century. And particularly, why medicine in these curious, tottering towers? There is, of course, nothing wrong with the idea that universities should be useful; the fault lies in a blinkered, short-term view of what is useful. 'All education… is undertaken not for its own sake here and now, but for the sake of the future. The outcome of education must be shown to be good, whatever its subject matter' (Mary Warnock, *Universities: knowing our minds*, 1989).

A NEW REREDOS FOR THE CHAPEL

As I write, in May 2005, the new reredos hanging in the Chapel is halfway to completion, replacing the great damask curtain that has hung behind the altar for fifty years. It is not a bad moment to stop work on the project and reflect.

I left Girton in 1969 and returned in 2003 to do an MPhil. I tried, during that year, to take Sunday afternoons off to pedal up to College for a swim, choral Evensong and a snack supper with the choir. It was at one of these choir suppers that, by chance, I overheard members of the Chapel Committee discussing the need to do something with the 'business' end of the Chapel, as the splendid new organ had drawn the focus of attention to the other end. Talk was of casting about for artists who could offer ideas.

I had left Girton after one undergraduate year to become an artist, and have spent all but the last of the intervening years applying art in some form to a wide variety of jobs, situations and commissions including several large installations, some permanent. I interrupted the conversation and asked if I might pitch a proposal.

Of the three strands to my work, the most appropriate seemed to be 'installation'. These are always site-specific, often non-figurative and usually very large, and over recent years I have used time-honoured women's craft techniques on a vast scale to make these installations. By comparison, the slightly over ten-foot square behind the Girton Chapel altar is quite small. But there are other challenges. The altar is very modest and should not be overwhelmed. The Chapel itself is plain both in form and decoration, just red brick and unadorned oak panels. It seemed to me that complementary simplicity was called for, rather than some arty flourish. A pattern, almost in the Islamic tradition, can

hold the eye without interfering with contemplation. It soon became clear that I should be thinking non-figuratively in white, picking up the rhythm set by the window mullions in some sort of bas-relief. In other words, I began designing a cabled knitting pattern. Among the treasures of which Girton is proud custodian are Julia, Lady Carew's crewel embroideries, work of imagination, skill and contemplation over years at her ailing husband's bedside. Old Girtonians, too, had acknowledged the centenary of the College in 1969, demonstrating their lasting affection by embroidering new gros-point hassocks and kneelers for the Chapel. Despite its primary task of promoting the work of women's heads, Girton also respected the work of their hands. It was not unreasonable, then, to propose a 'knitwork'. The Chapel Committee received my written offering and computer mock-up with interest and some bewilderment as the idea required a considerable leap of imagination. They asked to see a sample.

Choice of material was difficult. I was looking for 'yarn' that would stay white, last for many years, require no maintenance and might possibly include a metallic element to reflect the little available light. I eventually found a pure white 8mm three-strand nylon rope with a beautiful pearly sheen that needs no inclusions and is supple enough to knit. After much struggling with needles of various sizes shaped from dowel, 100 metres of rope became a small sample about one-thirtieth of the total area. I prepared scale models and samples to help the Chapel Committee perceive that the idea was feasible. They were convinced, as was College Council.

There is a long moment, following the acceptance of a proposal for a piece that is by nature experimental, when it is hard to breathe: I wonder what I have let myself in for, and I cannot let my brave sponsors down. However, buoyed up by their faith, delight and encouragement, I embarked on tackling the enormous technical and

logistical challenge of refining and executing the design. I made inch-thick, 14ft-long flexible knitting needles and a short cable needle, cast on 103 stitches and got cracking. I achieved a rate of about ten rows a day on three benches lined diagonally across my studio, working to half-way up the piece before bringing it to College to complete it on site over four weeks.

The cables in the design are paired beneath the mullions and the reveals of the window above. They separate and converge to form two, three and finally two long ogee-diamond panels filled with moss stitch to keep the work flat and create a regular, pebbly twinkle. For the upper pair of panels my plan had been to vary the infill by introducing the ermine and crescent roundels from the College crest in subtle bas-relief through changed texture. However, the various committees involved in commissioning the work expressed concern that this could strike the doctrinally sensitive as idolatrous. This came as a bit of a blow. But working for clients is a two-way street. Dialogue helps to mould an idea towards a smooth fit, and so, having cracked the problem of knitting roundels in this hostile medium, I am now back at the drawing board figuring out a way to include alpha and omega and possibly chi and rho within the circles so that I can vary the pattern in the upper half of the design and still remain close to the original plan. By the time you read this, artistic and technical problems will have been resolved and the work will be complete.

Helen Chown (Benians, 1968, 2003)

Medicine seems obviously useful (*pace* Illich's *Medical nemesis*), but it has been an uneasy bedfellow in the University. Cambridge has done it for centuries, yet in a hands-off sort of way. When it came to practical bedside matters involving patients, for the past five centuries, including most of the twentieth, Cambridge medical students were sent off to Padua, Leyden or the London hospitals. Those, after all, were the career schools where the hands-on business of medicine could be learnt, with a return to Cambridge only for sitting MB.BChir finals. It was only in 1976 that, after a hair's breadth vote, the University opened its own Clinical School.

This reluctance to go in for yellow-brick business schools is understandable. Was this place of proud independence, devoted to learning for its own sake, to be saddled with career training conducted under the aegis of Parliament via the General Medical Council? Worse, there was the prospect of the Continental model of medical training, with exams and certification tightly controlled by the state. And physicians are expensive, as well as rather cohesive as a guild. No wonder the Regent House was worried.

Thirty years on, the picture looks less alarming. The clinical academics have turned out to be rather effective researchers. They have made Cambridge a centre of international clinical excellence, with scholars streaming in and outside research funds in full flood. The anomaly of a medical school within the University and its colleges is now less prickly than it was in the 1970s. And Girton was not slow in showing the way at the time, electing first Carol Seymour and then me into its fold from the Clinical School.

The tensions on universities harbouring clinical schools will always be there, however. The funding for the clinical academic contract in England is now to be split 50:50 between the Higher Education Funding Council for England and the National Health Service, rather than being totally directed through the universities. In 2004, in a memorable TV confrontation between the Prime Minister and a medical student, she said: 'Why shouldn't a dustman fund me? He'll be jolly grateful when he has his heart attack.' The inequality tersely expressed there will go on

reverberating: medical students are heading for lucrative careers; but the country needs them!

The alternative to university clinical medicine was seen in the old Eastern bloc countries: dedicated state Schools of Hygiene. They were uninspiring or plain pedestrian, with a poor research record. The last thirty years in Cambridge suggest that accommodating the mixed intellectual/banausic business of medicine in the University is a tense but good anomaly; there are mutual benefits. The critics are still not silent, and that too is a good thing.

Thomas Sherwood trained as a radiologist at the then Royal Postgraduate Medical School (Hammersmith Hospital), becoming Senior Lecturer there and at the Institute of Urology. He was Professor of Radiology at the new Cambridge School of Clinical Medicine from 1978 to 1994 and was later (1984–96) Clinical Dean.

Pleading guilty
John Marks

I willingly plead guilty to attacking the prevailing conventions covering the admission of those wishing to read Medicine at Girton during the 1980s. Why? Because all I hear now convinces me that at the beginning of the twenty-first century independence of the type we applied to reading medical studies at Girton is just not tolerated, and I feel that somebody has to fight for the old standards of British medicine, which was the best in the world. I make no secret of the fact that I am increasingly disturbed by the standards of British medicine and, even more, feel that science has taken over from ethics and kindness in parts of the profession.

At Girton we took the view that some 80% or more of those who read Medicine at Cambridge, like most of those who read it elsewhere, were not going to become Nobel Laureates or Fellows of the Royal Society. Nor indeed did most wish to achieve this, even within the dreams of youth. They were going to be concerned with the care of the ill and frail in mind and body. Providing this care is an art as well as a science – an art and, even more, a vocation that requires above all the ability to communicate on a one-to-one basis with all

manner of people from prince to pauper, to establish empathy and to instil confidence.

We did not feel that numbers of high-grade A-levels were a *sine qua non* for determining the characteristics of those we felt would mature into 'good doctors'. To a substantial extent we ignored A-level results and tried hard to find other methods to select our candidates – though whether it is possible to determine, at the age of eighteen, whether someone has the characteristics that will allow him or her to blossom into a forty-year career as a caring practitioner is a moot point.

Over the period we admitted at least one candidate who had left school at fourteen, even before completing matriculation requirements, to become a barrow boy; we accepted several who wished to change from nursing to medicine; and we welcomed others who had previously read such diverse subjects as music and archaeology and had only limited knowledge of the finer points of physics and chemistry.

We believed quite passionately that the ability to determine empathy was best established on the basis of one-to-one conversations rather than formal structured interviews, and this was the policy we adopted. Some of those we accepted found it very hard going to keep up with the high academic standards of Cambridge, but the vast majority succeeded by sheer hard work and learned a lot about life by so doing. Even more, the Girton attitude in medical studies was to encourage the students to work to a high-second-class standard, rather than a starred first, and to enjoy the other opportunities through which Cambridge life nurtures a broad-based character. Whether these opportunities were found in the realms of music, religion, the stage or sport mattered not. Breadth of interest, we felt, was vital in clinical medicine.

Having kept in touch with many of the 1980s Girton medics and seen and heard about their lives, I am proud of their performance. They are keeping up the standards required by Hippocrates and are a continuing credit to the profession of which they are a part. *Floreat medicina Girtonia*!

For biography, see chapter 1

Delivering a new Veterinary Medicine
Josh Slater

Applications to read Veterinary Medicine, more so than any of the other vocational professions, are heavily influenced by media imagery. The effects of television and popular literature are profound. The early 1970s was the era of James Herriott; thirty years later, the first decade of the new millennium is the era of Rolf Harris, *Animal Hospital* and vets as characters in reality television. Neither image, of course, is an accurate portrayal of life as a veterinarian. Herriott's brand of veterinary medicine was irresistible: a rural idyll with the veterinary surgeon at the centre of a prosperous agricultural community making a major contribution to livelihoods and quality of life. Animals, but more specially their owners, were at the centre of his stories. The current media image is at once both more dramatic and more sentimental. Animals, rather than their owners, are now the focus of veterinary medicine on television and their suffering is portrayed with anthropomorphic zeal.

These two quite different images of the profession were, and are, important driving forces behind applications to read Veterinary Medicine. Yet media coverage does little service to those of us with responsibility for recruiting and educating veterinary students. There is clearly a need, and an important role, for the practicing veterinarian who cares for companion animals. There are other roles, however, that are probably of greater importance, not least because they have become neglected areas; these include food hygiene, public health, the control of emerging and epidemic diseases, epidemiology and disease modelling, and the translation of basic scientific research into clinical practice. The challenge currently facing Girton's veterinary teaching staff is to take new undergraduates who usually have little initial knowledge or interest in these areas and enthuse them for a type of veterinary medicine they have, in most cases, not considered before starting the course.

In common with other UK veterinary schools, the number of undergraduates admitted to Cambridge has expanded more than threefold over the last thirty years. The most dramatic change has been the sharp

increase in the proportion of women applicants. In the early 1970s Cambridge was admitting between nine and nineteen veterinary students per year, of whom the minority (less than 20%) were women. By the year 2000, sixty-five students were being admitted each year, of whom the majority (70%) were women. Girton has had a long association with Veterinary Medicine in Cambridge, and now admits the largest number of veterinary undergraduates of all the colleges: up to ten men and women each year, though, paradoxically, the high ratio of female to male applicants means that Girton typically admits few, or sometimes no, male veterinary students. As student numbers have expanded, the number of Fellows teaching veterinary subjects has increased from none in 1970 to five in 2004.

Veterinary practice has undergone major changes in the last thirty years. The public's expectations and the aspirations of young veterinarians have both changed almost beyond recognition. In 1970, the profession was predominantly practice-based; it still is in 2004 (80% of veterinarians on the professional register are in private practice), but the focus of practice has changed from mixed, mainly farm animals to companion animals (small animals and horses). Across the UK, farm livestock numbers have declined as the economics of farming have led to a sharp decline in the demand for farm animal veterinary services, while companion animal ownership has boomed.

Graduates in 1970 expected to enter mixed farm animal practice and to work long hours, including out-of-hours work. Today's graduates hope to enter companion animal practice and do not wish to work such long hours. The increasing proportion of women graduates has meant that the traditional male-orientated career structure is changing – to the benefit of both men and women – to part time and flexible working patterns. However, despite these changes and the political pressures being exerted on veterinary schools to train graduates with a broader range of skills and interest than simply practice, the attitudes and ambitions of Girton veterinary students are not fundamentally different today from thirty years ago. Our veterinary students remain very

vocationally focused and career-orientated. We continue to attract high-quality, academically gifted students who increasingly make the most of the science opportunities on offer as well as playing active roles in Girton's social, sporting and musical scenes.

So what of the future, and how are the new educational priorities, including those centred on clinical research, to be delivered? In many ways the traditional, and to some outside observers old-fashioned, Cambridge Tripos course and college supervision system are actually best placed to deliver these new educational needs. Girton's veterinary supervisors deliver teaching that is comparative, cuts across species and disciplines, and integrates basic research, thus scoring a political bull's eye. While the other UK veterinary schools have made sweeping modernising changes to their curriculum, Cambridge has adopted a more cautious and reflective approach. Nevertheless, almost all aspects of the undergraduate course have been revised and now embrace the best of modern teaching philosophy, including clinical relevance for pre-clinical courses, small-group teaching, high-quality practical instruction, problem-based learning, computer-aided learning and the opportunity to carry out research projects. The College's small-group supervisions incorporate these changes while remaining true to their original purpose of providing a high quality scientific basis to the art of veterinary medicine.

We are in an exciting time for Veterinary Medicine. The regulatory body wishes to impose radical changes on the veterinary schools, with pre-graduation streaming, a compulsory post-graduation intern year before registration to practice, and restrictions on the range of animals that individual veterinarians will be licensed to work with. The Cambridge undergraduate course may have to change considerably to incorporate these demands, but Girton's teaching will remain an integral part of the Cambridge veterinary undergraduate experience.

Josh Slater is a Senior Lecturer at the Veterinary School in Cambridge, where he teaches equine medicine and runs a microbiology research group. He has been a Fellow of Girton

College since 1996 and teaches anatomy to the first- and second-year veterinary students. His other roles in Girton have included Tutor, Director of Studies and Praelector.

Changing educational mores: some ethical reflections

John Hendry

About ten years ago, in the mid-1990s, a student on a professional course that I was then directing complained that the syllabus was not to his liking and demanded that it be changed. Another appealed after failing several modules on the grounds that he had paid his fees and expected a degree in return, even though he had absented himself from classes to pursue a business venture and averaged marks of around 40%, as against a pass mark of 60%, in his exams. A third refused to pay his college fees on the grounds that he did not want to buy the services provided.

None of these students was a Girtonian (though they might well have been), and, compared with the majority of university students, their position was unusual. They were in their late twenties or early thirties, with several years of business experience, were paying over £20,000 each in fees to take the course, and had given up good jobs and a year's salary to do so. 'Investing in education' had, for them, a very specific meaning. However, the attitude they displayed is far from unique to professional degree courses. Over the last thirty years, the relationship between students and the people and institutions responsible for their education has changed significantly across the board. What used to be primarily a moral relationship, between teachers and students, has become to a large extent an economic one, between suppliers and customers.

This change is not peculiar to the universities, or indeed to education. The relationship between health professionals and patients has changed in a similar fashion. Across the public sector, services in the moral sense have been replaced by services-as-products, and those for whom they are provided have come to be treated as consumers rather than as citizens. More widely still, traditionally moral ways of thinking have given way to more instrumental, economic modes of thought. Pecuniary self-interest has become increasingly legitimate as a ground for action, and money the overwhelmingly dominant measure of good.

However, the change poses particular challenges in the university and college context, where students attend voluntarily and for a variety of motives, not just because they are required to do so (as at school) or because they feel in particular need of the service provided (as most patients do). Some students are evidently motivated by a strong desire to learn, but for others university is a route to a job, where it is the degree that matters, not the learning that goes with it.

The same forces that underlie these changes have also led to a culture of accountability, not in the sense of explaining to interested parties what one is doing, but in the rather narrower sense of being required to submit to inspection and report to the world at large what one has done. In tune with the economic mindset, the focus of this reporting is on quantitative measures, and especially on measures of economic efficiency. In universities nationwide, this has had some bizarre consequences. Not surprisingly perhaps, more effort has gone into the reporting (since the report is what is actually judged) than into the doing. And greater emphasis has been placed on research output (which is visible and lends itself to quantification) than on the core academic activities of enquiry and teaching. All this has inevitably distracted teachers from their teaching and led them to focus on more instrumental aspects of their work: getting the job done and completing the paperwork in such a way as to protect themselves from criticism, rather than engaging directly with the learning of their students.

In some sense this account is, of course, a caricature. Brief sketches oversimplify. There was never a 'golden age' of morality, or of educational purity. Student/teacher relationships have always been characterised by a mixture of motivations on both sides. Moreover, the economic character of student/teacher and student/university relationships is far more evident outside Cambridge than inside. Most British universities, even those at the top of the rankings, now accept students onto Masters courses regardless of their first-degree performance. At

undergraduate level, 'seminars' are often in anonymous groups of twenty or thirty, 'personal tutors' never meet their tutees, and students can go absent for weeks on end without anybody noticing or caring (though woe betide anyone who is late with her fees). Struggling students, many of whom work two or three days a week even though they are taking 'full-time' courses, resort, not unreasonably, to plagiarism, and only in the most outrageous cases will teachers brave the bureaucratic and potentially legal nightmare of doing anything about it. By contrast, in Cambridge, both the academic standards and the personal contacts have been maintained. Residence may no longer be enforced in the way it was thirty years ago, but absence is still noticed. In Girton, and in the other colleges, students are still supported, both personally and academically; and plagiarism remains exceptional.

In other words, Cambridge is still a very privileged environment. The students are privileged to study in a system that cares for and respects them, and the teachers are privileged to teach students who are both able and (thanks largely to the interview process in admissions) engaged. But even here economic priorities and socially legitimised self-interest have complicated and clouded academics' relationships with their students. Many academics now see time spent teaching as something to be minimised, because the rewards both for them and for their institutions come from putting more effort into their publications. Employability and 'usefulness' are in danger of displacing learning and individual growth – the development of wisdom and character – both on the public agenda and on the student priority list, and are coming to be taken for granted as the end points of university education.

The moral challenge of teaching was captured well by the philosopher and theologian Martin Buber: not just to impart knowledge or skills but to participate directly and ingenuously in the lives of one's students, and to accept them not as they are now but 'as they *really* are, as they can become... [to] find out what is in them and what I can do to make it take shape' ('The education of character' in *Between Man and Man*, 1947 and 1961; emphasis in original). This has

always been a challenge, and few teachers have ever risen to it. It is in danger, however, of becoming an unthinkable challenge, and that is seriously worrying. As Richard Sennett put it (*The Fall of Public Man*, 1977), there is hope even in oppression, so long as we have something to rebel against. When everything is taken for granted, we lose even the power to rebel.[2]

John Hendry is a Supernumary Fellow of Girton College, Senior Research Associate at the Judge Institute of Management and Professor of Management at the University of Reading. From 1990 to 1998 he was Founder Director of the University of Cambridge MBA course. His current research interests are in business leadership and moral culture.

Unfragile monuments
Sarah Kay

Most humanities subjects have death at their core, recognising in it the necessary pre-condition for the renewal of life. This recognition is borne in upon medievalists with especial force, since so much of the art and literature of the Middle Ages revolves around the elegiac or the apocalyptic, the funerary or the spectral. It was a shock, however, to have this recognition effected in my own experience when, as a result of the almost simultaneous premature death of two distinguished Cambridge French medievalists, an opening was advertised and I found myself working in Cambridge. One of those who died was the troubadour scholar Leslie Topsfield; the other was the formidable and much-loved Fellow of Girton, Ruth Morgan. When I arrived in Girton in 1984, it was with the sense of occupying the places of people who should still rightfully have been alive. Even now I occasionally feel a sense of relief at having survived for twenty years in what bore all the signs of a 'seige perilous'.

Ruth Morgan's legacy – another term marking the interconnection between death and continuation – was impressive. She combined a razor-sharp intellect with personal warmth in a way that was clearly unforgettable. She left immense respect, numerous loyal students and friends, excellent library facilities and an important body of publications. One of my first tasks was to compile the bibliography of her

writings for the volume that the College produced in her memory. Stepping into her shoes was daunting, the more so as they seemed so welcoming. My own training was, after all, very similar to Ruth's and our fields were, in a sense, the same.

Looking back on this premature relay from the vantage point of today, however, what strikes me most is how what seemed like a continuation has been overlaid with change, to the extent that, while in some sense I occupy the same position as Ruth, at the same time my position is utterly different. Ruth was above all a philologist. She transmitted a discipline whose foundations lay in meticulous knowledge of the history of the French language and a commitment to appreciating the intricacies of early texts. In her own case an historical approach was, as it were, compounded by the fascination with history that inspired her work on crusade chronicles and the figure of Saladin. Ruth did not primarily see herself as a literary scholar, a fact that set her aside from her phenomenally distinguished French colleagues at Girton, Professors Alison Fairlie and Odette de Mourgues. Between them, these three women taught an extraordinarily high proportion of the female teachers of French in British universities today.

Nowadays, the study of medieval languages and literature has been reconfigured. In part this is due to the rise of Linguistics. The analysis of early forms of European languages now forms a part of this still-growing field. A theoretical as much as a practical discipline, Linguistics addresses the structures and functions of language, and the reasons for linguistic diversity and change. Undergraduates derive great benefits from studying it, but they no longer learn early forms of French in a framework that would enable them, should they progress to graduate work, to edit medieval texts. And conversely, I do not feel that teaching the history of French forms a part of my professional role, as it would have done in the past.

The way medieval French literature is studied has also seen major changes. At graduate level, no one in the United Kingdom today would seriously consider editing a text as a doctoral project. Instead, work on medieval literature has become much more akin to work on modern literature. A critical as much as an historical discipline, it has strengthened its intellectual affinities with philosophy, theology, anthropology and that controversial and ill-defined body of writing known as 'theory'. Regarded by some as a European imposition comparable in enormity with the euro or the kilo, and even to its exponents as a concept to be treated with some irony, 'theory' encompasses a whole range of political and philosophical developments that date back to the nineteenth century but draw new vigour from their reworking by mainly German and French thinkers in the twentieth. By referring critical readings of medieval texts to feminism or queer theory, to formalism or deconstruction, to Marxism or psychoanalysis, medievalists have established the centrality of their literature to contemporary debates, but at the cost, in the eyes of some, of diminishing its historical specificity. Ironically, what is called 'the linguistic turn' – a tendency in all disciplines under the influence of theory to ask whether knowledge is as much a product as an object of language – has resulted in a turn away from the study of language as such.

Another way of putting this would be to say that medieval studies has made itself less like Classics used to be and more like English is now, which is also ironic given that Modern Languages Departments are now under threat in exactly the way that Classics Departments were thirty years ago.

Ruth Morgan worked centrally on the Crusades, and on the textual and editorial problems raised by a particular French crusade chronicle. Neither the Crusades nor French crusade chronicles figure currently in either the graduate or the undergraduate curriculum of teaching in Cambridge outside the History Faculty. From next year, however, my colleagues and I will be teaching French medievalist students a new topic on 'Crusades and the Orient'; and this coincidence between Ruth Morgan's interests and ours highlights another instance where what appears to be a continuation may, in fact, represent a rupture. Ruth's approach, at least in her published work, was primarily historical, whereas our teaching will be shaped by the contemporary preoccupation with colonial and post-colonial thought. For most scholars who work in the

post-colonial domain, European powers are the colonisers and the East an object of appropriation. In the Middle Ages, by contrast, European writers were keenly aware that the refinement and sophistication of Islamic culture outshone their own. In addition, the European nations were perceived as occupying the position not of colonisers but of the colonised, since they believed themselves to have been founded by the heroes who, fleeing at the fall of Troy, brought with them the elixir of civil, civilised and city-based life.

Contemporary political rhetoric is much enamoured of the concept of crusade, a term whose religious resonance extends to inflate less admissible, more overtly Islamophobic sentiment. One of the main moral obligations of medievalists today is to remind the world how great was the contribution of Islamic civilisation to the West: not just as a passive intermediary in the transmission of an essentially European knowledge – the preservation of Greek philosophical texts is the classical instance here – but as the instigator of ideas in philosophy, mathematics and poetry. In deciding to work on Saladin, who captured Jerusalem from the crusaders in 1187 (a project left unfinished at her death), Ruth Morgan had identified the point at which the crusading ethos encountered its limit, as Saladin was acknowledged by his European contemporaries, including crusading chroniclers, to be exceptionally noble, intelligent, chivalrous and humane. Now seems an appropriate time for this knowledge to make a return – and to make a difference.

It is important not to moralise change. The cost of continuity is change, and the cost of change is loss. Yet the monument betrays its fragility when it fails to transform.

Sarah Kay is Professor of French and Occitan Literature at Cambridge, and has been a Fellow of Girton since 1984. She was Senior Tutor from 1992 to 1995. Her major publications are Subjectivity in Troubadour Poetry *(1990),* The Chansons de Geste in the Age of Romance *(1995),* Courtly Contradictions. The Emergence of the Literary Object in the Twelfth Century *(2001) and* Zizek. A Critical Introduction *(2003). She is a Fellow of the British Academy.*

1 Kate Perry, the Archivist, writes: Girton's Archive already has many scientific connections. We hold the papers of the biochemist Dorothy Needham (née Moyle 1896–1987), the crystallographer Helen Megaw (1907–2002) and the mathematician Dame Mary Cartwright (1900–98). In due course we shall house a proportion of the papers of Lady Jeffreys (née Swirles 1903–99) and take receipt of the papers of the botanist Ethel Sargant (1863–1918) and the neuropharmacologist Marthe Vogt (1903–2003). We actively seek the papers of contemporary Girton scientists and are happy to offer advice. Our special collections include books from the scientific library of Mary Somerville, given by her daughters in 1873, and the botanical library of Ethel Sargant which she left to College in 1918.

Girton has a strong tradition in the sciences and there are archival records and photographs that document the beginning of this tradition and chart its development, in particular the building of the first laboratory at Girton in 1877, the foundation of the Natural Sciences Club in 1884 and the opening of the Balfour Biological Laboratory for women students in the same year. We are currently collecting records which document selection, teaching and examination in the sciences, and our Oral History collection contains recordings with Fellows and students from a cross-section of scientific disciplines.

2 For further discussion of the issues raised above, see John Hendry, *Between Enterprise and Ethics*, 2004, and Ralph Fevre, *The Demoralisation of Western Culture*, 2000.

Chapter 6
A changing population

Thirty years is a generation. For UK-educated undergraduates, a comparison of opportunities now and then invites us to look both at social and educational mobility in the UK as a whole, and at changing patterns of admission to Cambridge. An account of access and aspirations across the generations in the families of present-day Girtonians offers an unusual perspective.

Meritocracy and mobility in British higher education
Alastair J Reid

During the first half of the twentieth century, British higher education was fragmented and confined to preparation for the traditional professions: fewer than 2% of eighteen-year-olds went to university, and these were mostly fee-paying men from middle-class backgrounds, alongside some on scholarships from lower-class backgrounds. Then, in the general mood of post-1945 reconstruction, the meritocratic principle of 'equality of opportunity' led to demands for expansion, a unified admissions procedure and the introduction of mandatory grants. These aims and methods were pursued through two further major phases of reform: the expansion of the number of places following the Robbins Report of 1963 and the inclusion of the former polytechnics within a single-tier system in 1992. This has resulted in over 40% of eighteen- to thirty-year-olds

benefiting from higher education, along with a marked increase in female participation, rising from 25% to 45% of new entrants to universities.

However, despite such massive institutional changes, quantitative evidence indicates that the proportion of the student population drawn from each major social group has remained remarkably constant across the whole of the twentieth century and up to the present day. The national statistical data collected by the Universities and Colleges Admissions Service (and its predecessor bodies) show that, since the Second World War, the proportion of the student body from the upper-middle classes has remained stable at around 20% and the figure for the middle classes has fluctuated between 40% and 50%. Among those from the lower classes the single clear change has been the fall in the figure for those from skilled-manual families, which dropped from 20% to 10% following the decline of traditional manufacturing sectors after 1950. The figure for those from unskilled-manual families has remained stable at around 5%, while that for those in the less well-defined non-manual category has fallen from 10% to 5%, probably because they have increasingly tended to report themselves as middle class or have ended up in the growing residual category of 'unknown'. Perhaps even more strikingly, evidence for Glasgow University in

1910 suggests that, in some regional centres of excellence, social inclusiveness was just as effective 100 years ago as it is today, and indeed for some groups of manual workers possibly more so. In this case the student population was already made up as follows: upper-middle class 19%, middle class 39%, non-manual 10%, skilled manual 23%, unskilled manual 9%.[1]

This marked continuity in the social composition of British undergraduates does not mean that there has been no social mobility during the twentieth century. In fact, Britain is a relatively fluid society. One factor is that after those from lower-class families have been through higher education and found appropriate employment, their children will then appear as coming from higher social backgrounds. And of course many others from manual-working-class families have risen to non-manual positions without going to university: studies of social mobility indicate that the main educational contribution to intergenerational change has been selective secondary schooling, not higher education. What the continuity in the social composition of undergraduates does indicate is that in the country as a whole, and despite all the attempts of Governments over the last fifty years, there has been a stubbornly traditional association between participation in higher education and certain kinds of family background. Indeed we might say that the processes of change in the twentieth century have been accompanied mainly by shifting middle-class perceptions and experiences of university education, from a carefully considered option to a general aspiration.

Why then has lower-class participation not increased more than it has? Quantitative studies indicate that this is not because of institutional exclusiveness: the share of each social group admitted to higher education has usually been roughly equivalent to the share applying. The difficulty appears to lie in making universities more attractive to the children of manual workers, and one plausible explanation for this is a paradoxical effect of the massive expansion in the numbers of those in higher education. For, with twenty times as many graduates coming onto the labour market now,

compared with the early twentieth century, there is no longer any guarantee that a degree in itself will provide privileged access to employment opportunities. Indeed, access to elite positions is widely seen as being as dependent as ever on family connections and other forms of 'cultural capital'. So, taking a utilitarian point of view, children of manual workers may be deciding that there are better ways of improving their prospects than by staying on into the sixth form and then spending another three years at least in a relatively restricted educational institution. Paradoxically, then, universities might have been more attractive to lower-class applicants if the introduction of fully competitive access had been accompanied by a traditional restriction of numbers.

Meanwhile, the twentieth century has also seen a significant shift among governing and higher-professional groups from a humanistic style, drawing on a background in classical languages, to a technocratic style, based on specialised occupational training. Making British higher education more attractive to those with social mobility in mind would therefore require a strengthening of its technical and applied aspects, backed up by an even broader strengthening of these features across all of the country's secondary schools, in order to prepare the most able students from the widest possible range of social and geographical backgrounds. Governments do make moves in this direction from time to time. Technical colleges were gradually upgraded first to polytechnics and then to universities, but the lack of applicants with suitable mathematical and scientific qualifications has led the former polytechnics to maintain their numbers by greatly expanding their admissions in the humanities and social sciences. In an attempt to fill this gap in preparation for higher education, City Technology Colleges (CTCs) were launched in the late 1980s with a strong emphasis on science, design and business studies. However, there are still only thirteen of them, compared to the 324 technical schools that were in existence in 1946, run by local education authorities but without any incentive to prevent them from being dissolved into grammar and comprehensive schools over the following decades.

There seems, then, to be something holding Britain back from a whole-hearted pursuit of meritocracy. Perhaps it is a half-conscious sense that it is likely to be incompatible with liberty and democracy: for meritocracy does indeed require egalitarian inputs, but its eventual outcome is just another form of domination by an elite, albeit chosen by ability rather than inheritance. Whatever its cause, the profound ambiguities of Britain's educational policy indicate a national dilemma. We seem to be caught between a duty to be economically competitive and an aspiration to a humanly satisfying quality of life. While the requirements of the former are clear but somewhat unattractive, the justification for the latter is more vague and still somewhat entangled with traditional aristocratic discourses. Can our universities turn themselves from symptoms of this dilemma to leaders towards the way out? And if so, in which direction will they lead?

Alastair J Reid is a Fellow and Lecturer in History at Girton. His books include United We Stand. A History of Britain's Trade Unions *(2004, Penguin 2005) and* A Short History of the Labour Party *(jointly with Henry Pelling; 12th edn, 2005). He is an editor of the History and Policy website at www.historyandpolicy.org.*

Changing assumptions and expectations in Cambridge admissions

Julia Riley

The last thirty years have seen great changes in undergraduate admissions to Cambridge. We have progressed from an almost completely college-based admissions system to one that has much greater cross-college cooperation and University and departmental involvement. Access to students from non-traditional backgrounds – an area on which changes in student funding have had a big impact – has become an increasingly important issue. Over the same period, we have progressed to the point where half the undergraduates admitted to Cambridge are women.

In 1970, two years before Churchill, Clare and King's admitted their first female students, only 14% of the 8,497 undergraduates in Cambridge were women. The success rate (the ratio of the number of students admitted to the number who applied) was 50% for men compared with 18% for women. By 2003, the overall undergraduate numbers had increased to 11,751, of whom 49% were women. The application and success rate for men and women is now roughly equal – but the chance of success has gone down to 25%, as the overall numbers of applicants have increased from around 6,000 in 1974 to around 14,000 in 2003. Although the overall numbers are equal, there is a large variation from subject to subject, with women outnumbering men by at least a factor of two in Archaeology and Anthropology, English, Modern Languages and Veterinary Medicine, and men greatly outnumbering women in Engineering, Maths and Computer Sciences. To a large extent these figures reflect imbalances in the university population nationwide.

Access to students from non-selective state schools has been an issue for many years. In the early 1970s, when there were large numbers of grammar schools, the proportion of students from maintained schools at Cambridge was higher than the proportion from independent schools. However, by 1982, after the phasing out of direct grant status, the proportion admitted from independent schools (53%) exceeded that from state schools (47%); and more significant still was the fact that the success rate for the independent schools was much higher (47% compared with 26%). At that stage, the majority of Cambridge applicants took an entrance examination in November, with a large number of them staying on at school for a seventh term in the sixth form to prepare for the exam. However, with the increasing awareness that the entrance examination favoured students from independent and selective state schools, the decision was taken to abolish the Cambridge entrance exam from 1986 and to make offers conditional on A-level performance. Huge efforts were made to encourage applications from the state sector and to ensure that the students with the best talent and potential were offered places. Changes are still happening, albeit rather slowly: in 2003, for example, 55% of the home students admitted to the University came from state

MUSIC AT GIRTON

Having started work at Girton in 1990, as the inaugural Austin and Hope Pilkington Fellow in Music, I was not witness to the transformation caused by the arrival of men. However, the change from a single-sex to a mixed college shaped my work from the outset.

One of my first tasks as Director of Music was to review Girton's library of performing scores. The collection within the College Library itself was, of course, maintained in perfect condition, but lurking in the music practice room I found a motley assortment of arrangements for female voices – everything from Elizabethan motets to Beatles songs. Most had lain neglected for years and were in the form of tattered photocopies. Having spent three years as Organ Scholar of Christ's College at the end of the 1970s, I already knew a great deal about the musical crimes that could be forced on those responsible for single-sex choirs. In Christ's we rapidly tired of the men-only repertoire and yearned to perform 'real' pieces. Our solution was to encourage countertenors into stratospheric realms too ghastly to contemplate, and to assign soprano parts to unfortunate tenors, thereby risking all sorts of musical solecisms. At Girton the solution to my mound of photocopies was, in most cases, the dustbin.

Of course, the College had had more than a decade to get used to its new status as a mixed establishment. The process of change seemed, to an incomer at least, to have been remarkably smooth. As a new Fellow I listened with curiosity to murmured comments at High Table about the divisions caused by the upheaval, and inevitably I tried to pin labels on the older Fellows. Who had been for the change? Who had resisted it? It is a tribute to the 1979 generation that few answers were forthcoming. Past divisions were rapidly forgotten, as the College looked to the future.

Girton's traditions were not entirely forgotten, however. One of the most vivid memories of my first days at Girton was my initial encounter with Lady Jeffreys. 'Who are you?' she barked in that intimidating tone of voice that – I later learnt – could be construed as endearing. Hesitantly, I advanced the possibility that I might be the new Fellow in Music. 'Oh that,' she replied, leading me to believe that such a person was hardly needed, and certainly not welcome. 'In my day, of course,' she added, 'the Professor of Music was Stanford.' I was not to know at that stage that Lady Jeffreys had once been Director of Studies in Music herself. But even a poorly educated neophyte such as myself knew that Stanford had died in 1924. And so Bertha's comment, delivered in that uncompromising tone that – I was fairly sure – could be construed as a put-down, gave me my first inkling of the traditions that lay behind Girton music.

The opportunity to start afresh at Girton was one that I relished, and the mixed choir that has grown up since 1990 has given scope for much more ambitious performances than would ever have been possible during the single-sex era (either at Christ's or Girton). It is against this backdrop that I recall, with a small sense of pride, a comment made by Professor Bradbrook at one of my first May Week concerts: 'I'm so glad we now have a Director of Music. I couldn't stand those Mickey Mouse concerts we used to have.' Clearly, not even a mouse cares to sing falsetto all the time.

Martin Ennis, Director of Music

The Chapel Choir

The Chapel Choir has traditionally been the focus of musical life at Girton. While the College has had its share of talented instrumentalists who have gone on to achieve distinction as soloists, chamber musicians, orchestral musicians and teachers, our location on the outskirts of town, without ready access to the pool of student players that feeds most Cambridge ensembles, has made it

Samuel Hudson, Music student, 2000

at King's College), Dr Christopher Robinson (recently retired Director of Music at St John's) and Judith Clurman, Director of Choral Studies at New York's Juilliard School of Music. So impressed was Ms Clurman by Girton choir's responsiveness and warmth of sound that she invited the choir to perform with the Juilliard Chorus in New York. The progress of the choir has also been marked in a series of recordings, each of which explores different types of repertoire. Some have involved collaboration with professional musicians, while others have used the cream of Girton's own performers. Thus the recording of Christmas music from England and Germany, released in 2005, features members of the Gabrieli Consort.

As the standard has risen, the choir has been able to undertake increasingly ambitious tours. The list of countries visited is now a long one, encompassing France, Germany, Switzerland (four times), Italy, Ireland (twice), the Czech Republic, Mexico, Japan (twice), Hong Kong, Thailand, Malaysia and even Borneo. Sadly, what would have been the first ever visit by a Western choir to Laos fell victim to what, we were told, was the worst monsoon in twenty years. Each individual choir member will no doubt retain his or her own memories of these tours, but no one who had the opportunity to sing for and meet Pope John Paul II in the Vatican will forget the occasion. Another significant occasion was the Takarazuka International Chamber Chorus Competition held in Japan in 1999. The choir won three prizes – the gold medal in the Mixed Chorus division, the silver medal in the competition overall and a special prize awarded by the Director of the Vienna Boys' Choir to the ensemble deemed to produce the best sound. Such international recognition gave a notable fillip to the choir's self-esteem.

difficult to sustain a regularly rehearsing orchestra. The soaring profile of the choir over the last decade, however, has made Girton an important contributor to musical life in Cambridge.

Now reckoned as a major player in the already richly populated field of university choral music, Girton Chapel Choir has, under Dr Martin Ennis, collaborated fruitfully with other city centre choirs, and has been privileged, in recent years, to work with distinguished visiting directors, including Sir David Willcocks (long-time Director of Music

Aside from purely choral activities the College has organised a number of high-profile concerts in London and elsewhere, several under the aegis of the London Girton

Association and many involving the help of Old Girtonians. The London Girton Association has fostered our music not only through its help in staging concerts, but also through the provision of a scholarship presented to the most deserving student performer in an annual competition. Of the various events outside Cambridge, perhaps the most memorable was the concert given jointly by the college choir and the London Mozart Players in St John's, Smith Square, in 2001. Mozart's Requiem was preceded by the same composer's Piano Concerto in C major, K415; the soloist in the latter was one of Girton's most talented recent music graduates. Other London and Cambridge concerts have involved Ensemble Chaconne, a group of Baroque specialists founded and run by another highly gifted former Girton music student.

Vital for all this music-making is the adequate provision of resources. In the early 1990s the College's musical infrastructure left much to be desired. The pianos in public rooms were of indifferent quality, the Chapel organ regularly broke down and the College had no harpsichord of its own. Now, however, through a series of initiatives, Girton has been able to raise the level of its provision substantially. Most urgent was the need for a new concert grand piano. This arrived unexpectedly, as the result of a generous gift from the Pilkington family. Concerts in the Stanley Library can now take advantage of a first-rate Steinway Model B grand piano. More recently, thanks to the generosity of an Old Girtonian, Elizabeth Werry (1955), we have been able to renovate another Steinway, now housed in the Fellows' Rooms and used for smaller-scale concerts.

A harpsichord arrived even earlier than the Stanley Library piano. Indeed, even before starting work the Director of Music was given the job of commissioning a harpsichord for the College. 'Here's a cheque for £10,000. See what you can get us,' Baroness Warnock told him during their first conversation after his appointment. The Milan Misina instrument that duly arrived about a year later has stood the College in good stead. It can be heard on a number of the choir's recordings and on several recordings with professional orchestras as well.

Finding the funds for a new organ was a much more difficult, but no less pressing task. By the late 1990s the College choir had outgrown its accompaniment. Making music against the wheezing of a geriatric was no pleasure for Girton's choristers, and it was proving increasingly difficult to attract organ scholars. Salvation came in the form of a legacy from Lady Jeffreys which enabled a small committee consisting of the Director of Music, the then College organist, Stephen Rose, and Peter Sparks to set to work. The story of the commissioning and installation of the organ has been chronicled over several issues of the Girton Annual Review. Suffice it to say here that the new instrument, built by St-Martin of Switzerland, is highly distinctive in its design and voicing. It has created waves in the musical press, both nationally and internationally, and it seems to attract a constant stream of visitors.

What of the future? Girton continues to attract very fine musicians. Indeed, this piece was written only one day after the graduation ceremonies for one student who completed her studies with what appears to have been the highest-ever first in Music. She is the most recent in a chain of music students who have brought distinction to the College in both academic and practical spheres. Girton, we can now say with confidence, is firmly on the musical map.

schools, though the success rate for independent schools was still higher (32% compared with 25%).

In the mid-1990s a review was carried out of the numbers of applications from students from backgrounds with no experience of higher education, and also from other groups that are traditionally under-represented at Cambridge (ethnic minorities, mature students and students with disabilities). As a result of the report, the Access Committee of the Admissions Forum was formed, and in 1997 the first Access and Schools Liaison Officer was appointed by the Cambridge Admissions Office (CAO). There are now eight staff working on access at CAO and some colleges also have their own access officers. In the early 1970s, Girton was the only college to run open days and the only regular University-wide event was a triennial teachers' conference. Now each college runs several open days a year and CAO organises a number of general open days and several large Oxbridge conferences around the country. CAO and many of the colleges run summer schools and open days aimed at widening participation, and visit schools and colleges in specially targeted Local Education Authorities.

The collegiate system is one of Cambridge's great strengths, but can be seen as a barrier to access: to some, choosing a college seems like a black art, both because of the differences in college admissions requirements and because of the large variations in numbers of applicants per place. It is essential that Cambridge can be seen to be selecting the best candidates regardless of initial choice of college, and that our admissions processes are clear and transparently fair, effective and robust. Much greater uniformity in admissions requirements has been achieved, and there has been an increasing emphasis on moderation across the colleges to ensure that the best candidates are indeed getting places at Cambridge. Departments, through the Directors of Studies, are now becoming involved in ensuring that this moderation takes place.

Over the past ten years, as student funding has become linked to our record on access, undergraduate admissions, once almost entirely a college matter, have become an increasingly important issue within the University, and there have been major changes in the way admissions have been coordinated across Cambridge. The departments themselves are now making an important contribution to access initiatives, with many having their own outreach and Schools Liaison Officers. With new accounting procedures being introduced throughout the University, the departments will, in future, also want to have more influence on student numbers.

Efforts to increase the proportion of students from under-represented groups have certainly been influenced by recent changes in student funding. Following the phasing out of grants, and their replacement by loans about ten years ago, and then the introduction about five years ago of the up-front contribution to tuition fees of around £1,000, there is now the prospect of top-up fees in 2006. Students from the non-traditional backgrounds, many of whom have no experience of higher education within their families and whose parents can often not afford to support them, are increasingly questioning whether the benefits of a degree outweigh the substantial debts incurred. There are very generous bursary schemes available to less well-off students once the step to apply has been taken, but for many the difficulty lies in taking the step in the first place.

It will be interesting to watch how things develop in Cambridge admissions following, and even prior to, the introduction of top-up fees. Will quotas on numbers from different school and social backgrounds be forced upon us? Is the college admission system going to be threatened? How will the prospect of having to pay large fees alter the numbers applying from different social backgrounds? Whatever happens, we hope that we will continue to attract and select the very best students, and that we will continue to be able to provide them with a university education of the highest possible quality.

Julia Riley is an astrophysicist working in the Cavendish Laboratory. She has been a Fellow of Girton since being appointed to a lectureship in Physics in 1975 and is currently also Director of Studies in Physical Sciences. She was the Girton Admissions Tutor from 1994 to 2004.

Opportunities across the generations

Marilyn Strathern and Pat Thane

What are the backgrounds of today's Girton students? Are they the offspring of people with a university education themselves, with careers in secondary-school teaching perhaps, in office administration or business and accounting, or in academia itself? Or are they the offspring of people who left school with few qualifications, perhaps gaining training later in life and finding work as (say) a tool setter or builder, post office worker, clerk or van driver? Of course, students come from both kinds of backgrounds. But this is not just because Girton draws widely from the population, as it does. In these particular cases, these are the same students. The difference is one of generation, between their parents and grandparents.

No one writing about the last thirty years in the UK could ignore the question of access and the part a person's background has in this. Now, this is a far cry from the connotations that 'background' used to carry; Girton was founded in an era when it mattered what your family did to an extent inconceivable in the twenty-first century. Social divisions in health, life expectancy, income and so forth remain significant, but 'family background' as such does not attach to people these days as it once did. For all that, however, background is seen to matter hugely in one respect – when the kind of education they have had influences people's wish go to university. Ever since the mid-twentieth-century education reforms, broadening people's opportunities in university education has been high on the national agenda. But if many traditional distinctions have shrunk, here the population is still divided by opportunity and what that means in terms of prospects. For regardless of whether or not people see higher education as leading to particular careers, it undoubtedly has the kind of transformative effect that is at the root of social mobility. And here the educational experience of family members may play a role.

Current Government plans for higher education (as debated over 2003–5) put considerable emphasis on aspirations and how to build them up. Students who come from families with no tradition of university education are truly pioneers. Once the first generation has taken the leap – and one can talk of this as an opportunity without suggesting that higher education is everyone's goal – the idea is that they will have the resources to take care of themselves. So it is widening primary access that is seen as crucial, even at the cost of creating discontinuities in people's values. One of today's students observed, 'My mother was the first in our family to go to university and she had to fight for the privilege. Although she was eligible for a grant, her parents refused to sign it and let her go – they couldn't see the point or value in it. So she worked full time for a couple of years until she no longer needed permission.'

Indeed, focusing only on the proportion of first-timers can be misleading; it can lead to the conclusion that social mobility is not working. A longer, cross-generational view tells us something about people who have made that leap in the past. Many who are not themselves first-timers are the children or grandchildren of those who were. And here there may be hidden continuities too. As one student wrote, in response to a question about who inspired the desire to go to university, 'My parents and grandparents; particularly my paternal grandmother, who wishes she could have gone.' Another wrote of parents being supportive of a system they had not experienced themselves. Yet when the desire to go to university is unrealisable for oneself but realised in one's children, then one's grandchildren, although they no longer come from first-generation families, are the outcome of earlier aspirations. If we call this 'secondary access' we are looking at how aspirations are passed on to the next generation. That is not to say that they will appear as such; the next generation may seem to take it for granted. Many of today's Girtonians would echo the comments of the person who said, 'I had just been brought up to assume that I would go to university.' And they would make the same assumption of their brothers and sisters. In other words, the aspirations have become firmly embedded – and may indeed start being so in experience at school: 'I assumed it would be the next step in life after school.'

We were intrigued by the phenomenon on which Alastair Reid comments, at least as it is relevant to

students educated in the UK, that, over the generations, those from lower-class families who have benefited from higher education will have children who appear as coming from higher-class backgrounds. That the children want to repeat their parents' choice should be a sign of the success of social mobility. Instead, 'mobility' becomes invisible. So we wanted to find out more about the 'backgrounds' of our students. What happens to first-generation access over the longer view? The picture that emerges helps us see how social mobility works.

Girton has a sizeable number of students who are the first to go to university in their families. However,

twice as many have parents who (one or both) went to university, and the proportion is much greater if one includes parents who went to vocational training colleges, polytechnics (as they were) or equivalent institutions of higher and further education. Clearly this does not correspond to the proportions in the population at large, the source of Government efforts on primary access. But present-day Girtonians give us some measure of secondary access as it has unfolded across the generations. When we consider their parents, from roughly thirty years ago, we find that most of them were first-time university students, and in only a small number of cases had parents who went to university or came from a background where university or comparable higher education experience was already familiar. Among the grandparents, of course, the proportion of grandmothers with university experience was much smaller than that of grandfathers. Go back another generation and the proportion of university-educated great-grandparents is tiny. For some, the issue was whether or not they were allowed to continue to secondary school.

Of course, nothing stays still, and a cross-generational study of this kind becomes difficult as soon as one realises that it is not just schools that have changed their classification over the years but the constellation of further and higher education outlets, and not just these but perceptions of class and what it means today to talk in those terms. We are not necessarily comparing like with like, and it would take a survey specifically measured against changing opportunities of the time to offer usable statistics. In the meanwhile, evidence we have collected from current Girton students has provided the information on which we have been able to base these indicative remarks.[2]

It is clear that the biggest leap in educational and social mobility occurred between the grandparental and parental generations, that is at the time when higher education became free and grant-assisted. Very few grandparents of today's Girtonians had degrees, and although many left school with, or went on to gain, some kind of qualification, among the grandparents were quite a number who left school at the minimum age with no qualifications at all.

Strikingly large numbers of great-grandparents were domestic servants, miners or factory workers.

A small stream of students come from families long established in university, including Cambridge, life. They are important to the college mix. And Girton's association with some of the major public schools goes back to the foundation of the College. The interesting point here is that this was the time when – radically and absolutely essentially for Emily Davies's success – those schools were pioneers in providing sustained education for middle-class girls when it simply did not otherwise exist. But even then, as today, where Girtonians have come from the middle class – and chapter 8 emphasises the lower-middle, as well as working-class, aspirations that were touched – it has been with parents in the middle to lower ranges of business and professional occupations. The difference today is that lack of privilege is frequently associated with type of schooling, which is why that has become an index of access.

One of the good things about being at college, MS is frequently told, is that, whatever they thought before they arrived, within a couple of weeks or so people's preoccupations with, or suppositions about, background fade. They stop thinking about where they have come from. There is simply too much that is going on; too much that lies ahead.

Marilyn Strathern (Evans, 1960) is William Wyse Professor of Social Anthropology at the University of Cambridge and Mistress of Girton College. While she is increasingly preoccupied with administration (the edited book Audit Cultures *(2000), subtitled 'Anthropological studies in accountability, ethics and the academy', touches on the institutionalisation of good practice), her research remains a lifeline. Starting in 1964, she has carried out fieldwork over several years in the Highlands of Papua New Guinea (Melanesia), the most recent field visit being in 1995. She is a Fellow of the British Academy and in 2001 was created DBE for services to social anthropology.*

Pat Thane has been Professor of Contemporary British History, Institute of Historical Research, University of London since October 2002. She was Professor of Contemporary History at the University of Sussex from 1994 to 2002. Her main publications are: The Foundations of the Welfare State *(1982; 2nd edn 1996);* Women and Gender Policies. Women and the Rise of the European Welfare States, 1880s–1950s *(with Gisela Bock; 1990);* Old Age from Antiquity to Post-Modernity *(with Paul Johnson; 1998);* Old Age in England. Past Experiences, Present Issues *(2000);* Women and Ageing in Britain since 1500 *(with Lynne Botelho; 2001);* Labour's First Century. The Labour Party 1900–2000 *(with Duncan Tanner and Nick Tiratsoo; 2000).*

1 The recent statistics come from the UCAS website at www.ucas.ac.uk; the more historical ones are drawn from R D Anderson, *Universities and Elites in Britain since 1800,* Cambridge University Press, 1995, which uses mainly data collected by the predecessor bodies of UCAS.

2 Analysed by PT. Two questionnaires were sent out, first to those who were in their third year in 2002–3, and then to all students in College in 2003–4. Thanks to Ruth Blacklock for suggesting the idea in the first place.

WOLFSON COURT – THE GRADUATES

In 1992 HM Queen Elizabeth the Queen Mother opened Queen Elizabeth Court, an extension at the back of Wolfson Court comprising thirty-two graduate rooms, two Fellows' flats, the Poppy Jolowicz Law Library, the Fletcher Moulton Reading Room and a computer gallery. Resisting a Girton tradition, architect Barry Brown designed his graduate houses on the staircase rather than the corridor system, creating houses rather than wings. This style of architecture lends itself to the creation of small and intimate communities and is much valued by international graduates who, arriving in Cambridge in September from all over the world and often only for a year, need a place where friendships can be made quickly.

Before1992 only ten graduates were housed at Wolfson Court and the rest of us (I came to Girton as a graduate in 1985, when there were just over 100 of us) lived in houses the College owned and rented across the city. Since 1992, the graduate community has gradually dug itself in at Wolfson Court and expanded its numbers. There are now more than 200, some forty of whom will be housed at Wolfson Court, with the College's houses mostly used to accommodate graduates who have already had at least a year of 'college experience'. Life for graduate students has changed in other ways too. In the 1980s it was understood that if you wanted your post you cycled two miles up to Girton for it; the Combination Room was out of bounds outside full term, because it was used for conferences; and our entire IT provision consisted of one Apple Mac housed ingeniously in a cleaner's cupboard on a boarded-over sink. Pressure from the increase in numbers and a determined MCR president finally led to the establishment of graduate pigeonholes at Wolfson Court and the conversion of the old reading room to an MCR for year-round use. All graduate rooms, including those off-site, now have networked internet points. And a new kind of meal, a sort of informal Formal Hall, has been established by the graduates, who dine together three times a term at Wolfson Court. The average attendance is usually more than eighty, and it is heartening to see the graduates taking hold of an old Girton tradition and re-fashioning it to create a new one.

It is to my predecessor, Lorna Troake, Warden for seventeen years until her retirement in 1993, that Wolfson Court owes its original attraction as a base and home for graduates. Lorna was 'our' College Officer, who looked after our interests and moved all of us around Cambridge with extraordinary generosity. The fact that it would now be impossible to contemplate moving a graduate student without the assistance of an articulated lorry tells us

something else about the increasing complexity of student life. In those days, in vacations, Mrs Troake, accompanied by what we rudely referred to as her travelling circus (mostly staff who, in those blissful days before conferences, needed redeployment over summer, along with the odd impecunious graduate student such as myself) would arrive at whichever house needed 'doing up' and proceed to paint, repair, sew, clean and tidy it before moving on to the next. Summer refurbishments nowadays are somewhat more professional, hedged round by health and safety considerations, planned long term, very much more expensive and not nearly so much fun. On her retirement, Lorna handed over Wolfson Court with the following words of advice: 'Never say no when you could say yes.' It is a valuable lesson for anyone trying to balance the needs of people, especially students, with the requirement to maintain safe and sound buildings, and as a statement encapsulates Lorna's positive, generous and accommodating Wardenship.

As the graduate community has expanded, so has its diversity. One-year MPhil courses were almost unknown when I was a graduate, but now that funding constraints make the PhD a major investment, and the research councils that provide PhD studentships increasingly demand a preliminary Masters year, the one-year course is developing in popularity. We now also have part time graduate students, notably those taking the Judge Institute's Master of Studies in Community Enterprise programme. An increasingly complex community requires careful stewardship to ensure that all needs are met, and so in 1999 the Graduate Office was established at Wolfson Court and Jennie Jenks was created Graduate Secretary, a new post providing a focal point and an outstanding welcoming service for graduates. This drawing together of the community has given it new confidence to become a distinct voice in College affairs.

Maureen Hackett, Warden of Wolfson Court

Today's graduates

In the 1983 Girton *Annual Review*, Margaret Worsey, the MCR Secretary, wrote: 'The MCR consists of a diverse group of graduates of different academic and social interests and a variety of cultures, which contribute to the stimulating and congenial atmosphere of our events.' Twenty years later I cannot find a better way to describe the current graduate community at Girton.

With very few graduates living near College, the overriding goal of the MCR Committee has always been to bring together the many graduate and research students scattered across the city. In contrast to the efforts our predecessors had to make to keep the whole community informed, in 2004 all we have to do is send one e-mail and all the graduates know about any forthcoming MCR activities. Yet, even when the graduate community was small in number, the MCR Committee faced significant challenges in arranging events that would be of interest to everyone. After a programme of joint ventures with other colleges was initiated in the 1980s, exchange Formal Halls are now a regular event, evenings that are always successful and confirm Girton's reputation for being a college synonymous with a friendly welcome and excellent food. Other events reflect the diverse backgrounds of the Girton graduates themselves. From an international buffet in 1979, via a special Chinese evening in 1983, to the MCR's first International Quiz Night in 2004, the MCR has consistently celebrated the global composition of its membership.

A constant issue throughout the past thirty years has been balancing the growth of the MCR with sufficient suitable accommodation. The arrival of male graduate students resulted in College purchasing, in 1979, a fourth hostel for graduates, and the building of thirty-two graduate rooms at Wolfson Court in 1992 was a major step forward. The MCR policy of reserving the rooms for new graduates ensures that students new to Cambridge have a modern, safe environment in which to settle in during their first few weeks.

A strength of the MCR, but also a challenge, is the fact that many graduate students are here for one year only. This means that the MPhil students seek to make the most of their relatively short stay at Girton and contribute an energy and passion to Girton's graduate life that is invaluable. But sometimes, come Michaelmas Term, the remaining Committee members find themselves doing the jobs of many people when welcoming the new graduates to Girton. When I arrived in September 2001, the Committee of only four members worked wonders in making the sixty-odd new arrivals feel settled almost straight away – testimony to the continuing vitality of the MCR and its commitment to all its members, both PhD and MPhil students.

James Owen, MCR President 2004

PART THREE: BEYOND

Chapter 7
Collegiate Cambridge

Three administrators, all Girtonians, reflect on some of the changes, administrative and otherwise, that have helped to create today's Cambridge. In putting their finger on the collegiate character of the University, they take nothing for granted about the future.

The Senior Tutor's perspective
Andrew Jefferies

In writing about Girton from a Senior Tutor's perspective, I am only too well aware that what I am offering is a view from a particular point in time, informed by my own experiences over the last seven years. Moreover, to understand this perspective it is perhaps important to know where this Senior Tutor fits into the Girton story. Across the colleges, Senior Tutors come in many different guises: some are full-time college employees, often also holding a college teaching appointment or the role of Admissions Tutor, while others are University teaching officers with a faculty job; it is to this latter group that I belong. This dual role introduces a degree of schizophrenia into the job, but it does provide a vital understanding of the fundamental challenge that is also an asset, namely the collegiate nature of the University of Cambridge. While many things have changed in Cambridge and at Girton in the last thirty years, it is perhaps the nature of this split personality – College and University – that has changed most markedly in my time as Senior Tutor, and that I believe will continue to change in the years ahead.

The University

Although all Cambridge colleges are independent organisations with their own particular character and ethos, they are inextricably linked to the University and to one another. In the past, this linkage was a rather elastic affair, with colleges showing their independence in a variety of ways, from variability of student room rents to differences in the approach to selecting students for admission. In the last thirty years, however, the political and educational landscape has changed. The vision of equality of opportunity for all, together with the Government's desire for accountability by all, have triggered a process whereby the colleges have come together in the face of this challenge (or threat, perhaps). The official administrative points of contact for the colleges are the various committees made up of Heads of Houses, Senior Tutors and Bursars. The overall response among them has been to seek increased cooperation between the colleges, to produce and promulgate common views and purposes and to develop a consistency of approach to all the challenges, many of which are coming from outside the University.

My first attendance as a new Senior Tutor at the Senior Tutors' Committee in the Council Room in the Old Schools was a slightly intimidating experience. But, over my seven years' membership of the Senior Tutors' Committee, I have seen a real development in the understanding of differences in approach and the establishment of common standards in areas such as teaching, admissions and welfare. Although there was not necessarily anything wrong with the previous variability – and in certain ways the ability to be different is a great Cambridge tradition – there is greater strength in acting together. This new-found intercollegiate cooperation is perhaps illustrated by the development of the electronic on-line reporting system for college supervisions, CAMCORS, which was conceived, developed, paid for and put into practice across all the colleges in about two years, a truly momentous achievement in a University where the pace of change is usually measured in decades. This intercollegiate sense of cooperation and common purpose is also now spreading to encompass the University administration, with the development of a common electronic database for colleges and University, CAMSIS.

For both colleges and University, the other major unifying factor to have come to a head over the last seven years is the spectre of financial insolvency. This is an unwelcome visitor: one that Girton has long been familiar with, but has perhaps fully come to terms with only in the last few years; it is no accident that the College accounting system – adopted for us at Girton by our own truly excellent Bursar – is now the model for most other colleges. The University's severe financial plight and the development of the resource allocation model (RAM) for University departments have introduced a devolved accountability that may change for ever the relationships between the University and the colleges. It is increasingly clear that, if the collegiate nature of the University is to survive, both University and colleges will have to continue to develop closer understanding and cooperation. My own belief is that, in the face of the common challenge of continuing to provide top-quality education while contending with diminishing resources, the pursuit of

a unified approach will accelerate to produce real benefits to both sides. Particularly important in this process will be better recognition of the essential role of College Teaching Officers (CTOs)[1] in the high-quality education Cambridge offers. Girton especially has a lot to gain from this recognition; only Trinity has more CTOs, and a better deal, in terms of employment, career prospects and promotion, for those supplying this vital resource is a theme dear to Girton's heart. The value of the CTOs in departmental Research Assessment Exercises, and the symbiotic relationship between colleges and University that they foster, have always nourished Cambridge excellence and should grow stronger.

The College

If my view of the wider University is optimistic, mainly because its fundamental strength, the collegiate system, is widely appreciated and supported, what is my perspective, as Senior Tutor in 2005, of Girton now, as opposed to Girton in the 1970s? Most obviously, Girton is now a mixed college with a striking parity between male and female in both the Fellowship and the student body. It is perhaps too easy to ascribe the friendly, relaxed and supportive atmosphere of College, and its total lack of pomposity, to this parity, but it is difficult not to believe it to be a significant factor. My personal belief is that the Girton ethos is something handed on from one member to another, and is particularly enshrined and valued by long-serving members of College, both academic and non-academic.

What makes Girton special is its concern for the individual. We give weight to the ability to 'add value' to our students and strive to ensure that they all achieve as far as they are able – a criterion recognised by the 'value added' (individual improvement over the years) increment evident in Tripos results. On these criteria, Girton turns out to be one of the best of the Cambridge colleges, an accolade that carries a special kind of satisfaction. And while it is self-evident that Girton has a long tradition of exceptional scholarship from its Fellows, regularly recognised by the receipt of honours of all kinds, not so apparent is the enormous amount of work that is put in by the Fellows in pursuit

of this 'added value' for individual students. The achievement of a lower second by a student who has struggled for three years with depression or anorexia is as impressive as the first gained by a highly gifted student, yet will probably be recognised only by that student and her or his family. These achievements are commonplace at Girton, and it is probably the Senior Tutor who is most aware of the many individual battles that have been fought and won.

This is an aspect of a profound change within higher education in the last thirty years: the increasing stress experienced by students entering higher education and the effects of this both on them and on College staff. Undergraduates coming to Girton are now usually eighteen, and are therefore 'adults'. This has inevitably changed the way we deal with them, and has also changed the relationship between College and the students' parents. No longer can students' problems be referred back to their parents, if indeed they ever could. College now has to support and deal with students as independent adults, perhaps even protecting them from parental interference, while at the same time acting responsibly toward parents who have a close interest in their children's progress and behaviour. In addition, parents often feel strongly that they have a justifiable interest in what is happening in College because they have paid their children's fees. There is a curious dichotomy here: Government makes the young independent of parents when they reach adulthood at eighteen, but then makes them dependent again in financial terms by their means-tested funding system for higher education. Is it any wonder that both parent and student are confused by this contradiction?

Student stress was no doubt present in the 1970s, but it seems that the recognition of pastoral needs, mostly manifested as concerns about money and mental health problems, is commoner now than it was then. In any yearly intake we can now expect a handful of students with eating disorders, several suffering from depression, and one or two more with severe mental health problems, not to mention an increasing number of dyslexic students. These problems have to be positively addressed by any caring institution, and in Cambridge the main brunt is borne by the colleges' tutorial system, which is probably the single most important reason why the drop-out rate from Cambridge is so small. This tutorial support system is a pastoral one, not directly involved in academic teaching. By standing outside the teaching system a tutor is able to look objectively at a student's learning experience, and even to evaluate whether the teaching experience itself may on occasions be the root cause of a student's problem or ill health. This system is expensive both financially and in terms of the time and emotional involvement demanded of tutorial staff, and it is not visible in any league table or accounts sheet, but it is exquisitely effective.[2]

Change and development are also apparent within the student body, with undergraduates and graduates increasingly involved in the administration and decision-making processes of colleges and University. For the first time this year a student representative of the student union, CUSU, sat on the Senior Tutors' Committee. It is hard to believe now that, when the decision was made in the 1970s for Girton to admit men, 'the undergraduates were not consulted, as they would not have approved.' On matters of this magnitude we would now, as a matter of course, consult the student body. Students sit on College Council and provide input to a number of other College committees, and their positive and constructive approach has become another feature of Girton over the last few years. Our students really do know what the College administration is doing and this, together with the openness on financial matters that the Bursar has instituted, has led to a feeling of partnership between the Fellowship and the student body in addressing the many challenges we now face.

The challenges

From the perspective of the Senior Tutor, it is difficult not to put finances at the top of the list of challenges. The now well-established budgeting system at Girton, whereby heads of departments (maintenance, catering, etc) devise and manage their own budgets under the overall control of the Bursar and the budget sub-committee, has dramatically improved the financial

health of the College. But it is clear that the financial priority of providing teaching to undergraduates, which up to now has suffered little, will have to change. We have had to start questioning what we do and why and whether we should or could do things differently in terms of teaching. Debates on this issue so far have concluded that there are, as always in a good academic institution, more questions than answers.

The other financial challenge – less direct but no less important – lies in undergraduate funding and the effect of top-up fees and the Government's changes to higher education funding. This will transfer the financial stress of higher education, albeit a deferred one, completely on to the student, rather than the student and parent. Although this may produce greater consistency in our attitude towards eighteen-year-olds as independent adults, it will not remove the advantage of having a wealthy home background or move forward the Government's aim of widening access to higher education.

Contrary to popular political belief, Cambridge colleges, and Girton in particular, have for many years been striving to widen access for students from deprived backgrounds, both financial and educational. Girton students have been much involved in visiting schools to promote wider access, hosting visits of ethnic minority groups and working within the local community to dispel the myth of Cambridge exclusivity. The establishment at Girton of bursaries for students from backgrounds with no history of involvement in higher education is an example of this outreach. In 2005, the appointment of a Schools Liaison Officer to raise the profile of Cambridge and stimulate the aspirations of students in state schools is yet another innovation in the quest for wider access. We should not be complacent, but things are being done.

After finances, certain pernicious effects of accountability are probably the second biggest challenge faced by the College. On the one hand there is the accountability to the Higher Education Funding Council (HEFCE) through the Research Assessment Exercise (RAE) whereby, on a four- or five-yearly basis, the research of all UK universities is peer-reviewed and graded. Research is, of course,

produced only by people, and the pressure on individuals to produce top-quality research – all the time – is immense. In this environment, giving priority to teaching students is a position difficult to maintain. The impact this has on the colleges is considerable, to the extent that some department heads actively discourage their staff from taking college appointments.

The other face of accountability to HEFCE is the quality-assessment exercise directed at teaching quality within universities. This, in my view, is of enormous value in raising awareness of good practice and in many places stimulating a fresh look at teaching from the perspective of the student rather than the teacher. The high scores for teaching quality at Cambridge enable us to have some confidence in what we are doing and offer some defence against the increasingly vociferous voice of accountability from our 'clients', the students themselves – although we can be brought down to earth with some force in the face of student complaints about their exam results, the quality of their teaching, facilities within college and the standard of our response to their demands. Complaints of all sorts are becoming more common, and the ability to deal with them has to be based on sound and robust procedural structures. Girton continues to define what it does in terms of best and fairest practice, but this is always open to challenge. Members of the College are willing to recognise this problem and to make the effort to address it positively, as can be illustrated by another first for Girton among the Cambridge colleges – the publication of a Freedom of Information Scheme before it became compulsory for all institutions.

The role of the Tutor is often defined as being a personal advisor to the student and also the intermediary and mediator between student and College or University authority. In this context, the Senior Tutor is perhaps the representative of the College and the intermediary with the University on all matters to do with students – academic and pastoral – and thus has an important role in the development of the increased cooperation now being established between colleges and University. I would like to think that there might also be an element of

proactive strategic thinking and development in the role of the Senior Tutor, but I am well aware that the job is more often reactive and involves a wide range of different roles.

Being Senior Tutor is a rollercoaster ride with no clue as to what trough lies beyond the current peak. The only certainty is that something awkward involving a student will probably land on my desk at some point. I entered higher education as a teacher because I like teaching and I like dealing with students – preferences that would seem to be important for a Senior Tutor too. The other important asset is to like sorting out problems and making things happen and happen better. That, in my view, is what administration – and perhaps being Senior Tutor – should be about: to try to make the whole College educational experience better for all students. That is a job that is worth doing and is at the heart of the Girton ethos passed on to me by my predecessors. While this continues to be the case I remain optimistic for Girton's next thirty years.

Andrew Jefferies completed his veterinary degree at Downing College in 1970, and then spent seven years in general veterinary practice. After two years in the government veterinary laboratory service he returned to the Department of Veterinary Medicine, University of Cambridge, as University Pathologist. He is now Director of Teaching in that Department. He was appointed a Fellow of Girton in 1991 and Senior Tutor in 1996.

An overview from the Pro-Vice-Chancellor for Education

Melveena McKendrick

My perspective on collegiate Cambridge is a complex one, informed by long years of very varied experience: as a Fellow, Tutor, Senior Tutor and Director of Studies at Girton; as a University Lecturer, Reader, Professor and recently Chair of a large faculty; as a member of the University's General Board in the 1990s and Chair of its Education Committee; and, more recently, as the wife of the Master of Gonville and Caius, which has placed me in the interesting position of living in one college and being a Fellow of another. The relationship between the colleges and the University over the years has therefore for me been a protean one, changing with the hat I have worn at any one time. The conviction that has never left me, however, is that the University of Cambridge is, and must remain, the sum of its parts, that it is the very synergy between the colleges and the rest of the University that at once gives Cambridge its special identity and sustains its reputation as a world-class institution. This conviction is stronger than ever now that I have been, since January 2004, Pro-Vice-Chancellor for Education – a new position in University administration. My portfolio includes undergraduate teaching, consideration of student numbers, access and admissions, and graduate studies, and this inevitably means working closely with the colleges, which are the very engine of Cambridge's distinctive approach to admissions, undergraduate teaching and learning, and student welfare generally. I therefore see the fostering of good relations and effective interaction between the University and the colleges as a central part of my role.

The relationship is, of course, an intricate affair. The University has always been a loose confederation of faculties, colleges and other bodies, with a relatively small central administration and with central governing and supervisory bodies consisting of, and mainly elected by, the academic personnel of the faculties and colleges. Its affairs are managed and taken forward through wide-ranging procedures for representation, consultation and decision-making, and many of its members, though by no means all, divide their lives between university and college responsibilities. Given this dynamic, nobody, I think, would claim that the relationship over time has always been a smooth one, not least because the colleges have distinctive identities of which they are understandably proud and have themselves sometimes found it difficult to arrive at a consensus. On the whole, however, this competitive and creative tension has formed part of the University's vitality and strength, and it is because of it, rather than in spite of it, that Cambridge has achieved its pre-eminent position among universities in this country and is a leading institution internationally.

walking down the wide central corridor. Wolfson Court is a building of interiors, of walkways, loggias and intersections, which makes it difficult to draw or photograph adequately. Each courtyard garden is overlooked by the rooms, and the rooms face one another across the central spine. From nowhere is it possible to get a perspective of the exterior that truly signifies what is inside. If you look down on Wolfson Court over the roofs, the two pyramid structures that you might imagine are important rooms mark only the crossroads of the corridors. At ground floor level, glazed walkways and doors lead the eye to look through or across the building rather than at it. These sectional vistas, including the much photographed Wisteria Walk, resist the framing of any particular space or room or person or activity as being more important than any other, and this has been significant in determining its character. It is an annexe of Girton; and an annexe should add a little bit extra where needed, without drawing too much attention to itself or distracting the eye from the main building. The focus-resistant architecture of Wolfson Court has allowed it, so far, to assume this modest function.

Cafeteria society

As a replacement for dining in the Girton rooms in St Edward's Passage, the cafeteria always was and still is the engine room of Wolfson Court. When the kitchens are closed the building seems sleepy and unlike itself. This is as it should be; the need for a space to dine near town is where Wolfson Court began, although the future importance of this College need was not perhaps anticipated. Informal, lively, cafeteria-style dining in counterpoint to formal High Table dining, and the opening of Girton's doors to other institutions by this means, are one of Wolfson Court's most striking and valuable contributions to College life.

Pressure on catering facilities (as well as a fire) led to the extension of the kitchen in the 1980s, and the dining area has gradually gained space by extending into what was

The original building

From Clarkson Road, Wolfson Court looks much as it did when it was first built in 1969. But over the last fifteen years the footprint of the building has almost doubled in size. Visitors find the original building difficult to date and are always surprised by its size, which cannot be anticipated from its modest front aspect. David Roberts' design, using bare brick, glass, glazed concrete and wooden shutters and trellises, with every space in a fixed proportional relationship to every other, seems to have anticipated more recent architectural styles and provides an integrity to the building that is hard to describe but is instantly felt when

once the JCR. The lunchtime 'experience', with 300 or 400 meals served daily, is international, multidisciplinary and outward looking, but the architecture maintains the intimacy. A few years ago a suggestion by this Warden that the cafeteria stalls should be replaced by an open plan arrangement was met with withering glances from Fellows who prefer to cosy in together, sometimes eleven or twelve to a stall. One can find oneself wedged in a corner seat for hours, but the experience is always pleasant. Having no High Table creates space for discussion across the traditional boundaries of JCR, MCR and SCR, and the College's academic life is enlivened by this opportunity.

It is important too that Girton has a place where children feel comfortable and can be accommodated, so that Girtonians with families can take part in College life. Menus have changed considerably over the years, and we now routinely serve vegetarian, vegan, halal and kosher food. The truly weird Plaice with Banana and other favourites of the 1970s are now (thankfully) in the back catalogue and the Food Committee keeps a watchful eye on standards. The current debate over nutrition in institutional catering has long been anticipated and acted upon at Girton. The success of the Wolfson Court cafeteria is in no small part due to the long-serving and incredibly loyal members of staff who have spent most of their working lives in its service. Graham Hambling, Kevin Sheen and Mary Bartley have together given more than seventy years to Wolfson Court.

Adjacent to the cafeteria is the 'Airport Lounge' – a nickname that has survived many attempts to suppress it. Here Brad (the affectionate name for Muriel Bradbrook, the Mistress who established Wolfson Court) used to tuck up on the sofa to read the newspaper in this interdenominational and very informal open area that is unlike any other in College. The nickname is apt perhaps: marking a point of arrival and departure. Like much of Wolfson Court, it resists

Florrie Buck, long-standing member of Girton's domestic staff, who still works in the canteen at Wolfson Court

a frame. As with the rest of the original building, the lounge is largely unchanged since the 1970s – although financial pressures have forced the covering up of much of the polished red lino with carpet. No employee nowadays can be expected to spend all day polishing the floors, as Pauline Palmer, the only employee who has been here since the building was opened, remembers doing during the long, peaceful summer vacations that are now only a distant memory thanks to the conference trade.

Childcare and partners

David Roberts' design for Wolfson Court shows a crèche in what is now a Fellows' flat. This tiny space was never used for its original purpose, but the desire that Girton should provide some kind of nursery facility was not forgotten and became a particular interest of the Bursar, Debbie Lowther,

who served on the University Committee for Childcare. After years of complicated discussion with a number of other colleges, Debbie finally achieved her purpose and the latest extension to Wolfson Court is an eighty-place nursery on the back field catering for College staff, students and Fellows. Alongside this facility, College has maintained its commitment to provide access for students with partners and families, and we now own six units of accommodation suitable for this purpose. From the graduate perspective, and particularly for women, the difference is immense. Those who came here in the past often left partners and families behind, sometimes overseas, in order to undertake their research, and will surely applaud the freedom from heartbreak, homesickness and distraction that the new nursery and family housing provide for their successors today. Nancy Lane Perham (p.98) describes the situation with feeling. Thankfully Girtonians can now plan and be with their families all year round, supported and assisted by our workplace nursery, family housing and childcare bursaries.

Conferences

During the 1970s, Girton decided to try to meet the costs of maintaining its buildings and paying its employees all year round by hosting conferences during vacations when the students are away. Nowadays we turn any little bit of spare capacity to good use by hosting local, national and international conferences, training courses, meetings and events. In forging strong links with the academic and business communities outside Girton, as well as with individuals hosting dinners, parties and weddings, we have created new opportunities for the College. Conferences bring financial rewards but also, and perhaps more importantly, they allow us to open our doors to the wider world and to share our buildings and our College life. This turning outwards, breaking down barriers between academic and non-academic communities, is a tremendous and perhaps unforeseen benefit of the economic necessity that forced us to open our doors.

The people

Wolfson Court ('Wolfie') is a friendly and supportive place to work. In part this is due to its architecture, which encourages interconnections and provides spaces such as the cafeteria where Girtonians can meet without the usual segregations inherent to the academic community. The reputation for friendliness, however, owes far more to the family atmosphere provided by the Wolfson Court staff, long-serving, long-suffering and extraordinarily kind to students and visitors alike. The smallness of scale of this nevertheless important – even vital – annexe to Girton College gives employees a close perspective on each others' work and lives and allows a harmony of purpose that cuts through any differences.

Maureen Hackett, Warden of Wolfson Court

In recent years, the situation in which we find ourselves has been changing. External developments and pressures are impinging upon us in ways that require even closer cooperation between colleges, and between colleges and University, and which in some respects are conspiring gradually to reshape this loosely knit multi-faceted relationship. The Government no longer pays college fees directly to the colleges: instead the University, after negotiation, decides on a total fee for the colleges, which the Bursars and Senior Tutors then translate into student numbers. The colleges and the University are all subject these days to uniform quality-assurance standards for teaching and learning provision, to the requirement to engage in high levels of activity in the areas of aspiration, access and widening participation, and to compliance with new legislation in all areas of student welfare, including disability. Cooperation and collaboration across the board is the sensible response to these demands, and transparency and fairness of course require it. The outcome is that the colleges are now working together with greater conviction and energy than ever before. Returning to the world of admissions and tutorial affairs after many years in which I focused on other matters, I have been enormously impressed by the professional way in which the Senior Tutors now organise these activities, putting huge amounts of time and energy into achieving consistency across the colleges. This in itself then provides an excellent base for dialogue, when necessary, with the University's central bodies.

Some developments are, of course, more readily dealt with than others. The University is at a crossroads where decisions about our future will have to be taken in the context of changing circumstances, the effects of which are not yet entirely clear. Teaching in UK universities is under-funded and will remain so even after the introduction of top-up fees, and research and research funding are increasingly becoming the drivers of university strategy. At the same time, given the way in which the Government funds home and EU students, the only realistic possibility for student expansion is at graduate level. These two circumstances, unchecked, could lead to a very different University – a predominantly graduate and research University, weighted towards the sciences, with the traditional role and contribution of the colleges fading away. Many colleges are already finding it difficult to sustain their employment of College Teaching Officers, and, at the same time, to persuade teaching fellows with University posts to take on college pastoral and administrative responsibilities because of the pressure placed upon them by the Higher Education Funding Council's research assessment exercises.

When Baroness Warnock was Mistress of Girton (1985–91), I remember her saying that she thought the supervision system, the very heartbeat of the College's identity, would have disappeared within ten years. Fortunately, although the system is undoubtedly under severe strain in some subjects and in some colleges, this prediction has proved excessively gloomy, but we are going to have to think very hard about how to use our inadequate resources to support undergraduate education. Although it is unlikely that the University will expand dramatically, some continued expansion in graduate numbers (already increasing at the rate of 2% a year) is probably inevitable, because, if we are to remain at the forefront of research universities, we must fish for talent in the international graduate student pool. A review of the size, composition and balance of the student population is therefore now well under way; as the Vice-Chancellor has said, 'whom we educate is what we are'.

The University as a whole is committed to remaining a broad-based institution and is keenly aware that the collegiate system is Cambridge's hallmark. It must therefore work in harness with the colleges to protect the precious balances on which our collegiate identity depends. In her inaugural speech to the University in October 2003, the Vice-Chancellor rightly expressed concern about the future vitality of the colleges in an increasingly busy world of two-career families and intensifying academic pressure. She suggested that the development of new accommodation in north-west Cambridge would be an opportunity for collegiate Cambridge to explore innovative ways to expand the nature of college communities. The colleges, however,

must look to their future in other ways as well: by committing themselves to more of the coordinated activity that, without any threat to their rich diversity of identity, will guarantee their strength and vitality; by considering how to expand their provision for graduates so that colleges play a central role in the lives of all students; by developing more flexible mechanisms for attracting and retaining brilliant young Fellows; and by investigating ways of extending college membership to far more of those in the University without any college affiliation, not least because it would be unwise to ignore the implications for the future of a Regent House where the majority would have no vested interest in the future of the colleges.

The challenge for collegiate Cambridge is to evolve to meet the requirements of a changing University in a changing world, without sacrificing its traditional mission of providing the most talented students from all backgrounds with an education that is second to none.

For biography, see chapter 4

Speaking as a Girtonian
Pauline Perry

What is it that Girton alumni recall when they think of their undergraduate days? Memories abound: of dinner in Hall, late-night parties, cycling along the Huntingdon Road in all weathers, supervisions in College, lectures and lab work in the centre of Cambridge, perhaps Evensong in King's and romantic walks along the Backs. In all these memories the distinction between 'college' and 'university' is meaningless: together they make up the unified and cherished experience of those magic years.

Fifty years ago, the Oxford philosopher, Gilbert Ryle, wrote that a stranger coming to visit Oxford or Cambridge might see all the colleges and the faculty buildings and then ask 'but where is the University?' It would have had to be explained to such a person that the University was not 'another collateral institution', but rather just 'the way in which all that he has seen is organised'. Looking for the University in addition to the institutions of which it is composed would, in Ryle's terms, be a category error.

Fifty years ago, that analysis was uncontroversial. Then, the University had a small administration and a part time, temporary Vice-Chancellor, and devolved most of the decision-making to college or faculty. Cambridge survived happily with this structure for many generations, when there was little need for a central administration and the decentralised system was seen to work to everyone's satisfaction. In the past twenty years, however, the relationship between the University and the colleges has become much more complex. Many forces of change have been brought to bear on a structure that is increasingly proving unable to bear the stresses of modern times. Radical thinking will be needed in the years ahead, not least by colleges such as Girton.

Although for most students the collegiate university is still a given, for academics it is a little less simple. Until recent times, the vast majority of those appointed to University lectureships were given college Fellowships very quickly, but the sheer weight of numbers in recent years has meant that an increasing minority are now excluded from college life: for them, the collegiate university exists only in theory. For research associates in faculties, access to college life is even more restricted, and the University has had to encourage colleges to offer some form of college membership to this ever-increasing and important group.

The number of academic staff now excluded from college life is only one of the reasons for recent strains on the collegiate ideal. The increasing burden of Government and funding council bureaucracy over the past few decades has loaded the central administration of the University in ways that have inevitably increased its size and influence. Then, in 1998, the Further and Higher Education Act made changes to the college fee system at Cambridge and Oxford, thus at a stroke influencing the relationship between colleges and University and forcing some fundamental thinking on the way in which the totality of teaching within the collegiate university was to be funded.

In recent years, the pressure from Government for admission procedures to be more transparent and defensible has also made faculties and the central administration look warily at the present system,

which allows the colleges to be in overall control of the process. In some areas, such as Medicine, the balance between college and faculty has already tipped towards a centralised admission by the faculty, albeit with college input, and others openly envy the medics their success in that debate.

At a time when it is under such strain, from within as well as from outside, it is necessary for those of us who love our college to clear our minds and ask a hard question: is there still a case for the collegiate university?

I believe very strongly that there is indeed a case to be made, mainly in the interests of the individual student. In a large and increasingly diverse student body, a sense of belonging, in both pastoral and academic terms, is a benefit beyond price. The college system splits up the huge annual intake of thousands into units of a few hundred who find, in the college that interviewed and selected them, a place where they truly belong and where their social and pastoral needs are catered for, albeit not in an intrusive or 'nannying' way. Here too, the roots of their academic experience are firmly planted by a Director of Studies who advises and monitors them throughout each year of study. In my experience of other universities, both in the UK and elsewhere, there is no alternative as powerful and successful as this. Student residences lack the academic element that lies at the historic heart of the collegiate system, and year tutors or course tutors lack the pastoral and social component that gives unity to the undergraduate life of a Cambridge college.

Many critics of the collegiate system would claim that the academic success of the University has no need of the colleges. I disagree. While it is true that the care of graduate students and research fellows is still an issue to be better tackled by many undergraduate colleges, it is rare in modern Cambridge to find a college without a substantial cohort of its own Research Fellows and without an increasing commitment to its graduate members. Interdisciplinary understanding is a necessity for the modern world. Other universities have tried various means to achieve multi-disciplinary groupings for their students, but none has achieved what the colleges can offer without conscious effort. In their daily college life, students meet and form lifelong friendships with their contemporaries from other disciplines, and learn from them in debate and discussion in ways that would be very difficult otherwise to contrive. The contribution of Cambridge is, without question, a gift from which this country derives countless benefits, spiritual as well as monetary.

Pauline Perry (Welch, 1949) read Moral Sciences (Philosophy) at Girton and, for ten years after graduating, taught philosophy, mainly at postgraduate level, in American and Canadian universities. As Her Majesty's Inspector in the Department for Education, she worked on projects in higher education and teacher education, participated in the EEC working group on teacher education and was promoted to Chief Inspector in 1981. In January 1987 she was appointed Vice-Chancellor and Chief Executive of South Bank University (formerly South Bank Polytechnic), and in July 1994 became President of Lucy Cavendish College, Cambridge. Since 2001, she has been Pro-Chancellor of the University of Surrey and Chair of Council at the University of Roehampton.

1 College Teaching Officers (CTOs) are Fellows whose teaching is wholly supported by the college. Many others who teach for the college, including Fellows, also hold University posts. Like such University Teaching Officers (lecturers), CTOs are also expected to have a strong research profile.

2 The tutorial system relies heavily on the work of individual Tutors, but at Girton we take very much a team approach, supported by ten Tutors, two nurses, two counsellors and four office staff. In 2004 the decision was taken to amalgamate the tutorial and admissions activities, together with the graduate tutorial system, to provide a coordinated approach to student support right through from application to postgraduate study.

Chapter 8
Life choices

The period 1976–9 from another angle: individual futures; how women of that cohort fared once they had left College. The Girton focus is set beside a study of Cambridge women graduates in 1979–80, a reminder both of the particularities of that period, and of concerns that refuse to go away. But the wheel is reinvented a little differently each time, and in bringing discussions of the work-life conundrum up to date, the 'Girton project' uses women's experiences to talk about issues common to men and women alike.

Work and life after College
Pat Thane

What has happened to the women who attended Girton during its final years as a single-sex college? A unique source suggests some answers: questionnaire responses received by the University and Life Experience project. This research was directed by Dr Amy Erickson, Research Fellow at Girton 1990–3, Kate Perry, Fellow and Archivist of Girton, and myself (St Anne's College, Oxford, 1961–4). A lengthy (twenty-nine page) questionnaire was completed in 1998–9 by a 10% sample of women who had attended Girton between 1930 and the 1980s, and by all surviving pre-1930 Girtonians whom we could contact. We also interviewed about 10% of the respondents. The questionnaires and transcripts of the interviews will be housed in the expanded College Archive. Unusually for a questionnaire survey, the response rate was high, about 70% – though we had expected this, given the educational level of the respondents and their likely interest in the outcome of the survey. The questionnaires allowed respondents to express their opinions, as well as to give factual responses.

The research was not designed to focus on conventionally successful Girtonians, but to assess the full range of experiences of Girtonians, from birth through school, college and beyond, and the influences shaping their lives. We were particularly interested in the relationship between their domestic lives and their roles outside the home, both paid and unpaid. However, we were, irresistibly, fascinated to explore why female Cambridge graduates have been, and remain, so much less likely to reach 'top' positions in Britain compared with Cambridge men of similar age and academic achievement. After all, if any women were to attain such positions, the chances were greatest for the intelligent, highly motivated and well-educated women graduates of Oxford and Cambridge. Can the different experiences of men and women be explained as the outcomes of women's free choices?

Most of the questionnaires were completed about twenty years after Girtonians of 1976–9 graduated, when most were established in their careers and

households. To help to place their careers in context, I have made a comparison with Girtonians who graduated twenty years earlier, in 1956–9, examining both their lifetime experiences (most of them were approaching retirement in the late 1990s), and their activities in the late 1970s, when they were at the same stage of life as the 1976–9 cohort. We have thirty-three completed questionnaires for 1956–9 graduates and thirty-five for those of 1976–9.

It is important to be clear about the backgrounds of the respondents. It is often assumed, by non-Girtonians, that Girtonians must come from 'elite' backgrounds. One thing that the two generations have in common with one another, and with Girtonians of earlier and later years, is that most of them grew up in the middle-middle or lower-middle classes. At any time, only about 5% came from obviously wealthy or influential backgrounds, and, even in the pre-war years, about the same proportion came from working-class backgrounds (see chapter 6). Overwhelmingly, Girtonians were not born with silver spoons in their mouths.

The 1970s graduates did not enter a dramatically wider range of occupations than their predecessors. The breakthrough of women into male-dominated occupations came in the 1950s and 1960s. Both groups included lecturers, schoolteachers (many fewer than before the Second World War, when teaching was the dominant occupation of Girton graduates), medics (both GPs and consultants), scientists, librarians, journalists, computer specialists and freelance writers. The 1970s group also included two senior civil servants (who were also present in earlier cohorts), three lawyers (a real change: the 1970s saw the first real breakthrough of women into the legal profession), two business managers, one accountant and one farmer (not unusual, though equally few, in previous cohorts).

A major difference between the 1950s and 1970s cohorts was that, overwhelmingly, the 1970s Girtonians kept up continuous, progressive careers through the twenty years after graduation. Most took only short breaks (three–six months, or even just a few weeks) after childbirth and were more likely to return to full-time work than the women of the 1950s were, though some of them opted, at least temporarily, for part time work. Unlike the 1950s graduates, they were more likely to do this after the second child, or in one or two cases the third child, than the first. A very few 1950s graduates said that, in their environments, as had been the normal expectation up to the 1940s, it was expected that they would not work for pay after their children were born. 'I had been expected', wrote one, 'to play second fiddle to my husband's career and find useful things to do, as had my mother.' No 1970s graduate made such comments. In both cohorts there was a greater tendency for unmarried or childless women to reach 'the top' in their professions (as head of a major public school, senior civil servant, medical consultant, partner in a successful law firm), but this was not invariable. The only woman in either group to become a Professor at Cambridge had three children, born in the 1960s when she was in her twenties and living abroad where her husband was working. Childless women did not necessarily have notable careers.

Throughout the period of the study, from the 1920s to the 1980s, the exceptions to the broad trends were the medics who were more likely, always, to work for most of their adult lives, despite sometimes encountering barriers and discrimination, especially in the earlier years. Strong dedication seems to have carried them though.

A number of 1950s graduates compensated for the absence of satisfactory paid work through voluntary work, as school governors, for churches or political parties and much more. This was less prevalent among the 1970s graduates, though by no means absent. Women of their age group, with young children, have tended to be less likely than those of other age groups to volunteer, for obvious reasons. However, the greater involvement of graduate mothers in paid work in the recent past unavoidably means that they are less likely than the non-employed Girtonians of the past to make the outstanding contribution they often did (as our survey documents) to the Magistracy, Relate, WRVS and many other organisations. This does not necessarily

signal a permanent decline in the contribution of Girtonians, and other women, to the voluntary sector. The questionnaire responses of retired women who attended Girton in the 1940s and 1950s indicates that, as members of the largest, longest-lived and most active generation of older people ever known, women who have been active in their careers often become active in voluntary work after retirement.

It appears to have become somewhat easier by the 1990s, when most of the 1970s graduates had their children, to continue part time in an established career. It was a source of frustration for many 1950s graduates that they could not. Perhaps in consequence, the 1970s graduates were more likely to stay and to progress in the same careers, with perhaps occasional shifts between employers (more frequent in the private business sector and in the media than in the public sector and the professions), than the 1950s graduates, who seem often to have had to shift careers in order to gain employment following motherhood and a career break. Many of them moved into teaching from other careers, such as scientific research.

This calls into question a common contemporary assumption that career patterns have become more complex in the recent past, the restless 'portfolio career' and frequent job shifts replacing the job for life. In fact, this has occurred in very few sectors of the work-force. Our evidence suggests that, for Girton graduates at least, shifting 'portfolio careers' were more characteristic of the 1960s and 1970s than of the 1980s and 1990s, and were due to the restricted opportunities of women who wished to combine motherhood and a paid career.

The proportion of Girtonians who had children was remarkably similar in the two age groups. The older group had more, on average, but many of the younger group had not completed their families, though all but one who intended to do so had started them. The twenty-seven 1950s graduates who had children had 2.76 children on average; the twenty-four 1970s women who had or intended to have children averaged 2.12 (including two pregnancies at the time of the response). The similarity is surprising, as the 1960s, when most of the 1950s graduates had their children, saw some of the highest birth rates in Britain in the second half of the twentieth century, and the 1990s, when most of the 1970s graduates had theirs, saw the lowest. It is all the more surprising because the 1970s graduates started their families at later ages than the older women did (in their thirties rather than their twenties), which is normally expected to lead to smaller family size. They perhaps presaged the recent (2003–4) upturn in the British birth rate.

In the 1950s, Girton graduates, like British women in general, married and had their children earlier than at any time in recorded British history. By the 1980s and 1990s they were having them later than at any other time, and were conspicuously less likely to do so within wedlock. All of the 1950s Girtonian mothers were married; just one, childless, woman lived in a long-term, unmarried, heterosexual partnership. Three mothers among the 1970s graduates were unmarried, one of whom was living in a long-term stable partnership. None of the 1950s graduates stated that she had chosen not to have children while living in a stable heterosexual partnership; two married 1970s graduates did. Their main reason was not commitment to career but lack of interest in motherhood. There was no sign that these women consciously put off childbirth in order to pursue their careers, risking heartbreak by leaving it too late.

A very small number in both cohorts did not marry or have a long-term heterosexual partnership, in striking contrast to the 35% of unmarried Girton graduates of the 1920s and 1930s. Again this is in line with national patterns. Two of the 1970s graduates were in long-term, contented, lesbian relationships and one other stated that she was single because she was gay. None of the 1950s graduates described themselves as gay and it is very rare indeed in responses before the 1970s, another expression of changed national and international (one was living in the US) culture. In both cohorts there were women who had consciously chosen a career and personal freedom in preference to partnership.

The 1970s graduates clearly worked hard, combining careers and domestic life. Strikingly,

PEOPLE'S PORTRAITS AT GIRTON

In 2000 the Royal Society of Portrait Painters mounted a millennial exhibition entitled *People's Portraits*. The idea was to paint people who would not ordinarily commission a portrait. Those who suddenly found themselves artists' subjects were depicted in terms of their occupations and activities – as members of a lifeboat crew, as farmers or butchers, as a nanny, a motorbike dispatch rider, scaffolder, singer. The result is a collection of faces and figures from many walks of life, and from many parts of the United Kingdom as it moved from the twentieth century into the twenty-first.

The artists, all members of the Royal Society of Portrait Painters (RP), donated their paintings to the exhibition, and then did it all over again in generously allowing the RP to keep the collection together as a coherent entity. The President of the RP at the time, Daphne Todd, who was painting the Mistress's portrait, thought that Girton's walls would be a hospitable hanging space for a long-term loan, though it was a staircase and not corridor walls that finally recommended itself.

The exhibition is freely available to the public, and captures a moment and an ethos that College found inspiring – and indeed captures something of the character of Girton's eclectic community. What is so arresting about this collection is the remarkable range of talent that the painters

and sitters together convey between them. That wouldn't be possible if there weren't such a diversity of occupations and backgrounds represented here. Above all, the representation is not static, and the exhibition continues to grow. To the original thirty-two paintings, new members of the RP each add a fresh portrait that comes to hang in Girton. So coal merchant, garage owner and furniture maker have since been joined by an ordinand and a park keeper.

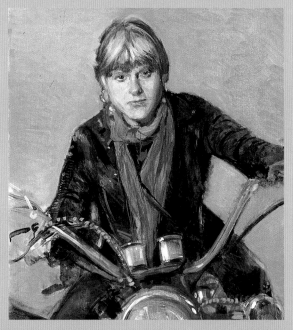

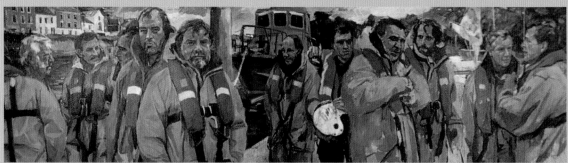

Above: Lifeboatmen of Fowey, by Jeff Stultiens RP

Top: Fran Maranzi, motorbike despatch controller, by Jane Bond RP

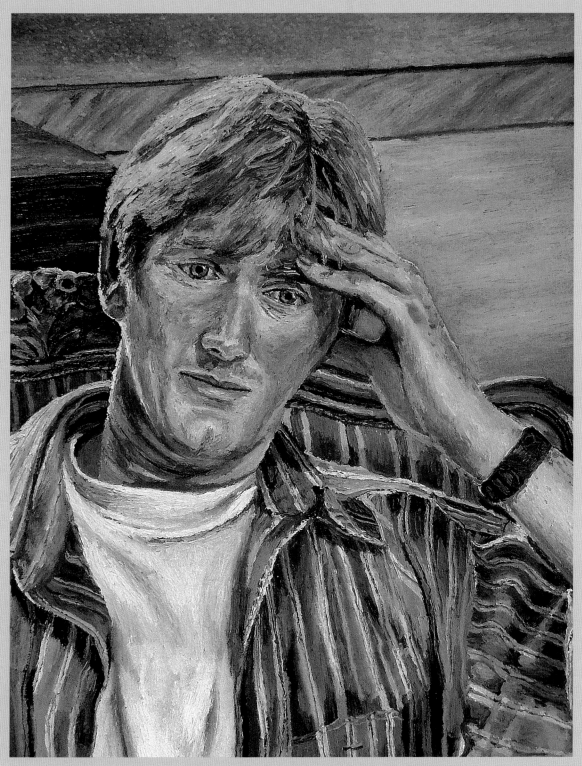

Frank Walsh, wheeler-dealer, by Melissa Scott-Miller RP

however, they were less likely to point out on the stresses experienced by their generation than were the 1950s graduates when asked to comment on the lives of the younger generation compared with their own. Repeatedly, the older women expressed their fears that, although the younger women appeared to 'have it all', their lives were more stressed than their own had been. As one 1950s woman put it, her own was a 'golden generation' with more options than previous generations, and more freedoms than the younger generation. The younger women, on the other hand, appeared to have adjusted to the demands of their lives by switching to part time employment and/or employing childcare when necessary. Of course it is possible that the most stressed of this generation were too stressed to find time to answer the questionnaire! Nevertheless, it is tempting to conclude that one asset possessed by highly educated Girtonians is a capacity for organisation and hard work. There is little sign that, by the age of around forty at least, the need to juggle domestic and career roles hampered their capacity to sustain long-term partnerships.

At this stage of their lives none of the 1970s graduates had divorced, compared with four of the early-marrying 1950s graduates at a similar stage of their lives, though some of the 1970s cohort had experienced more than one live-in relationship before settling into their current stable partnerships. These are not the patterns that national trends would lead us to expect, but perhaps it is not surprising that the 1950s graduates who married at such unusually young ages were more prone to divorce than the more cautious younger women who, perhaps learning from the experience of their parents, took longer to settle into long-term relationships.

What effect did Girton itself have on their future lives? Something the two groups had in common, with rare exceptions, was their conviction that their time at Cambridge/Girton was a transforming experience, which increased their confidence and sense of independence and broadened their horizons; though the younger women were more likely to attribute these benefits to the University than to Girton. They

also laid greater stress on their time at university as an avenue to a good job rather than as a good in itself. The generations nonetheless shared the conviction that their tutors at Girton showed little interest in their futures, unless they were high-flying academics, and that they received less support and advice than their male counterparts. Perhaps this is one of the explanations for the different career trajectories of male and female graduates. Another must be social expectations and conventions about the role of mothers: unquestionably, many of these women, still in the 1980s and 1990s, experienced hostility and discrimination as women and mothers in the workplace. The sheer difficulty of combining full-time commitment to a career with parenthood is clearly a major factor, the more so since there are very few signs that the roles and expectations of male graduates have changed even fractionally as much as those of females since the 1950s. Our evidence shows that, by the 1990s, fathers were playing a larger role in household management and childcare than their predecessors, but mothers, not fathers, were still expected to put family first, and the bulk of domestic work and responsibility fell upon the mothers. Not that most of them resented this; rather, they believed that children more than compensated for a slowing of their careers and many of them were confident that they could resume a successful career trajectory in the many years of active life left to them after their children were grown. This sense of a long and active future in middle age and beyond is another difference between the younger and the older group.

Another sentiment the generations had in common, expressed by many of the women, was that women had certain advantages over men and a different approach to life. They commented that women had greater 'emotional intelligence' than men, benefited from warmer friendships and were under less pressure to conform to stereotypes and to achieve success; though some feared that the latter quality disadvantaged women. When asked at the end of the questionnaire what they considered their greatest achievements, most in both generations, including those who had had highly successful

careers, put their children and partnerships ahead of their career successes. These responses help to suggest why female and male graduates have different life experiences.

For biography, see chapter 6

Anticipating futures
Jane Selby

Around 1980, I interviewed forty-two graduate women across the University, including Girtonians. As PhD scholars at the University of Cambridge, these women were on the cusp of significant success and achievement. The study, itself a Cambridge PhD (1984), was a child of the late 1970s – a kind of golden era when we could refer to equal opportunity legislation, anti-discriminatory laws and access to educational equality in ways to which only the most reactionary could object. These changes included the invitation to men to join Girton College. But strands of feminist thinking, forever reassessing the contours of oppression, also focused at that time on sexual politics, collusion on our oppressions and sexual inhibitions. The concern was that even the most economically, socially and educationally privileged, with access to knowledge about legislative rights and feminist support, would be found to be oppressed and suffering in the most private areas of their lives – their sexual relations with men. Initial interviewing made it very clear to me that few of these vanguard women thought of themselves as feminist or were overly concerned with such matters.

The main period of interview collection was 1979–80 when, according to the Board of Graduate Studies list, there were 388 graduate women in the humanities and social sciences departments, and 300 in the sciences. The average interview time was seven hours spread between two and six meetings. Girton women are not specifically identified here, partly for reasons of confidentiality but mainly because the psychological themes of the study were present across colleges, mixed and single-sex.

The daily work lives of the humanities and the science students were quite different. Humanities students tended to work alone, at home or in libraries.

While all of the science students interviewed had their own laboratory and/or desk spaces, only five of the nineteen humanities students did, three by virtue of the fact that they held college Fellowships; the other two were in the social sciences departments. Within both types of settings, individual circumstances varied. Some scientists worked within a tight-knit group of researchers in a laboratory, other science laboratories were characterised by a tense and competitive atmosphere, and yet others fostered anxiety because of the sexual harassment of a lone woman. Some humanities departments lacked any common room or physical space, or 'even a drinks dispenser' for departmental staff and postgraduates. The relative lack of institutional structure within the work settings of the humanities students may have contributed to some of the work difficulties experienced and the greater drop-out rate compared with the sciences.

This greater drop-out rate corresponded to the national pattern at the time, whereby only 40% of humanities candidates gained their PhDs within six years (*The Times*, 27 May 1980). Only two of the twenty-three science students interviewed dropped out, one after four years and the other after three; the latter, a biological scientist, also held a full-time research job while studying. Eleven of the nineteen humanities students interviewed did not complete, and of the eight who succeeded only three finished within six years. This success rate does not correspond with undergraduate performance. Most of the humanities students (twelve out of nineteen) had gained first-class degrees, whereas only five of the twenty-three science students had done so. Only two of the sample had lower seconds and both these scientists completed their theses. Five of the eight humanities students who gained their PhDs had been undergraduates at Cambridge. Perhaps, given the isolated nature of the humanities students' lives, it is not surprising that those already familiar and 'at home' at Cambridge were more likely to succeed.

The other general aspect of the sciences/humanities dichotomy thrown up by this study and well documented in studies on girls' schooling at that time is the under-representation of girls in the

sciences. Of the fifty-two science departments at the time of study, eleven had no women PhD students.

All those interviewed came from families that, to a greater or lesser degree, followed the traditional sexual division of labour within the home. All had married parents until they were at least fifteen years old, and only one had a mother who had been in full-time employment throughout her adult life. All of their mothers had been employed before marriage or child-rearing, and all but one gave up work on having children.

Of the forty-two women interviewed, thirty-three said they wanted to have a traditional family life at the expense of their careers. This choice entailed, for them, the prioritising of the husbands' careers over their own and taking responsibility for child-rearing. The current work settings of the women concerned were key. The case of Margaret illustrates how this can happen (all first names are pseudonyms).[1]

Margaret's career was characterised by firm encouragement and enjoyment of the work.

I've always been a bit lacking in confidence in my ability, and I really didn't, I mean, I was amazed when I got into Cambridge [as an undergraduate], let alone anything else, so, uh, but … my Director of Studies… pointed me in the right direction so much, and, uh, well, I got a first so then I realised that perhaps I could do it…

She described in detail the 'friendly atmosphere' of her department and her plans for post-doctoral training. But in other parts of the interviews we learned that, surprisingly, the 'atmosphere' of her department was at the same time undermining.

I suppose I just feel that I, in a way I had to do more to impress them than if, you know, when – which is, which is silly but, uh, it just worked like that… I suppose, in a way, being the only girl at seminars and so on, if I'm not there they notice it, if I am there they notice it, if I don't ask a question, it all, all sort of mounted up, whereas they could miss things and not, you know, and just not be noticed at all.

I want to be accepted by all my male friends… and for them to feel quite happy with me when we go out to the

pub and so on. I hate it being, sit there you know, and they mind their language and all that sort of thing. But at the same time I do want to be treated like a girl, I don't want to just be one of the lads… It's rather a difficult thing… to get right, I think.

During a discussion with her peers around that time, she described how one of them said: 'All the women undergraduates here are really stupid, you know, all they do is work all the time, they don't have any ideas.' They were saying: 'All, all the women undergraduates, they only come here to, you know, get married, and that's all, they all want to find someone nice, get married and fade into obscurity.' This put Margaret into an impossible position, represented as both work-obsessed (albeit unimaginatively), and as uninterested in and not serious about her work. It was not surprising that her intellectual identity wobbled and disappeared under inner emotional turmoil:

I enjoy being an aca – in an academic atmosphere with whom I can very much discuss what I am doing.

But what Margaret had, which seemed under much less threat, was a set of memories and observations about her mother as a happy housewife always keen to please her father.

That's how she wants it, not because my father – and also my father helps washing up and things like that when he's there.

Similarly, in considering the attractions of future domestic life with her boyfriend, she looked forward to taking the traditional roles:

Not because I feel any sort of ideas that the wife should do this, the wife should do that… but simply because, you know, that's something I don't mind doing and I'm quite happy to. I'm quite happy to do that.

Margaret wanted to reproduce her own family background because 'I don't think I could wish for a better family'. Her mother was seen as 'fulfilled' and successful. Bolstered by seeing her background in this light, and given the struggles and conflicts associated with her work environment, it is not surprising that

Margaret eventually decided to marry her boyfriend and shelved her thesis once pregnant, too tired to continue 'for the time being'.

But while this apparently smooth transition to domesticity from front-line researcher seems understandable, it masks other aspects of Margaret's story that illustrate how we think selectively when forging a difficult path. In the context of her own future marriage, Margaret spoke about her mother's life as happy and fulfilled; but when she was interviewed in detail about her mother's life and health, independent of parallels between mother and daughter, we learned that it was not entirely satisfactory: her mother had suffered from a 'mysterious' serious illness, from migraine and from menopausal problems, and was considered 'hyperactive' by her husband and children. But Margaret did not suggest that her mother's ailments might have had psychosomatic or stress origins; to have done so would have been to question the accuracy of her perception of her mother's life as 'completely happy', a question that might undermine the set of decisions Margaret herself was making in the face of her work experience.

Other women discussed similarly contradictory aspirations. This was Lisa:

I've come to realise now that there's no time that I can choose to have children… I can't take a year off… It'll be ten years before I properly qualify in Medicine and I can't spend twenty-two of my life getting qualifications just to stop to have a family… I'm not just doing this off the top of my head, I'm not just doing it as a little whim for the moment, you know. I really want to do medicine, and so I will do it… I want to be the clinical person doing collaborative work with the scientist.

In direct contrast she also said:

My idea has always been never, never to work while I have children, because my mother never did. That was an important point – to be at home with the children.

On the idea of men bringing up children:

God forbid! I don't believe in that at all. I'm terribly anti-women's lib. I love to have a man to look after me, to protect me…

But in a *volte-face* in a different section of the interview:

If I had a child, I think it would be a mistake, I mean, a lovely mistake.

There is no overt way to reconcile Lisa's conflicting visions, but since mistakes can happen, she may be provided with a rationale for finding compromises.

Obviously, ideally I need to marry someone who, again, it goes against all my principles, you know, who would actually, sort of, looks after the children as well… especially if I was working hard all day… I couldn't marry a male chauvinist pig who just expected the stuff to be on the table when he comes home – slippers, whisky ready… I couldn't marry someone like that, although, you know, that's really what my father is, you know, that's how my father and mother are, but, um, I want to be like my mother but I can't because of the situation I'm walking into.

These cases illustrate what was a widespread conflict for these women and how they were trying to manage these clashes. Particular circumstances can feed into particular visions of the past, obscuring other aspects as we draw on our resources when plans and decisions need to be made: a vision of domestic bliss is a godsend for the embattled student. On the other hand, an 'accident' might allow us to reconcile ourselves to change, and we might find new ways to balance both aspects of our aspirations.

Another point that came out of the study was the way in which gendered roles and aspirations were structured across generations. While we can try to effect changes in opportunities and legislate to support and empower the sexes to diversify, we ignore the inner psychodynamic processes at our peril. One student articulated this:

What struck me most of all by being at [my college] was the number of, of women who had mothers who'd been to [my college] before and who'd at some stage decided they'd have kids, they'd given up their job, maybe for just five or six years for having kids, maybe for much longer and had never gone back, um, clearly thinking that, you know, that um, the way to bring up children was to devote one's soul

to them and, to um, maybe also wanting to enjoy it while they were young, but, what I was struck most by was the way all these girls were, had really most extraordinary relationships with their mothers. In a sense it seemed that because the mother had given up so much of what, in retrospect, seemed so much, they had therefore, by definition, in- invested a tremendous lot of emotional capital in these girls and that investment put an appalling pressure on them to succeed in the way their parents wanted them to, and particularly their mothers, and I had about four or five of my close friends who were in that kind of situation with their parents, and I met their mothers sometimes and they were clearly discontented, although you could see easily how they got into that situation, and they were bright women. One thing that unnerved me especially was that, the fact that my mother gave – went on working when – fulfilled herself outside that realm of home and nappies and listening to me prattle on – is the basis of our successful relationship, and I don't feel guilty. I feel that a lot of these girls are always feeling terribly guilty that there was no, that there were these obviously bright, you know, get a first in Modern Languages, taught for a few years and then, um um, gave it all up, to do then some part time teaching.

We have a glimpse here of what may have occurred for those scholars who 'shelved' their theses for a while.

These were some of the circumstances and experiences of women PhD students around the time that Girton went mixed, focusing on the psychological processes functioning on a range of contradictory imperatives, especially internal ones, that may continue to hold sway through generations. While these processes are not peculiar to women, they are gendered evidence for those in our cultures who continue to struggle with embedded gendered values and practices.

Jane Selby graduated in Psychology from St Andrews in 1977 and gained her PhD at Cambridge in 1984. She then migrated to Australia where she now practises as a Clinical Psychologist. Over the years she has instigated a range of projects that reflect a focus on characterising the links between our innermost psyches, our cultural milieux and the political processes that hold sway. Much of her work has been with remote indigenous populations, with severely traumatised abused children, with infant development and with adult professional life.

Complexity, careers and community
Louise Braddock

Jane Austen famously remarked that she could not imagine what men talked about when women were not present. In the last thirty years in particular, women's access to male institutions and the conversations that occur in them have changed a great deal. At the same time, men have been admitted to institutions, and to activities such as parenting, that were formerly regarded as the province of women. The advent of co-residence in Oxbridge colleges, a small but significant step in this progress, does more than raise questions about the ability of men and women to enter each other's worlds; it also provokes reflections on how the men's and women's worlds of the late twentieth and the early twenty-first century are to find a new accommodation with each other, how they are to understand one another individually and collectively, and how they are to share the world.

The admission of women to the former men's colleges was the major contributor to numerical undergraduate co-educational parity at Oxbridge, but the admission of men to the former women's colleges – of which Girton was the first – introduces a different theme. For here, men entered an academic environment that had been the exclusive province of women, and from its experience in welcoming men and adapting to the change, and from its rapid arrival at full parity for both junior and senior members, Girton is well placed to promote conversation between worlds. But life is wider than College, and it is with the wider world that the Girton Project concerns itself.

The Girton Project began with conversation among women. This is 'The Conversation' between educated women who say things like:

I had a good education, which I enjoyed and intended to take into a career. But I haven't done as much as my male counterparts, haven't 'got to the top'. Since family

responsibilities and interests came on the scene, they have come first and I have fitted in my working life accordingly. So I haven't 'fulfilled my potential' in the way I thought I would. I wouldn't change (much) of what I have done, and I feel it to be a worthwhile way to live a life, despite not succeeding in society's terms.

There are many tensions here: between the world of work and the world of home; between the personal, professional and intellectual aspirations of educated women and their attitudes towards family, friends and life. With greater equality of opportunity has come a tension with the cost of this greater opportunity; a fulfilling professional life and a full personal one are in competition.

The details and the determinants of these attitudes and tensions are well documented in the University and Life Experience study, as Pat Thane has described. But as a point of view shared by a significant social group – educated working women – it is taking a long time to be articulated forcefully and in public, and to become serviceable to the newer generation of educated women for whom work is not, as it was for some of their mothers, optional. Articulation is difficult, just because two sets of values are involved, provoking dual attitudes of apology and defence. Success as prescribed by the masculine model is both endorsed and rejected; the Women's Alternative is seen as second best to a standard that, at the same time, does not bear on what many educated women feel to be a successful or desirable life for them.

Girton's ambition to bring this conversation into the wider world originated with the 1993 inaugural meeting of one of the earliest Girton local associations, Oxford Region Girtonians. 'The Conversation' occupied much of the informal part of that meeting and out of it came the first attempt at articulating a position. A 'Working Women's Group' of members produced four articles, which appeared in the *Oxford Magazine* in 1996 under the general title: 'Work, family and the educated woman'. What lay behind this effort, an unusual one for an alumni association, was the belief that individual voices could be 'collectivised' into a more forceful and so more

audible form, and that an organisation of Old Girtonians both could and should be doing this.

After Marilyn Strathern became Mistress of Girton in 1998 she came to talk to Oxford Region Girtonians about the wide role of colleges in the educational process and about the need for colleges to respond to social and political change. Shortly afterwards, the new Registrar of the Roll, Eileen Rubery, arrived at Girton, bringing her many and varied interests in flexibility of career patterns, lifelong working and the need for traditional conceptions of professional life to respond to social changes. At this point, Girton and Old Girtonian preoccupations came together to articulate the ways in which the interests and purposes of College and its alumni hung together as a coherent whole, in three articles printed in the *Oxford Magazine* (Trinity Term 2001) under the general title 'Educating everyone: collegiate education and the life cycle'.

The community of interest articulated then describes the thinking behind the Girton Project now. The papers were about three different sorts of relation between Oxbridge collegiate higher education and the rest of life. 'Living complexity' (Strathern) argued that colleges educate for the capacity to grasp social as well as intellectual complexity. 'Educating for life not youth' (Rubery) described how colleges could work as lifelong resources for education and career support. 'Educating people' (Braddock) viewed the college as a supplier of educated individuals to the community as social rather than (just) economic contributors. The unifying conception was of the college as a social organisation, harnessing the capacities and the motivation of individuals to produce an output that is both individual and social. It is from this conception, the college as an engine, that the Girton Project has sprung.

For some time the project was called 'Educating Everybody', after the title of those original pieces, but the intended ambiguity was not readily graspable. 'Girton Project' gradually came into use, its neutrality proving handy in dealing with the difficulty of categorising the project. It was not a committee or an association, but more of an initiative, a 'gadget', an enterprise, an undertaking with a purpose. That

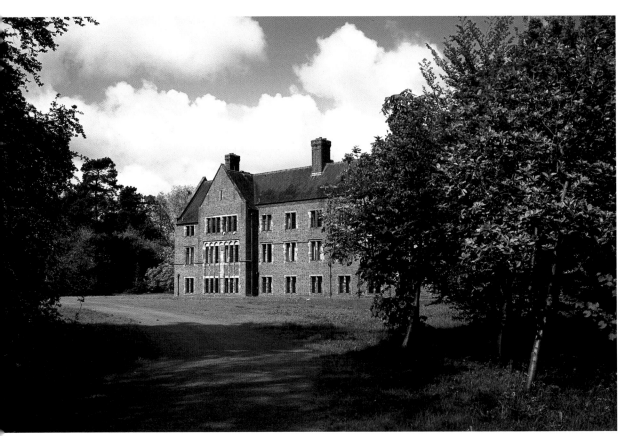

purpose has always been to join College and alumni together in communication, to allow Girton to reach into the wider world from its base in Cambridge. College actively engages Girtonians in conversation about those central questions about life and work that form 'The Conversation' for women and men alike; questions that almost everyone thinks are important but that have still not become properly reflected and respected in society. For people (of both genders) still struggle to keep room for a personal and family life while pursuing the career they also want, or 'fail to realise their potential' as they opt instead for the emotional rewards of family life. Many Oxbridge graduates feel, sometimes passionately, that college experience makes a difference to lives, and yet collegiate education is often under attack. These questions about the value and role of education in life are not asked just by Girton women and men, of course. But here is one place where Girton's contribution is distinctive in promoting – perhaps even

'exporting' – a truly communicative conversation about life choices, about values and about getting life and work into a proper equilibrium.

The Project started from the question of how individual experience and conviction can be 'collectivised' into a voice. But it is also centrally a Project to Do Things, in particular to organise opportunities for talking about these questions and to make sure that the discussions get spread around more widely in printed form. The College aims to involve Girtonians directly, as it sees its graduates as a resource in taking these questions forward, and Old Girtonians – female and male – have been the core audience at Project events. Proceedings of the Project's first conference, called 'Changing roles: the work-life conundrum', were published in an academic journal for the corporate and entrepreneurial business world, the *New Academy Review* (Summer 2003).

Eileen Rubery's report of the conference in the 2002 *Annual Review* led to an approach from the Work-

Life Balance Trust and to the Project's next conference, the Girton Work-Life Balance Workshop in 2004. This event, bringing in Girtonians from the London Girton Association and elsewhere, embraced the three 'C's of my title: complexity, careers and community, as well as a fourth: college. The day and the material were indeed complex, ranging over personal reflection and research data from individuals and groups, presentations on policy and practice, and a philosopher's reflection on the need to integrate conceptions of work and life. Career choices were seen as unavoidably complex, made within a framework of demands and values, on the one hand professional and intellectual, on the other personal and family-oriented. Life is not lived in isolation, and engagement with community is integral, not just to personal and family life, but equally to work. Particularly interesting to the community of Old Girtonians was the idea that a college could support its graduates in thinking about career choices. Finally, there was conversation across worlds, between College and the outside world, between the professional and the personal domains, between the disciplines – psychology, anthropology, philosophy – and, almost unstoppably, between people.

The Project remains informal, voluntary and cooperative. It is, as it must be, a 'cottage industry', something done if not exactly round the kitchen table then still on a human scale, one that answers directly to the capabilities and interests of ordinary individuals (always remembering that 'ordinary individuals' here are Girton graduates). For the scale of discrepancy between individual and institution to be managed so that individuals remain motivated and feel a sense of ownership, it is crucial that Girtonian preoccupations should define the Project. It is for Girtonians to decide how, and how much, to work with College on activities that thereby become the Project's. Equally, for 'collectivisation' to work, for individual concerns to find a voice, thinking has to be part of that activity. Collective thinking is the Project's *modus operandi* – perhaps what it is is a 'thinking collective' – and its way of working is part of how the College itself works.

The Girton Project brings to life and brings into life the three components of the collegiate engine described in the 'Educating Everybody' papers: lived complexity, educating for the whole of life and linking College with its graduate self in the world. Those papers simply set out to coordinate three points of view into an intelligible and intelligent description of how College works for people. What we have gone on from there to do is find a good way of 'making College work'.

Louise Braddock read Medical Sciences and Moral Sciences (Philosophy) at Girton and is a former psychiatrist. After her daughter was born she returned to philosophy, which for the past four years she has taught to undergraduates in Oxford. Her research is in the philosophy of psychoanalysis.

1 Square brackets denote added or changed text; … denotes a deletion.

THE GIRTON ROLL OF COLLEGE MEMBERS: CONTINUITY AND CHANGE

What we now call alumni were once simply known as Old Girtonians (or OGs). And it is certain that the alumni of Girton – members of the Girton Roll – have always, from the earliest days, been important in maintaining the ethos of the College and promoting its message of higher education for all.

The Roll consists of all those who have matriculated at Girton College and gained a Cambridge degree. Graduates working for higher degrees and new Fellows automatically become members of the Roll when they join the College and matriculate. Membership is free and expresses the fact that students and Fellows join the Girton College community for life, not just for the duration of their studies.

The Roll aims to provide a forum for Girtonians to keep in touch with the College and with each other, for pleasure, advice and support. Thus, as Registrar, I aim to facilitate the exchange of expertise and information between Roll members, provide a stimulus and focus within College for a range of Roll activities and support the Regional Associations, for example by providing advice on speakers and contact addresses if they wish to set up a new Association.

Looking back through the Roll Committee minutes since the 1970s while preparing this piece, I found, as one would expect, signs of both continuity and change. In 1970 representatives of Local Associations joined the Roll Committee for the first time, and the 1971 minutes mention that, following expansion of senior members and Fellows on the Committee, they could 'now muster twenty children between them'. Quite what had provoked this observation is not clear from the minutes, but it was possibly linked to the ongoing discussions on the issue of admitting women to the male colleges and men to Girton, since the following year's minutes note that three men's

colleges had started to admit women and the minutes for 1977 and 1980 record the admission of the first male Fellows and then the first male undergraduates. The first male Fellow to address the Roll was Professor Lesley Hall, in 1983, who spoke on 'The Development of the Veterinary School'. Since then there have been many male speakers

(left-hand photos) The 1999 Emily Davies Forum, with Professor Jean Aitchison and Matthew Parris

at Roll events, and although our membership, of course, remains predominantly female, the Roll Committee is fortunate to have many enthusiastic male members, full of ideas on ways of ensuring that we serve all our members through our programme.

Since the 1970s the main Roll events have focused around an annual Garden Party in July and a Roll Dinner in September, coinciding with the University Alumnus weekend. The Annual General Meeting and address by a Guest Speaker, which previously took place in London, now happen on the afternoon of the Garden Party. The Regional Associations, which have been a major part of the Roll at least from the 1970s, hold many lively events, allowing those geographically remote from Cambridge to make contact with other Girtonians.

In the 1990s, the Emily Davies Fora, involving leading thinkers and writers, were held in London covering topics related to women and their careers. The inaugural event in 1992 focused on 'Balancing life's choices', with the Right Honourable Gillian Shepherd, MP, as the leading speaker and Lady Howe, Chairman of Opportunity 2000, as Guest of Honour. At the last Forum in 1999, called 'Lost for words', Matthew Parris, Beryl Bainbridge and Professor Jean Aitchison led discussions on concerns about the perceived decline in the abilities of school leavers to compose competent letters or put together job applications.

The focus on supporting our members in career choices has continued in the most recent major Roll initiative, now called 'The Girton Project', which explores issues related to

work-life balance and the role of colleges in education (for more details see chapter 8). There is no doubt of the quality of the expertise potentially available to Girton alumni via the Roll; the trick is to devise a way to tap into it that is both reliable and affordable.

Girton has always sought to keep in touch with members of the Roll. In 1948 the College published the first volume of the *Girton Register*, covering those attending between 1869 and 1946, and the second volume, closing with the centenary year of 1969, was produced through the 1980s and eventually published in 1991. Paper records of alumni are still maintained in the Roll office today. The *Girton Review* was published every term from 1882 until 1973, when it became the *Girton Newsletter* and was published annually. In 2000 it changed its name again to the *Annual Review*. Updates on all Roll activities, major and minor, local and regional, are now available on the Girton website www.girton.cam.ac.uk.

Eileen Rubery, Registrar of the Roll

Chapter 9
Girton beyond Girton

The personal face of Girton beyond Girton: a sense of internationalism links these accounts. Many of them come from overseas students who studied at Girton or students who then found themselves in international institutions, including the initiator of an international court of arbitration who was both. By the time Girton went mixed they were all set on their careers. The last thirty years is represented rather differently: another institution builder describes the foundation of the Cambridge Overseas Trust, and we have records almost from its inception of the overseas students it supported at Girton. Of course, the other enablement is, for home and overseas students alike, 'Girton itself'.

Personal odysseys
Professional and personal networks
Barbara Isaac

Students at Girton not only travel 'in the realms of gold' but are a community with links across the physical world. Today, overseas Members of the Roll, numbering just under 1,000, have addresses in ninety-two different countries. Most are to be found in the USA, then Australia, Canada, France and Germany; however, there are also members as far afield as Guam, Cameroon and Estonia, and two are listed for Iraq. The chances are that, wherever you travel, you will find a Girtonian.

From the beginning there were students either born outside the UK or whose later interests led them overseas. By 1874 the College had enrolled members born in Valparaiso, Egypt and Tasmania; the first American student matriculated in 1875. The breadth is impressive: of the twenty-six students admitted in 1882, four were born, and seven found careers, outside Great Britain.

I am one who falls into the category of British-born, but who spent most of her adult life overseas. My husband was an archaeologist of human origins, and we moved constantly between four continents. In Berkeley in the 1960s we learnt that 'black is beautiful': the sub-text for us, although we were not black, was to be proud of whatever we were. And as I travelled more and met more people, this perception was reinforced: mid-morning tea under the acacias in Kenya with our local Kamba excavators; collecting witchetty grubs with Selma and Jane from Central Australia in Katulkajara; dining black tie with the President of Harvard; observing priests of the Flute Society climb precipitous Walpi Mesa; sitting in the fire-lit darkness at the centre of the centre of the world, waiting for the spirit whistle to announce World Renewal. I was always privileged by the dignity of the company I shared and the knowledge exchanged. And I have been continually surprised and welcomed by strangers; they have assuaged my curiosity

and made me more comfortable with myself, as human and English.

For many years I did not seek out compatriots or fellow Girtonians, but latterly I realised that my closest, although not necessarily geographically close, friends were coincidentally from Girton. In Boston I greatly enjoyed the occasional lunch with the resident OGs: we shared a wide-ranging, rigorous intellectual curiosity, combined with a magnanimous view of the world. We found ourselves also to be a useful network and a fount of local and international information.

In contrast with British universities, students in America enjoy an enhanced sense of unity and responsibility to their *alma mater*, encouraged by the constantly nurtured 'class' system. British graduates are more loosely organised; in my view, both the members and the institutions fail to make the most of the tangible and intangible benefits that can spring out of supportive college networks. While it is true that there is much on offer to those living in the UK, a quick surf of the Internet reveals that, of the eight Oxbridge women's colleges founded by the 1950s, only three advertise a specific programme for overseas members: bed-and-breakfast opportunities in seven countries; an overseas alumni weekend in college; and an impressive American Friends network.

A year ago I travelled for the first time in India, in Rajasthan, and was overwhelmed by the architecture, the richness and sophistication of the culture and the quantity of new information to be absorbed. Yet again I appreciated how much was to be gained from meeting and talking to people in their home country – a truism perhaps, but not always easy for the traveller. I was now retired, living in the UK and ruminating on the future. As can happen, different interests met to create a new opportunity: colleges offer travel programmes arranged by outside companies and sold to more than one institution. Why not develop a Girton journey, taking advantage of the College's global network of Members of the Roll? From whom better to learn about a place? The discourse promised to be illuminating and unprejudiced, and a check on present member density by the Development Office suggested that India would be a good place to start.[1]

As it happens, the College has had close connections with India since its foundation. Elizabeth Adelaide Manning (1869) provided medical women to work in the sub-continent, and also kept open house for Indian students in London, compiling a 'Handbook of information for Indian students'. One or two girls born in India of expatriate parents came up most years, and other graduates went out as medics, teachers and missionaries. Dame Edith Mary Brown (1882) founded the first women's medical college in the Punjab, now in Pakistan. An Indian national, Sarojini Naidu (Chattopadyiya, 1896), became one of India's most distinguished women in her career as poet, lecturer, biographer and politician.

The first itinerary was circulated in 2004, and it is hoped that the visit to India will be the first of many trips to interact productively with Members of the Roll who live abroad, thus strengthening the College's international network.

Barbara Isaac, after reading English at Girton, pursued a career in museums: from the Sheffield City Museum to the Coryndon Museum, Nairobi, and finally to the Peabody Museum of Archaeology and Ethnology, Harvard. Her marriage to the late Glynn Isaac (1937–85) actively involved her in the archaeology of human origins in East Africa. From 1990, she was responsible for implementing the controversial legislation (Native American Graves Protection and Repatriation Act) for the largest and most complex museum collection in the United States. She is now retired and is on the Council of Friends for the Pitt Rivers Museum, Oxford.

Another daughter
Shailaja S Chandra

My mother, Lilla Wagle Dhume, was at Girton College in the mid-1930s. By God's grace she is still alive today and has always stayed with me. At ninety-six, she is in a wheelchair and a shadow of her former self. However, her memories of Girton are still sharp. After returning from England in 1935, she taught English literature in various colleges in Bombay (now Mumbai) before joining the Government of India as a civil servant. After retirement, she went back to academia and became Principal of Lady Shri Ram College, a

prestigious women's institution in Delhi. In her own time she was known to be a powerful public speaker and one of the early examples of educated women reaching heights in a chosen profession – among other factors, an outcome of an education at Girton.

What I value most is the fact that her continued stay with me, ever since I got married, gave a different kind of presence to our family life. Three children came along and grew up under a secure umbrella provided by their grandmother. Her repertoire of stories included a description of the journey from Bombay to Aden and on to Marseilles by P&O steamship, then the train journey from Marseilles to Calais, and the final crossing of the English Channel to Dover. Two months to get to Girton! Perhaps, owing to the stories she told them about Girton and all that the path of higher education leads to, she may have unwittingly influenced my three children to pursue the academic path. Two of them acquired their PhDs in the USA and became professors there. One is about to get his doctorate. What they are doing is irrelevant; suffice it to say that it was their exposure to my mother that inspired them to join academia. Perhaps her stories of Girton played a part in influencing their young minds.

Shailaja S Chandra has been a career civil servant who has occupied the positions of Permanent Secretary in the Government of India as well as Chief Secretary, Delhi; she was the first woman to hold this post. She is now Chairman of the Public Grievances Commission in Delhi, where she hears appeals filed under the Delhi Right to Information Act.

Translation
Elizabeth Scott Andrews

It's been thirty-five years since my Girton days, and what days they were! As a very young student, I was fortunate to learn Spanish before it was commonly taught at school, and that led to my being accepted by Girton to read Modern Languages. For the first few months – like many of us, I suspect – I always felt I'd be tapped on the shoulder one day and told it had all been a mistake and I should go home now!

The Modern Languages Faculty at Cambridge in the late 1960s was impressive and colourful, and I was fortunate to be taught by such luminaries as Helen Grant, Theodore Boorman and Alison Fairlie, to name only three. Helen read lengthy quotations from Spanish literature – with a perfect English accent; Theodore seemed to know everything there was to know about Latin American literature (when you could pry him away from his horses to talk to you); and Alison expounded brilliantly, in her rasping voice, on Baudelaire and Flaubert, lighting one cigarette from another. Then there were the Backs, the Cam, theatre and music, and the daily feeling of being overwhelmed by the sheer beauty of the place.

My journey from Cambridge to New York and the United Nations was a tortuous one; in between, I got married to a New Yorker, became a film editor and a translator and had three children. With the birth of my first child I decided to pursue a more home-based career than the film business would allow, so I started doing freelance translation work whenever I could fit it in. That evolved into a position as translation manager for a small international law firm. Then, in 1989, I saw an advertisement for a similar post at the United Nations Development Programme (UNDP) and was lucky enough to be the successful candidate.

Working for UNDP has been – and continues to be – inspiring. The organisation is the development arm of the United Nations and has offices in 166 developing countries. We work with a wide range of partners to help improve people's lives, focusing on poverty reduction, democratic governance, human rights and women's empowerment. It's a privilege for me to make even a small contribution.

It is striking, with hindsight, how my Cambridge background stood me in such excellent stead so many years after graduation. While those credentials hadn't been of compelling interest to any of my previous employers, I almost certainly wouldn't have stood out sufficiently among all the other candidates for my UNDP job without them. And another enduring legacy of my years at Cambridge is the several wonderful friendships that started all those years ago and have continued to this day. My experience at Girton has indeed enriched my life in ways that have often been as unexpected as they were enduring.

Elizabeth Scott Andrews (Scott, 1966) read Modern Languages at Girton and is now Senior Editor for the United Nations Development Programme, where she served as translation manager from 1990 to 2002. She worked as a freelance translator before joining UNDP, translating from French and Spanish both professionally and for pleasure. The songs of Jacques Brel have been a particular source of inspiration. She is a former president of the New York chapter of the American Translators' Association.

Personal visions

Sustaining understanding

Sigrun Baldvinsdottir

From a relatively early age I have had a strong attachment to the idea that global welfare and peace could be achieved by means of the collective collaboration of international organisations, which could provide safeguards against the abuse of power without distinction as to religion, race, language, gender or age.

At the onset of my professional career I had the good fortune to work briefly in an international organisation. The international civil servants that I came in contact with were honest, committed and courageous people of impressive calibre. Yet the cultural difference in such organisations today lies within the multifaceted nature of decision-making and non-action, as the consequences for global society can be greater than ever before.

The cultures of such organisations can be markedly different, but there are certain characteristics that are inherent. Regardless of their specific mandates, their institutional infrastructure can create an atmospheric cocoon where outdated concepts and perceptions are the norm. General historical knowledge and an understanding of the trajectory of history are paramount among international civil servants, whereas awareness of current and contemporary processes in the making and the needs of the global society can be lacking. They speak the pragmatic language of consequences, yet they often do not address or assess pragmatic possible outcomes.

The analysis of the intricate character of situations and possible outcomes can be overwhelmingly complex. More and more, international civil servants are realising that it is necessary to go beyond language and that the main emphases are on enhanced accountability for the decisions taken and their implementation. A greater recognition is emerging that an effective multilateral approach is needed, and that an interconnected process between the various international organisations is essential in order to achieve a positive and sustainable outcome for the implementation of decisions. Otherwise, the decisions taken may have unforeseen long-term consequences and at worst prove to be counter productive.

Creative and alternative solutions have been voiced behind the scenes by many international civil servants and now, more than ever, by outspoken critics. These people are pioneers, people who encourage others to look within and search for solutions that are more strategically suitable for achieving maximum impact for the benefit of the global society. A deeper understanding and clarity has emerged, an insight and empathy that were perhaps not previously identifiable. It offers a coherent voice that transcends iconoclastic views, national alliances and intergenerational and gender differences. Thought-provoking ideas are being propelled and reassessed by collective and collaborative efforts by an increasing number of international civil servants.

A unique blueprint for the betterment of global society does not exist as such; rather it is a process in the making with infinite possibilities. It is to be hoped that the process will not be too arduous and that international civil servants will listen with integrity to the many voices of the global society, and that this process will lead to the gradual outcome of unification in peace, democracy and sustainability, with respect for cultural differences and a deep sense of intergenerational solidarity for the benefit of generations to come – a commitment to dignity for all.

Sigrun Baldvinsdottir was born and bred in Iceland and completed a law degree at the University of Iceland in 1971. She came to Girton in October 1971 to do an LLB (Public International Law), which she completed in June 1973. She moved to Australia, where she has worked both in the public

and the private sector. She is currently self-employed and works in an honorary capacity for the Icelandic Government. She has three children.

Why not?
Olugbolahan Abisogun-Alo

If it is not clear, what you think you have is not a vision; if it is not defined, your pursuit of it cannot be a mission. When your vision is clear, it embeds reflection and revision. Because your mission is defined, it cannot help but be dynamic. To me and for me, this is Girton – proactive, forward- and outward-looking, not reckless, yet not afraid to say 'why not?'

The role of education is to anticipate growth, identify trends, impart knowledge and create the processes to achieve all these. In effect, education is a catalyst for change. Because they embrace change more readily and comprehensively, the young are noted worldwide as prime vehicles, the arrowhead of change.

In my experience, the most beneficial change, the longest lasting, is an evolution that seeks to situate new concepts on a backdrop that accommodates something of the tested. To accept the challenge of other options is not to be rash or, paradoxically, timid and unimaginative. It is the 'why not?' quotient in the equation. I have discovered that, even in the most conservative conclave of elders or the most flint-faced committee of ideologues, there is always one 'why not?' member! The joy is to identify one early and work out a way forward.

Daring to think and do differently is not new. Technology has simply enhanced our opportunities for trans-world advancement and for foraying into areas ready for change. Cambridge remains relevant in the twenty-first century because of its versatility, spearheading new developments and championing the innovative approach. And Girton is integral to the Cambridge ethos. Ideas are plentiful in Africa too. Nigeria alone is a fertile garden of Ideas and Views. We have the privilege of world philosophies. We imbibe them all. We dare to share with the world. Nigeria's National Policy on Education is rich in concepts and strategies; but parochialism tramples on

objectivity. Success therefore depends on 'why not?' individuals or situations.

We need more troubleshooters to convert stark directives into ventures that turn entire communities into stakeholders. In Abuja, I was privileged to constitute the traditional leadership into a strategy team, to share access to potable water, to accept payment in kind in lieu of nominal school dues, so keeping girls in school, and to groom students to demonstrate social sensitivity through community services. There is so much to do. One must simply dare to act, such as when creating a new school in Abuja, salvaging another in Lagos and hoping to seed them with an ethos. Establishing a consultancy service through which one's team facilitates both international and local programmes has given invaluable opportunities to turn theories into practice.

Chairing university councils is tailor-made for the 'why not?' approach. Our universities have been live-in, fully government-funded ivory towers that enjoyed internal autonomy. Invasive military rule, civil-service power play and competing ideologies bedevil the system. The 'why not?' push is needed to restore autonomy, including the challenge of generating funds internally; to establish programmes that are relevant to twenty-first-century needs and an external body to ensure overall quality control; to revise admission criteria in order to eradicate massive cheating; and to encourage the acceptance of the fact that university education is not appropriate for all. Funding problems grow. Because of our economic situation, some government funding remains essential, including grants-in-aid, scholarships and bursaries. Private-sector contributions may be 'fund and bond'. Government universities can reduce overheads by merging programmes and facilities to create 'centres of excellence', and by not providing living accommodation. We need more private universities, and parents are willing to pay. The new, open university offers additional prospects. The challenge? University governance needs to be proactive.

At the Nigeria chapter of Forum for African Women Educationalists (FAWE-N), we network across

FUNDRAISING

The foundation of Girton and its expansion in the twentieth century depended on large numbers of donations. However, in the post-war era, fundraising was limited to major capital projects. The centenary campaign, led by Muriel Bradbrook in 1969, was an early direct mail appeal to Old Girtonians; it was coupled with centenary memorabilia and a major gift appeal that resulted in a donation of over £1 million (equivalent to around £15 million in 2005) from the Wolfson Foundation to fund the building of Wolfson Court. During the Mistress-ship of Baroness Warnock, in 1988, the College made its first major appeal to the alumni, which focused on raising unrestricted funds and setting up the first Friends Groups. Since then, the Friends of the Chapel, Choir, Library and Gardens, which are all subscription-based, have been vital in maintaining these College assets. The Friends Groups also organise many activities for their members, including talks and the annual Friends of the Choir Concert.

The financial pressures the College faced in the early 1990s meant that, in order to improve facilities, systematic fundraising had to be a priority and donations had to be proactively sought. The first big campaign was to endow a Fellowship in memory of Muriel Bradbrook, and early results of these newly vigorous fundraising activities allowed the refurbishment of Woodlands wing in 1994 and the building of new graduate blocks at Wolfson Court in the mid-1990s.

An initial fundraising initiative was the Adopt-a-Room scheme, which began in 1993 when the College began to appeal to alumni to pay for the refurbishment of individual student rooms. At that time each room cost £2,500, and the donation was commemorated by a plaque on the door. Many Girtonians were inspired by this campaign, and rooms were adopted by alumni in particular regions, for example the New England Girtonians, by years, such as those from 1948, and by individuals wishing to commemorate teachers and friends. To date, over sixty rooms have been adopted. One of the most significant donations within the scheme was from the 'Obedient Ears' group, all from the 1950s, who took their name from a poem by Bai Juyi, inspired by Confucius. They adopted a total of nine rooms.

These fundraising campaigns attracted support from trusts such as the Wolfson Foundation, the Clothworkers' Company and the Mercers' Company. However, further changes in higher education funding, combined with the 20% cut in College fee income over ten years, were a driving force towards more development activity and to the recognition that fundraising must be integral to Girton's long-term strategic planning. It was clear that, in future, most capital projects would have to be funded by donations, as fee income would be prioritised for core activities.

By the mid-1990s, the College had appointed a Development Director and quickly appointed more development support staff. The first Development Campaign was launched in 1997, with the priority of raising money for student support, the endowment of Fellowships, the Library, Archive and Special Collections Project and student room refurbishment.

When fees for tuition were introduced the question of student support became a concern for the College. The idea that no student should be deterred from applying to Girton by lack of funding inspired a major endowment that enabled College to establish the Emily Davies Bursary Fund. The same donors also partly endowed a Teaching Fellowship, the first to be so adopted. Further fundraising for student bursaries through the Emily Davies Bursary scheme inspired another group of Girtonians to fundraise for the Jean Lindsay Bursary scheme, targeted to a specific discipline (History). To date more than £2 million has been raised for these various student support schemes, ranging from major donations to small gifts from a large number of Girtonians.

It is significant that the College's early appeals were mainly to Old Girtonians of the pre-1979 era, and as such were directed to women. Fewer than 5% of donors up to 1997 were male, and it was only with the launch of the wider development campaigns that male alumni began to support College. One factor, of course, is that it was only at this time that the College's first male alumni were reaching a position in life where they had the means and capacity to donate. The College embarked on its first telephone fundraising initiative in 2000, which greatly increased participation rates among younger alumni. This has also had the effect of establishing more links between alumni and current students, and greater awareness among students of the financial pressures facing the College.

The first campaign raised over £5 million pounds in total, if we include the significant gift of £1 million from a Girtonian

and her husband to fund a Bursary and a Fellowship, and £500,000 donated by a Life Fellow to the Library, Archive and Special Collections Project. Girton is currently on its second major fundraising campaign, with a target of over £10 million. As the sum contributed to higher education by the state gets proportionately smaller, the importance of fundraising and other income streams for the College continues to grow.

Francisca Malarée, Development Director

Gifts to College

In 1996, coinciding with the British Museum exhibition 'Ancient Faces: Mummy Portraits from Roman Egypt', the opportunity was taken to scan, using computer tomography, one of the most famous of those portrait mummies, Girton's 'Hermione Grammatike'. Hermione had come to Girton as a class gift from the graduating year of 1911, in return for a subscription of £20 given to Flinders Petrie towards his next excavation. He had discovered her at Harawa in the Fayum oasis south of Cairo in 1910, and since the inscription 'Grammatike' must have meant either 'teacher' or 'one who can read and write', she seemed a particularly appropriate gift for Girton.

She had been x-rayed previously, in 1952, when the examination revealed that the mummy case did indeed contain the complete skeleton of a young woman (by no means a foregone conclusion), and age at death was estimated at about twenty-five. Now, the new techniques allowed a great deal of additional information to be gathered, of significance to studies of Egyptian burial practices during the early years of the Roman Empire. This more detailed investigation of the body resulted in an age at death revised downwards to around twenty or twenty-one. Her teeth were in a good state of preservation and her bones showed no signs of illness; one wonders what caused her early death, and the sad expression of her portrait only adds to this poignancy.

Iznik water bottle, late sixteenth-century, given to the College by the Estate of Sylvia Fletcher-Moulton

The CT scanning allowed a further fascinating piece of investigation: the opportunity, using the techniques developed over the last thirty years, to recreate Hermione's face and compare it with the artist's version on her mummy. The results were remarkably similar, showing a young woman with large, liquid eyes, high cheekbones and a long nose. Even the hairstyle depicted in the portrait could be verified, since the scan showed the outline of her hair along the skull, finishing in what looked like a bun piled on top of the head.

Many gifts have some to Girton over the decades – gifts that relate not just to the importance placed by the donors on education for women, like the magnificent books, collections and papers given to the Library and Archive, but also to the donors' desire to benefit the College in other ways. Girton continues to be the only Cambridge college with its own swimming pool, which opened in 1900 at a cost of £1,225 thanks to 'J Lindley and students of the College'. Crewdson Field, now transformed into sports pitches, was left to the College in 1913 by Gertrude Crewdson, and many buildings on the south of the College were made possible by the John Lewis family in memory of John Lewis's wife, Eliza Baker, who was a student in 1872. In 1902, the Hon Evelyn Saumarez gave the College an important collection of Tanagra figurines, which have been much requested since for exhibitions of early Greek art.

From the last thirty years there is also much to record. In 1990, Girton was left a substantial legacy by the Hon Sylvia Fletcher-Moulton: a magnificent Iznick water bottle (left) dating to the late sixteenth century. Her family gave the College permission to sell the gift at auction, where it raised £190,000 which was used to fund the Library extension at Wolfson Court, now named the Fletcher-Moulton Room. Girton is the fortunate owner of a Second Folio edition of Shakespeare, given to the College in 1997 by Dadie Rylands in memory of Joan Bennett (Frankau, 1916). He

Juliet Campbell and Elizabeth Penny, great-granddaughter of Joan Bennett, collecting the Shakespeare Second Folio from Dadie Rylands at King's College in 1997

himself had been given it by Nathaniel Mayer Victor Rothschild (later 3rd Baron Rothschild) on his graduation in 1933, in gratitude for Dr Rylands' teaching. A 'Treacle' Bible was bequeathed to the College by Jean Lindsay, a fifteenth-century Flemish Book of Hours was given in 1977 by Mary Baker (Keeling-Scott, 1925) and she followed this in 1991 with the gift of other manuscripts. P D James has given Girton the original manuscripts of most of her novels.

Girton has been given silver too, most recently a collection of modern and antique silver for High Table donated by Barbara Megson (1948). The set includes pieces contemporary with the early years of the College, as well as Art Deco and modern pieces. Chairs for High Table, made of solid oak, were specially commissioned by Rosalie Challis (Jones, 1957) in memory of her parents. And sport has benefited too: Claire Barnes (Turner, 1982) gave the Boat Club a single scull, now known as 'the Claire'.

A remarkable recent legacy from Dr Diana Lorch (Robinson, 1940) is a collection of northern Russian icons, dating from the seventeenth to the nineteenth century and featuring two little-known saints of the Orthodox Church, St Zosima and St Savatti. Many of the gifts Girton has received since its foundation have to be kept in secure, controlled conditions, visible only on special occasions. But where possible they are in use or on display, and all are cherished for the value they add to Girton's history and significance.

the continent in the service of the girl-child, running practical programmes in order to keep girls in school and achieve gender parity. Pre-school education now beckons. In 2003, six of us established, in a small way, the first institution purpose-built to give professional training to serving carers and teachers – the Early Childhood Teachers' Academy. This level of education has emerged as essential to the success of the whole enterprise.

The vision grows clearer. Education is one whole. Our national experience is proving that every single level of the process must receive high-quality attention. The mission strategy is simultaneous tendering – moving on several fronts at once. 'Daring to do' produces its own multiplier syndrome. Others will join in. It is a mix, after all. And the global village provides increasing opportunities to share, to grow and to ask 'why not?' Hello Girton!

Olugbolahan Abisogun-Alo graduated in History from Girton in 1961 and has held a wide variety of positions within Nigerian education, ranging from teacher, vice-principal and principal of schools for girls to education officer and later Secretary General of the Nigerian National Commission for UNESCO. She is a member of several social-services organisations in Nigeria and has broadcast widely on African subjects, including apartheid, the place of women and Yoruba culture.

Institution building
P G Lim

In 1982, after diplomatic assignments as Ambassador to the United Nations, Yugoslavia, Austria, Belgium and the EEC, in that order, I was appointed by the Malaysian Government to take over as the second Director of the Kuala Lumpur Regional Centre for Arbitration (the Centre). This had been established in 1978, following an agreement between the Government of Malaysia and the Asian-African Legal Consultative Committee (AALCC), now renamed the Asian-African Legal Consultative Organisation (AALCO) – an intergovernmental organisation comprising forty-four member governments from the Asian-African region with headquarters in New Delhi.

The Centre is a non-profit and independent intergovernmental arbitral institution.

It is one of two Centres – the other is in Cairo – provisionally established under AALCO's Programme for the Settlement of Disputes in Economic and Commercial Transactions. The Programme envisaged the establishment of regional Centres to provide institutional facilities for the conduct of international arbitration and to promote a pattern of cooperation between the national institutions in the field of arbitration, especially in the Asian and African region. Because of the enormous increase in international trade, including foreign investment in developing countries, and the use of arbitration in the settlement of international business disputes, it was felt by some Asian-African governments that they were often handicapped for want of appropriate rules and institutional facilities, and that parties from the region had no alternative but to have recourse to private arbitral institutions in the West.

As institutional arbitration was practically unknown in the Asian-Pacific region, it was hard to predict whether the Centres would be successful, and their future was uncertain. Misgivings were also expressed in Western circles that the establishment of regional Centres would impede the growth of national institutions (of which there were hardly any) in the regions. There was also a general reluctance among foreign parties to arbitrate under laws that were fragmented, outmoded or ill-suited to the needs of modern arbitration practice. Moreover, the 1976 Uncitral Arbitration Rules, which had been recommended by the United Nations for adoption by member countries in the interest of harmonisation, had yet to make an impact. However, having examined these rules, AALCO concluded that they were suitable for adoption by the Centres, and as a result the Centres were to be the first arbitral institutions to have adopted the Uncitral Arbitration Rules to govern their international arbitrations; this in turn created a favourable environment for the conduct of international arbitration. AALCO thus played a crucial role in promoting international commercial arbitration in the Asian-African region.

We realised that it would take some considerable time after services became available before arbitration references would begin to come in, not least because we had to compete with the established arbitral institutions in the West. When I became its Director, the Centre had yet to receive its first reference to arbitration. In this very competitive arena, we saw the need to participate in international arbitration conferences to publicise our existence, to provide information on the scope and application of the Centre's rules and the services offered, and to focus on the aims of arbitration as a service industry intended to resolve disputes in a speedy and cost-effective way.

The pioneering efforts of AALCO in setting up the Centres as alternatives to traditional arbitral institutions in the West had a worldwide impact. In the Asia-Pacific region, in particular, the Kuala Lumpur Centre evoked considerable interest in arbitration circles and among practitioners from both East and West who came to visit and to learn from its experience: the Centre was the only institution of its kind offering services in international arbitration in Asia. Our tentative efforts at promotion would only bear fruit a few years later, but this did not, to our surprise, prevent the subsequent burgeoning of national Centres providing arbitral services in the Asia-Pacific region in the meantime.

To emphasise the independent and non-national character of the Kuala Lumpur Centre, the Malaysian Government, in its agreement with AALCO, stated that it respected the independent functioning of the Centre. Furthermore, in 1980, the Malaysian Government took a bold step in introducing a significant change to its arbitration laws by an amendment that excluded arbitrations held under the ICSID Rules and the Rules of the Centre from the application of the Arbitration Act of 1952. A few years later the Centre was gazetted as an international organisation enjoying certain immunities under the International Organisations (Privileges and Immunities) Act 1992. Under the regime initiated by the 1980 amendment, the supervisory jurisdiction of the Courts over the Centre's arbitrations has been

removed. This bold and innovative detachment of the arbitral process from the legal restraints of the domestic courts was to provide for the tribunal's greater autonomy, and was intended to respond to new developments, described as delocalised or denationalised arbitrations, and to improve the environmental climate for the conduct of international arbitrations at the Centre. The changes effected by this amendment are far more sweeping than those envisaged by the UN Model Law on International Arbitration, which does provide for court assistance or supervision in certain matters.

We were fortunate that, in 1992, the Malaysian Government, in a major boost to our work, made available new premises, free of rent, which provide hearing rooms that seat between eight and thirty people, waiting areas for witnesses, an arbitrators' lounge, a well-equipped library and conference rooms. The Centre, now fully operational, holds seminars and workshops for the training of arbitrators and mediators conducted by experts from Asia, Europe and the US. The caseload of international arbitrations shows a steady increase and in 2003 the Centre reached its twenty-fifth year of existence. Over this period, the practice of arbitration has undergone many changes, evolving from a process that is largely adversarial to one that permits of permutations to temper the rigidities of arbitration – something that a highly placed British law lord once described as being 'hijacked by the lawyers'. As a result, we now see arbitrations that allow conciliation or mediation in the course of arbitration, mediation preceding arbitration, changes in legislation in Asia, and institutional rules incorporating such procedures. There is a cross-cultural diversity of approaches to managing arbitration in the region, bearing in mind that Asians, on the whole, prefer compromise to litigation, and mediation to arbitration. The Centre has had to respond to these challenges.

In this era of globalisation and e-commerce, trends are developing to transform traditional mechanisms to a cyber-like format (dispute without borders) by which disputes are handled quickly and effectively. In all likelihood, this will result in a dramatic decrease in

the fees and costs involved – an unintended, perhaps, but nevertheless welcome consequence of the use of sophisticated technology in the field of alternate dispute resolution.

P G Lim graduated from Girton in Law and practised as an advocate and solicitor in Malaysia. In 1971 she was appointed as Malaysia's first woman Ambassador to the United Nations, and was subsequently Ambassador to Yugoslavia, Austria, Belgium and the EEC. In 1982 she became Director of the Kuala Lumpur Regional Centre for International Arbitration, a post she held until 2000.

The web that joins us
Saeeda Ahmed

As my parents and niece walked up the steps of Girton College to drop me off for my next teaching block in Cambridge, they were quite overwhelmed by the beauty and character of the institution before them. They looked around the College and met some of the staff who worked there, and I could see in their eyes how much this reassured them. As they left to return home, leaving me with their usual best wishes and safety prayers, they repeated to me that I had to work hard, as I had a big responsibility to fulfil both in terms of completing the course and making an impact in the community. As I waved them off, I realised how much depended on my completing the Masters that I was undertaking.

I am now nearing the end of my part time Masters degree in Community Enterprise, a course set up by the Judge Institute of Management to support the growing needs of an emerging community enterprise sector. The course has been designed for practitioners and senior policy makers, and the participants are seeking to address social inequality and poverty, locally, regionally, nationally and internationally. I am currently engaged in research for my dissertation into how the social-enterprise sector will provide leadership and career-development opportunities for women where other sectors may not succeed as effectively.

Girton couldn't have been a better choice as a college for me. For cultural reasons, I stayed at home while doing my first degree, so even in my mid-twenties

I had never really been away from home independently for a substantial amount of time. Although this didn't intimidate me, I missed the bustle of a busy household and the chatter of visiting neighbours in the background. When I came to Girton, the first friendly contacts with the porters and the housekeeping staff were reassuring and comforting. And as I walked through Wolfson Court, I immediately felt that the building and the people it accommodated were like a family, exuding such a warm feel that it almost seemed like a home that a mother had nurtured for her children. When the catering staff went out of their way to find out what my specific dietary requirements were, and tried to cater for them, I realised that this College wasn't just *saying* that it supported equality and diversity. These people actually were what it said on the box — committed to the needs of different people. Girton's personal approach felt genuine compared to larger institutions elsewhere, and even felt culturally different to the main University of Cambridge. Most organisations that I had previously come into contact with seemed to tackle equality and diversity-related issues for tick-box purposes only, without any real understanding of their purpose or depth of application, and, occasionally, without any human compassion. I didn't realise the relevance of Girton to me academically, personally or professionally until I started attending the University in person.

I still cannot believe that I am a student at Cambridge. Growing up in Manningham, Bradford, as a Pukhtoon girl (a member of a strict Asian community present in both Pakistan and Afghanistan) and the daughter of a Hafiz (an Islamic scholar who has learnt the Quran by heart), I never really had any idea that I would become involved in the work that I do or that I would ever get to do a degree, never mind a Cambridge postgraduate degree. Cambridge as a city, and the University itself, are so different from the area that I grew up in and worked in that they are almost a different world, with affluent people, large beautiful houses and none of the visible poverty that I am so used to seeing in inner-city areas.

I missed much of my early schooling for many different reasons: peer disaffection, lack of role

models and a local community where males underachieved as much as females and a genuine lack of aspirations prevailed. There was no real push from my parents until they realised that my younger sister was academically very able and ought to continue her schooling, and that I had to have the same opportunities. I then had to catch up a significant amount of my missed education within a few months, and I went on to do A-levels and a degree in Accountancy.

I have never, however, envisaged myself in a purely financial career, as I am passionate about finding a way to deal with social injustices within an economically viable framework. I searched for the sector, the type of organisation and the people who had the same dream as I did by working for numerous 'public good' organisations until I finally realised that, as the opportunity I really wanted didn't exist, it was time I created it. So, in August 2001, I set up Trescom as a socially motivated company in Bradford, with two other like-minded people and with nothing more than an aspiration that we wanted to help people.

Since our formation, we have undertaken a number of projects that work with diverse communities and socially excluded groups and organisations in order to bridge the gaps in service provision and products, to make them generally more inclusive and to reach out to communities and individuals experiencing social deprivation and high levels of isolation. Our innovative and ground-breaking projects have ranged from evaluating the potential for tailor-made housing for people with disabilities, to equality and diversity support to large and small organisations in the north, and delivering support to new and emerging social enterprises. We have also developed opportunities for socially excluded groups to train with us, and have then provided intermediate labour-market opportunities in some of the social research projects we are involved in. Many women returning to work, and those with caring responsibilities, were attracted to the well-paid and flexible opportunities we were providing, and came to form a large proportion of our project delivery team. This resulted in our being nominated for the Castle Award, named after Barbara

Castle and run by the Department of Trade and Industry and the Women and Equality Unit, for equality of opportunity and equal pay for women. We became finalists in two categories – a massive achievement for a company that, at that time, had been in existence only just over a year. Since then, my colleague, Marbat Hussain, and I have been Millennium Award winners and we and the company have been profiled in many different publications.

One particular project is called Women Winning Work, designed as a means of dealing with the multiple barriers that lone mothers and women from minority ethnic backgrounds face in accessing employment. The project has enabled women who would otherwise never have ventured out of their homes to succeed in making changes to their lives through intensive eight-week personal and professional development programmes. We have already started to see good results, and we are increasingly showing that the contributions we are making, both directly and indirectly, to the growth and development of some of the most deprived groups and communities in the UK have real potential for transforming the way public services are delivered. The continuing link that I have with Girton will only enhance what Trescom achieves and will contribute to fulfilling my personal vision. It is the perfect backdrop for the work we are doing to achieve positive change and to promote inclusion nationally, and it links the history of Girton with our aspirations for the future.

Saeeda Ahmed has a BA in Accountancy from the University of Huddersfield and is currently undertaking a Masters in Community Enterprise at Cambridge. Before she became involved in the social-enterprise sector, she worked within the voluntary, community and public sector. Her expertise lies in equality, diversity and social-enterprise support, and she is a Millennium Award winner and a Fellow of the School for Social Entrepreneurs. She runs her own business, Trescom, and has set up a social enterprise called Trescom Unity, through which she works extensively with what are termed 'hard-to-reach' groups in localised regeneration and development.

Enablements

Creating opportunities

Anil Seal

As every academic knows, to remain in the front rank, universities must keep their doors open to talent, whether from home or abroad; and academic potential and purses deep enough to meet the high costs of study abroad do not always go together.

So the Government's decision, more than two decades ago, to triple the fees paid by overseas students to cover 'real' costs represented a grave threat to Cambridge's international standing and its traditional 'open door' policies. The increase in fees provoked an outcry overseas, as well as in circles of domestic enlightenment. To Cambridge's credit, it responded by defying the fiat for a while and then, in May 1981, by setting up a committee with the remit of helping overseas students and devising schemes of awards for them. A year later, the Local Examinations Syndicate, which had done well for the University by examining many students from the Commonwealth, donated £10 million to establish a Cambridge Commonwealth Trust. This was the University's first big step towards creating a 'needs blind' system of admission for talented overseas students, and an important milestone in its history.

The donation, substantial though it was, was dwarfed by the resources of Oxford's Rhodes Trust, the legatee of much of the wealth of South Africa. But when, at the first meeting of the Trustees in October 1982 under the chairmanship of His Royal Highness The Prince of Wales, James Callaghan, another founder Trustee, enquired how many scholars the Rhodes Trust supported at Oxford (*c* 180), the Trustees ambitiously agreed that the Commonwealth Trust should aim, within a century or so, to support twice the numbers of scholars at Cambridge as Rhodes supported at Oxford. Within five years, the Commonwealth Trust had achieved that target, and today the two sister trusts (the Overseas Trust was set up in 1988), and their associated trusts, support ten times that number.

This makes it clear that the strategy devised for the Cambridge trusts has merit. Like all the best strategies it has a simple premise, which is that gifted students are often able to attract financial help from more than one source. So it has made sense, even if the task is very labour-intensive, to put together packages of support for individual students from various sources, and to elicit as many partners as possible from outside in numerous schemes tailored to the differing needs of different regions and responding to the different priorities of the trusts' many supporters.

Partial grants from the trusts, sometimes large, often quite modest but sufficient to get the scholars here, had, by October 2003, enabled the two trusts to help more than 10,000 students to take up their places at Cambridge. In 1982 there were about 750 overseas students at the University. Today that number has quadrupled, and more than half of them are on the books of the trusts. A gratifyingly large number of them have been students from relatively disadvantaged backgrounds coming from developing countries. Many of them, having studied subjects at Cambridge relevant to the needs of their societies, have returned and contributed to their countries' development.

But the main beneficiary of this enterprise has been Cambridge itself. Overseas students have been a vital source of talent, which has enabled Cambridge to remain the outstanding university in the UK and, however precariously, still among the best in the world.

In this cooperative effort, the trusts have been helped by many friends and supporters, including leaders of governments, philanthropists and captains of industry, several colleges (Trinity especially) and many University sources (particularly the Local Examinations Syndicate), all of whom understand that the biggest boon to the young is a good education. In turn, the Cambridge Commonwealth Trust and the Cambridge Overseas Trust have brought into being many associated trusts and foundations across the globe, manned by alumni and bound to their *alma mater* by silken but strong ties.

The trusts have also fortified Cambridge's role in the outside world through a variety of initiatives. One of these is the Commonwealth Studies Centre, generously funded through Malaysian sources, with its meetings of Commonwealth Finance and Cabinet Secretaries and most recently, on a regular basis, of

Election Commissioners responsible for more than a billion voters. Others include bringing the unique Library of the Royal Commonwealth Society to Cambridge, and setting up a chair in International Relations. Indeed, Trinity's initiative in setting up the Newton Trust, with its record of good works on behalf of the University and of disadvantaged domestic students, owes much to the example of the overseas trusts with which it shared a founder director for the first decade and more of its existence.

The Cambridge European Trust, launched in 1995 to assist talented students from the EU, has, with recurrent support from the University and from Trinity in particular, itself brought more than 2,000 scholars from the EU to Cambridge in the first nine years of its existence. And not long ago, Cambridge received from the Bill and Melinda Gates Foundation the largest benefaction that any university in this country has ever received. The Gates Cambridge Scholarships came our way because the existing trusts had helped to place Cambridge prominently at the crossroads of the world.

None of these dry statistics or stilted accounts conveys the vibrant excitement (or indeed the hard labour) involved in getting talented young people from overseas to Cambridge. In an odyssey where the University has had help from many friends, both here and abroad, we continue to travel rather than to arrive.

Anil Seal has been a Fellow of Trinity College since 1961 and has also been a University Lecturer in History and a Tutor for Graduate Students at Trinity. He has been Director of the Cambridge Commonwealth Trust since 1982, the Cambridge Overseas Trust since 1988, the Isaac Newton Trust from 1988 to 2000 and the Gates Cambridge Trust since 2000. He has also been Executive Trustee of the Cambridge European Trust since 1994 and Joint Director of the Malaysian Commonwealth Studies Centre since 1995.

CUSAFE
Chloe Hamborg

On arrival at Girton as an undergraduate, I had just returned from an unforgettable six months teaching at a school in Lesotho, southern Africa. Like many others returning from similar projects, I was bursting with stories of my experiences and the insights I had gained, which at first seemed worlds away from Cambridge life. This was soon to change, however, when I discovered Girton 'SAFE'.

The Cambridge University Southern Africa Fund for Education (CUSAFE) is a University-wide society that raises funds for charities and NGOs working to advance education in sub-Saharan Africa. Originating as a student movement campaigning for an end to apartheid in South Africa, there are today sixteen college SAFE schemes in Cambridge that raise money and promote awareness across the University.

Girton students have supported this cause for a number of years. The strength of the scheme lies in its simplicity and sustainability: money is raised through an annual opt-out system where each Girton undergraduate donates £5 to Girton SAFE in the Lent Term bill, unless they opt out. The SAFE committee then distributes the money between various charities and NGOs on the basis of their funding proposals, an activity that offers valuable experience to Girton students who wish to work in international development.

In the midst of a busy Cambridge term it can be easy to forget that millions of children worldwide are excluded from receiving even the most basic education, and that a large proportion of these live in sub-Saharan Africa. The challenges facing this region are vast and complex, with problems such as political instability and HIV/AIDS maintaining widespread poverty. Education is a powerful tool that can enable individuals and communities to break out of poverty, with the potential to transform nations. This is why SAFE focuses so specifically on education in sub-Saharan Africa.

Over the years, Girton SAFE has been an invaluable source of funding for a number of projects. One of these is CAMFED, a Cambridge-based charity that promotes female education, and through which Girton students have sponsored the schooling of girls in Zambia. Another is Link Community Development, which was originally started by SAFE students and would not have progressed to its current level of

impact without the regular support of Cambridge SAFE schemes. Projects linked to individual Girton students have also been supported by Girton SAFE, such as the funding of Braille computers for a school in Lesotho.

While the amount of money donated by each Girton student is small, its impact across the whole College can be enormous. Not only do charities and students in Africa benefit from SAFE, but the whole College is enriched by the global dimension the scheme brings. The success of SAFE in Girton and across the University displays the power of students working collectively to make a difference and to bring students in Cambridge and Africa closer together.

Chloe Hamborg graduated from Girton in Theology and Religious Studies in 2004. She was an active member of the Girton College Southern Africa Fund for Education (SAFE) for three years, and President of CUSAFE, the central University body, in 2003–4. She is now a civil servant in the Department for Education and Skills, currently working on the department's international strategy, with a particular focus on Africa.

The Girton brand
Sue Palmer

There are probably Girtonians reading this who twitch uncomfortably at the idea of Girton as a 'brand'. Yet when I was an undergraduate it was one of the most powerful Cambridge brands. Cambridge itself is a very strong umbrella brand; but many of the colleges were not, and are not, individually distinct. Girton was and is: its place in history is guaranteed as the first female college. Like all strong brands, it stood for something clear, distinctive and different.

The admission of male undergraduates could not wipe out its history, but it could, over time, erode the values underpinning the Girton brand. Did it? What does the brand stand for now? How successfully has Girton reinvented itself? In response, every Girtonian will have an opinion. This is mine.

All those who have been undergraduates at Girton will have their individual images of the College, their interpretation of the brand shaped by their unique experience, their 'million moments of truth'. In 1970, the first in my family to go university and the first female from my school to go to Cambridge, I knew little of Girton. Indeed at interview, in response to a question from Margaret Bowker, I replied that I had put Girton first (of the female Cambridge colleges) because it was first in alphabetical order. Put simply, I had no idea of its potential to change my life by creating opportunities.

What was Girton in 1970? Clearly it was a large, all-female college. It was also, thanks to Victorian sensibilities, rather remote and a long walk for non-cyclists if the last bus had departed. The red-brick buildings were rather welcoming, if the unheated swimming pool was not. Girton today, still the first female college, is among the largest colleges, located on two sites. It still has a Mistress, but now boasts bars and a heated swimming pool. These are facts. Bald facts do not of themselves communicate the brand. Strong brands are underpinned by shared experiences and values, and they appeal to senses and emotions.

So what was 'my' Girton? It was a welcome oasis of warmth, away from the ultra-competitive 'male' university. It was the woodsy smell and hollow echo of Library-wing corridors as essays were delivered in the early hours. It was the formidable array of stern women, former Mistresses with penetrating features and hair in a bun, glaring down on meals in Hall – enough to curdle the breakfast milk. It was civilised chairs instead of benches in Hall. It was raking over the soil to disguise the post-gate-hour male exodus, which can't have fooled anyone. The list goes on. All Girtonians will have their own. And underpinning this composite for me were its special qualities – opportunity, community, support, friendship and pioneering.

If this was what Girton meant to me, how has this 'essence', this soul and spirit changed in the mixed Girton? In reinventing itself, has Girton changed its features and values to such an extent that pre-1976 Girtonians would not recognise the brand?

There must be many Old Girtonians who started to disconnect with College, as I did, when they read

OVERSEAS SCHOLARS AT GIRTON
SUPPORTED BY THE CAMBRIDGE TRUSTS

Records go back to awards made in 1982. In the early years the annual number of new awards to overseas students in Girton from the Trust schemes ranged from four to eleven, but over the last ten years the figures have risen from fourteen (1993) and fifteen (1994) to twenty in 2002 and twenty-three in 2003. These cover awards both to undergraduate students and to a growing body of graduates, some coming to Girton for a year to take a Masters degree and others embarking on a three-year PhD course.

There cannot be many countries whose students have not studied at Girton. Outside the European Union, the Trusts have supported Girtonians from all the following countries:

Albania, Argentina, Australia, Bangladesh, Barbados, Belize, Brazil, Bulgaria, Canada, Chile, China, Colombia, Croatia, Cyprus, Czech Republic, Egypt, Estonia, Ghana, Greece, Hong Kong, Hungary, India, Israel, Jamaica, Japan, Kenya, Korea, Lithuania, Malawi, Malaysia, Malta, Mauritius, Mexico, Mozambique, Nepal, New Zealand, Nigeria, Pakistan, Papua New Guinea, Poland, Romania, Russia, Sierra Leone, Singapore, South Africa, Sri Lanka, St Lucia, Sudan, Tanzania, Thailand, Taiwan, Trinidad and Tobago, Uganda, USA, Venezuela, Vietnam, Virgin Islands, Yugoslavia, Zambia.

And they are spread across all subjects (graduate and undergraduate courses combined):

African History, American Literature, Anatomy, Anglo-Saxon/Norse and Celtic, Applied Biology, Archaeology, Archaeology and Anthropology, Architecture, Biochemistry, Biological Anthropology, Biology, Biotechnology, Botany, Brain Repair, Chemical Engineering, Classics, Computer Science, Computer Speech and Language Processing, Criminology, Development Studies, Economics, Economics and Politics, Education, Egyptology, Engineering, English, Environment and Development, Epidemiology, European Studies, Finance, Genetics, Geography, History, International Relations, Land Economy, Latin American Studies, Law, Linguistics, Management Studies, Materials Science and Metallurgy, Mathematics, Medical Genetics, Medical Sciences, Medicine, Medieval and Renaissance Literature, Micro-Electronic Engineering, Modern and Medieval Languages, Molecular Biology, Music, Natural Sciences, Nutrition, Oriental Studies, Philosophy, Physics, Physiology, Plant Breeding, Plant Sciences, Polar Studies, Social Anthropology, Social and Political Sciences, Statistical Science, Technology Policy, Theology, Theoretical Physics, Veterinary Medicine, Zoology.

about the progress of the men's boat, the prowess of the football and rugby teams and words of wisdom from the fresh-faced male president of the JCR. These were small changes initially, but after several years they made alumni communications increasingly irrelevant and impossible to relate to. What had happened to 'my' Girton? I only knew that deferential and polite legacy requests were likely to be ignored.

In the late 1980s, Felix Warnock, then general manager of the Orchestra of the Age of Enlightenment, of which I was a non-executive director, said to me, 'My mother wants to meet you.' That was my reintroduction to Girton, which began with a dialogue with Mary Warnock and continued with Juliet Campbell and now Marilyn Strathern. Trying to assist, a small group of OGs has given informal advice to the current Mistress over the last fifteen years. It has been challenging: the acceptance of our ideas and our essentially straightforward commercial advice by academics has been difficult.

However, our discussions always started in the same place. College wants to reach out to potential undergraduates. The selling pitch is more difficult today than it was when there were only three women's colleges at Cambridge to choose from. Why should a potential undergraduate choose Girton? College also wants to reach out to OGs now occupying key roles in public service, business, media, creative arts and government (and not only for legacies!). Why should they respond?

To succeed, Girton needs to be clear about what it is, what it stands for and why it is different. I think that under Mary, Juliet and Marilyn, College has clarified this. The lively current undergraduate prospectus provides answers – and reflects, to my surprise and pleasure, 'my' Girton. Through conversations with undergraduates, the prospectus communicates a clear sense of what is different and special. The legacy of pioneering and the creation of opportunity blaze through. The sense of community and the spirit of compassion that supported me thirty-five years ago still exist and still support today's undergraduates. There is still the 'freedom to escape' to the 'friendly, lively and supportive... out-of-town location [which] results in a community spirit unique to Girton.' There is a real commitment to equal opportunities, believable because in part this is Girton talking, and a commitment to open access to a Cambridge education for all. There remains the commitment to academic excellence.

Every disconnected OG should be sent a copy of this prospectus. The values that underpinned the brand since the days of Emily Davies, the values that made Girton special, have not only survived but thrived and still make Girton special. College has reinvented itself while remaining essentially Girton.

Sue Palmer came up to Girton in 1970 to read History and has worked in marketing for over twenty-five years. She is currently Director of Marketing Communication for Grant Thornton International. She is involved with a number of arts and heritage organisations, including Chatham Historic Dockyard and the Orchestra of the Age of Enlightenment, and was for six years a Trustee of the Heritage Lottery Fund. She was awarded an OBE for services to national heritage in June 2004.

1 For the first trip to India, an initial letter of enquiry was sent to Indian Girtonians to see if any of them would like to meet with a group from the UK, to talk about their work, careers and research and perhaps to show us round places of particular interest. The response was most gratifying, and the itinerary included a seminar at the University of Delhi, South Campus (Dr Christel Devadawson); performances and tour of the Indian School (Dr Nayana Goradia and Mrs Brinda Schriff); a visit to the reserve collections in the National Museum (Dr Janet Rizvi); and a performance of Bharatnatyam dance (courtesy of Professor Manju Jain).

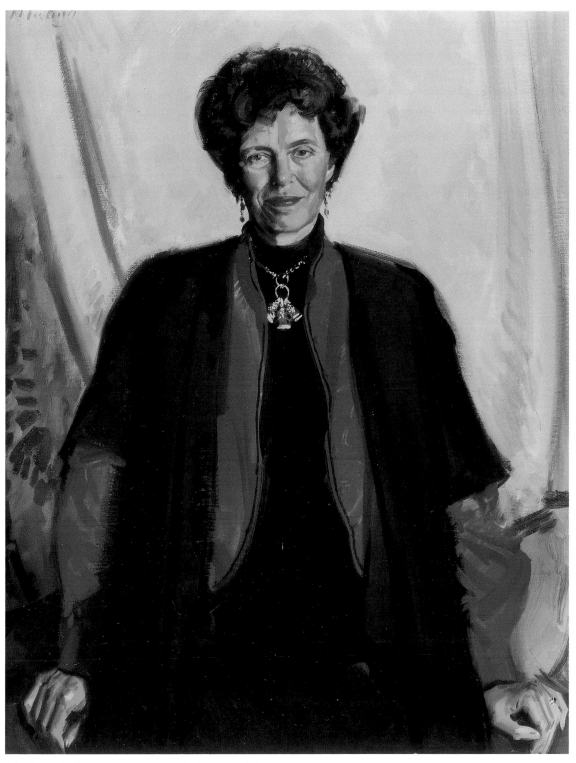

Juliet Campbell, Mistress 1991–8, painted by Andrew Festing RP

Epilogue
Unexpected resources

If the College is a microcosm of the University, the library is a microcosm of the College, and the last two accounts capture both its intellectual and its physical presence. Reflection on change from an anthropologist, a user of the Library and the Librarian bring out some unexpected facets of Girton's multiple identities.

The genius of scale:
growing large, remaining intimate
Marilyn Strathern

Muriel Bradbrook was quoting the President of one of America's great universities when she said that the academic society should 'feel small as it grows large'. The phrase appears in Bradbrook's '*That Infidel Place*'[1] published in 1969 at the start of her own Mistress-ship (1968–76). By the end of her tenure, when she handed over to Brenda Ryman, the plans had been laid for admitting men. To pick up the story where Bradbrook left off is to pick up the story of Girton's life since it became a mixed college. Hers was not a chronological account as such, although she divided her narrative into rough epochs, but was rather a series of perspectives on Girton's first 100 years. It was written at the time of student revolution, when student representation on Council was still in the future; tellingly, it ended with an essay on 'The collegiate university in the modern world'. It was partly her comparison with the situation in the USA that led us to include a comparative section (in chapter 3), while the present compilation faintly echoes her diverse perspectives.

Certainly, the present book has neither attempted a chronology nor presented the decades in distinct succession. Rather, it has juxtaposed moods and processes, taking the time span in terms of some of the many changes that have marked these years. Most notable was the very decision to 'go mixed', for this came with expectations that the move would be bound to bring about a quite radical disjunction in Girton's history. Yet in retrospect it all seems rather self-evident and undramatic! I think that is partly because the momentous changes have been happening elsewhere: it is the landscape itself that is in upheaval. Writing about Girton over the last thirty years is to write about the changes there have been in terms of ideas about national developments in tertiary education, funding and accountability regimes, student participation in College government, the role of a collegiate system and indeed about new technologies, new disciplines and the kinds of life–work choices that people make and the – global and local – society in which they live.

So what has been so fascinating about the individual contributions is the continuity of which they also speak – how one can constantly return to earlier moments and find them still relating to what

one does and how one is. Those earlier moments laid down resources for the present.

That is why this Epilogue ends by recalling the College's beginning: the familiar story of women's aspirations for higher education. But to think that Gillian Beer's piece is about the past would be to miss the point. We are shown how a thoroughly modern scholar finds, in the interdisciplinary efforts of earlier years, tools that assist thoroughly contemporary thinking. The topic of interdisciplinarity could not be more germane to the twenty-first century, to the growth of disciplines and their ever-changing constellations. But this is not a state of affairs that might interest just scholars or (as it does) the research councils that provide the infrastructure for much of Cambridge's cutting-edge work. Today's Government has aspirations for the knowledge generated in the university system as a whole. Crises over health and food, dilemmas posed by medical technologies or new genetics, issues such as social exclusion that will not go away – if there are problems that need information and research, they can be addressed only from multiple, and thus from diverse, perspectives. And how diverse perspectives can be made to speak to one another is the issue that lies at the heart of work that is self-consciously interdisciplinary.

Now the resources of the past are no different from any of the resources on which scholars and researchers draw: they would not exist if they were not embodied in minds that had access to books, experimental equipment and tools to work with, and if it were not for the buildings that house laboratories and computers. For a long time now, and largely dependent on outside funding, labs have been the province of the University. As for libraries, there is a University Library but – like sports facilities – Cambridge would not be what it is without the independent libraries maintained by the colleges. Open to users of all disciplines, these are constantly replenished resources. And in Girton that goes for both the Library and its Archive collections, as the Librarian explains below.

Today's students take these things in their stride, as they do the multiple identity of the College generated at different points in its history. If Girton conveys so vividly the sense that one is of the past and present at the same time, there is more than one location in the past to refer to. The moment it went mixed is truly cause for celebration. It has generated new ways of thinking about what collegiate education means; a resource, if you like.

The Girton that is not one time is not one place either. It is a truism that its people are everywhere, as would be the case for many organisations. The genius of the Cambridge college system is how it collects them together in the first place. I would call it the genius of scale. As Muriel Bradbrook anticipated, the University can carry on expanding, in staff and student numbers, range of enterprises, acreage of buildings. Yet people's experiences on a day-to-day basis remain steady in one respect: they are played out in social groupings on a scale that fosters intimacy and community. Of course to some extent that is what the segmentation of departments and faculties also does – but there the walls may get too high and the distances too great. Colleges open all that out again. They are interdisciplinary by their very nature: not necessarily for the scholar or researcher – there may be a rather intermittent flow of directly useable knowledge! – but for the academic. And by academic I mean the member of an institution, the employee, the administrator for whom College is both a workplace and a domestic space, as the debates at the time Girton opened its doors to men so vividly portray.

Here academics join with the students, and with College staff. For colleges are places where everyone becomes aware of different work practices, of diverse patterns to the day, of exotic avenues to relaxation; they are where one learns something of the commitments others have or the priorities that bear in on them, or hears about concerns, anxieties, enthusiasms or reasons for exhilaration far from one's own. People are connected up. It is not the kind of knowledge one loses.

For biography, see chapter 6

Interdisciplinarity and the Girton Library: a user's story
Gillian Beer

In everyday life we live in multiple disciplines and could not survive without doing so: travelling to one

end of town from another requires skills in navigation, reading, history and a number of scientific fields. But we don't boast about the implicit kinds of knowledge that allow us to complete humdrum tasks. Equally, it is important for the academic not to represent interdisciplinary studies as arcane, though working in this style certainly demands wide reading, shrewd judgment and the willingness to confess ignorance. Interdisciplinary work may involve the examining of materials from other fields according to the skills learnt in your initial discipline, or it may involve learning completely new skills in a short time, where others have spent years acquiring them. So it is full of hazards but also of excitement. It allows fresh forms of understanding to emerge, in part because it places under pressure the taken-for-granted categories within which knowledge is organised. Indeed, libraries themselves are paradoxical in this regard, offering great diversity of argument and learning on their shelves, while subtly grading all those volumes into systems of reference that tend to stabilise the current disciplinary bounds. The user appreciates the practical advantages of such specificity but can enjoy venturing into unknown library zones.

Libraries are by their nature indisciplinary but Girton's Library has a particular interdisciplinary flavour because of its association with women's education, aspirations and enjoyment over the past 130-odd years. During our immediately past thirty years, there has been a striking growth of interest in issues that bear on women's achievements, and the Library has found an expanding role in this field. That interest has coincided with the College's more recent identity as a mixed college.

What makes the Girton Library an extraordinary resource is not only the range of works acquired at the start for the education of young women on an equal standing with men, but also the special collections that bear particularly on the conditions and aspirations of women: the Blackburn Collection of nineteenth-century pamphlets and books concerned with women's issues, the Somerville Collection of books given by the daughters of the distinguished scientist Mary Somerville, one of the first women to earn a place at the forefront of scientific debate in the earlier nineteenth century, and the Bodichon Collection drawn from the library of one of our founders, Barbara Leigh Smith Bodichon, artist and feminist activist. Alongside these, within the Library collections, is the Archive, an invaluable resource for historians of all kinds.

At present in academic life we are all encouraged to work in interdisciplinary ways. Indeed, it sometimes seems that interdisciplinarity has become the goal rather than the medium, and 'disciplines' are treated as if they are entities rather than shifting categories. So it is refreshing to turn to the nineteenth-century volumes where such different – and, to our eyes, sometimes very odd – opinions and assumptions about connections between fields of study prevail: there one can find expressed in thoughtful journals the view that philology is *the* central science, that classical learning is the sole key to education, that the sciences lead to infidelity and that anthropology is the study of racial hierarchy when it is not a sub-branch of archaeology. At the same period, the social sciences, statistics, economic theory, child development and sexological studies were all newly asserting their importance as tools for understanding across fields. Such topics certainly make it clear that the characterisation of fields of study, and their alliances, change over time.

The Girton Library was a fruitful resource for me in learning to work with materials from several disciplines during the years when I was preparing my book, *Darwin's Plots* (it first appeared in 1983). But it became absolutely fundamental to my work when, in the mid-1980s, I was writing a study of George Eliot in relation to the Victorian women's movement and exploring the writings of Victorian women beyond the literary scene. I can best express the significance of the Library by taking one moment in its history to demonstrate the support its collections have given to me personally in learning to think and work across disciplines.

In 1985 and 1986 the College was considering how best to use the generous bequest of our former Librarian, Helen McMorran. At that time I was Vice-Mistress and in the thick of archival work as well.

Should we not seize the opportunity to catalogue the Archive and appoint an Archivist? There was at first some disquiet expressed as to whether this would be a backward-looking option, but College Council became gradually convinced that, on the contrary, the Archive was a potential resource for advancing understanding now, and that far from being a backwater it would fire the interest of many, very diverse workers. And so it has proved. The cataloguing yielded many treasures, and, while it was underway, the College had the opportunity to purchase the Parkes papers. This was an extraordinary adventure.

Betty Wood and I were sent down to Dorset to see the collection of letters, books, drafts and diaries, which were owned by Lady Iddesleigh and her sister, Susan Lowndes Marquez. The house was a beautiful and gently shabby Queen Anne mansion. The two sisters, now themselves elderly women, had known Bessie Parkes when they were little girls, and she had told them many stories about her own youth. So they talked with great zest about tea parties that had taken place in the 1850s, and recounted conversations that had come to them through her lips. They told these tales with such conviction and lack of self-consciousness that it was as if our memory span had been enlarged by 100-odd years. We sat at tea not only with two old ladies but with their forebears.

So who was Bessie Parkes, and what was her connection with Girton, as she never studied here? She was a figure who spanned widely different cultures: she was the first editor of the *English Woman's Journal*, the earliest magazine devoted to the Victorian women's movement and its concerns, and she was a close friend of Barbara Bodichon, who funded the journal. The collection we were being offered also included materials used by her daughter in writing a biography published as *Et in Arcadia ego*. The collection has given us a unique entry into the network of English women who collaborated on the *English Woman's Journal* and on the interlocked campaigns for work for women, as well as for their education and their right to own property. Girton owns one of only two complete runs of the *EWJ*.

The Blackburn Collection of pamphlets extends the range of this material, as it covers a very wide social span. And the Library at large has a great collection of novels by names now perhaps unfamiliar but at that time challenging – for example, the Swedish writer Fredrika Bremer, whose feminist novel *Hertha* stimulated the young George Eliot to admiration and resistance – particularly Bremer's suggestion that what has to be renounced is not worth keeping. (Barbara Bodichon named her adopted daughter Hertha, and as Hertha Ayrton she was one of Girton's most brilliant early students.)

What is striking when one turns to the material in our Library, its special collections and the Archive is the degree to which the combining of diverse kinds of knowledge, and the claim on fresh fields, were intrinsic to the Victorian women's movement. The collection of books from Bodichon's library makes clear the wide range of her personal interests: in art, music, sociology, economics and literature. And volume two (1 November 1858) of the *English Woman's Journal* (her own copy is in the collection) includes a report (p. 145) on the Liverpool meeting of the National Association for the Promotion of Social Science, which refers back to the first year (1857) when:

> ... *there were innumerable papers, furnished by highly intelligent men, and by some few women; men and women who had each and all been working diligently and with all attention to detail in their own separate departments of legal, sanitary, educational, reformatory, or economical action, and who then gave the results of their experience to the world, compressing into a few pages the intellectual essence of months and years of practical labor (sic). Those who imagined that the effects of such a meeting consisted only in a froth of words and compliments all round, could neither have heard nor read of that which was actually said and done.*

It is hard for us now to recognise just how radical was the innovation of an interdisciplinary conference where women's voices were welcome. Now conferences are the common medium and interdisciplinarity more or less required for academic funding. But in 1858 such a meeting was a political

upheaval. It was out of such movements that the Library collections of the College were formed. The reporter for the *EWJ* has 'carefully noted any passage in which reference was made to the condition or duties of women in regard to society at large' (p. 146). In his opening address, Lord John Russell asserted that 'if the young generation are to be an improvement on their fathers… it is to women that we must look for such a regeneration' (p. 146).

As part of the ferment of social concern expressed through the National Association for the Promotion of Social Science, the future of women's issues became urgent. And the novels I was reading alongside these materials proved to be not simply autonomous units but in debate with these urgent questions of the day as well as with each other. That led me to a greater awareness that no books are ever entirely enclosed: each of them is in debate with past and present companions, some of them now lost to us because they are no longer famous. Those lost companions energise the works we still read.

When I think about these people and their writings, one person stands out for me: Barbara Bodichon. I would dearly like her to walk into the room. In some measure she does so through her writings, but there is so much more to this woman than her writings can represent. She seems at home in Girton, but also in places and concerns far away. It was she who persuaded her friend George Eliot to contribute to the College. It was she also who lived half the year in Algeria with her doctor husband and half the year in London actively engaged in women's issues. She loved liberty – liberty of person and of opinion.

Her collection has two copies of John Stuart Mill's *On Liberty*. On the half-title page of the first edition (London: John W Parker, 1859) she writes, with decisiveness and vagueness: 'This book has been to Zanzibar with Colonel Churchill & returned to me by him in London 10th I think. B L S Bodichon'. She annotates extensively and energetically Mill's chapter on 'The elements of well-being', particularly pp. 126–7 of this edition. Mill writes: 'The progressive principle, however, in either shape, whether as the love of liberty or of improvement, is antagonistic to

the sway of Custom.' Further down page 127, where Mill fears the loss of individuality in Europe, she rejoins: 'The women of England have not lost their individuality or rather are gaining it.' But she agrees with him that young men (as Mill writes, p. 125) 'can be kept in outward conformity to rule' because they lack strength of will or reason. Mill: 'Already energetic characters on any large scale are becoming merely traditional. There is now scarcely any outlet for energy in this country except business.' She: 'Alas too true of young men of *fortune* in England' [her italics].

Bodichon also has the 1875 edition (London: Longmans, Green, Reader and Dyer. People's edition). On the half-title page of that book she notes, 'I have two copies of this admirable book.' This later copy is not annotated but one passage is side-lined; again the attack on custom from 'The elements of well-being' chapter (p. 41). Mill writes:

The despotism of custom is everywhere the standing hindrance to human advancement, being in unceasing antagonism to that disposition to aim at something better than customary, which is called, according to circumstances, the spirit of liberty, or that of progress or improvement.

She side-lines this passage down to:

The progressive principle, however, in either shape, whether as the love of liberty or of improvement, is antagonistic to the sway of Custom, involving at least emancipation from that yoke; and the contest between the two constitutes the chief interest of the history of mankind.

The emphasis on resisting custom is what speaks most strongly to her through her adult life, over the period from 1859 through to 1875. And that eagerness for liberty was what marked the founders of the College, though in many cases they were obliged to practice caution in its service.

Working with the resources of the Library at the time when the Archive was being catalogued, and Kate Perry, the Archivist, was first appointed, gave me a much richer sense of the College and its meaning. It made me aware, too, of how much knowledge always eludes us. Yet working with these interdisciplinary

resources, so close to the institution in which they are lodged, led me to recognise also how knowledge, apparently lost, may crop up again in unexpected contexts in our continuing present. And the recent history of the College, with all its changes, has shown a willingness to resist 'the despotism of custom' that would make Barbara Bodichon rejoice.

Gillian Beer was until recently the King Edward VII Professor of English Literature and President of Clare Hall College, Cambridge. She was a Fellow of Girton from 1965 to 1994, and Vice-Mistress from 1984 to 1987. She is now an Honorary Fellow of the College. Among her books are Darwin's Plots *(1983; 2nd edn 2000),* George Eliot *(1988),* Open Fields: Science in Cultural Encounter *(1996) and* Virginia Woolf: the Common Ground *(1996). She is a Fellow of the British Academy and in 1998 was created DBE.*

A platform for the future: the Librarian's story
Frances Gandy

In the entrance way hangs a mirror, which faithfully duplicates appearances. People are in the habit of inferring from this mirror that the Library is not infinite (if it really were, why this illusory duplication?); I prefer to dream that the polished surfaces feign and promise infinity…

Jorge Luis Borges, The Library of Babel

Whatever the professed identity of an academic institution, you may be sure that its library will reveal its character by offering a reflection, or rather a series of reflections, of that institution. There is nothing essential here, no real history, fixed or determined, but rather a series of appearances over time. From these we may infer many identities, but would perhaps be wiser rather to identify a series of principles that remain constant, but which are applied in varied ways to changing circumstances. Whether the institution follows what Barbara Bodichon dubbed 'the despotism of custom' (I draw this from Professor Beer, above), or what she called 'the progressive principle', may swiftly be established by a few hours exploring its library. In terms of both feigning and promising, nothing can quite match the library.

Girton's Library is a multitude of collections and resources. It offers information to undergraduates, postgraduates, Fellows, staff and visiting researchers. It holds material for every tripos in the University, and research material in many subjects. It contains historic special collections – of rare and unusual books on travel, natural science, philosophy, history – and the personal libraries of notable women such as Somerville, Blackburn, Bibas, Bodichon, Frere, Sargant and Gamble. It holds books given by George Eliot and John Ruskin and works owned by Florence Nightingale and Edmund Burke. It owns books of hours and a Second Folio of Shakespeare's plays, recently given to the College. It has manuscripts in Sanskrit and some very early printed books. It holds copies of their own work by Girton's distinguished Fellows and scholars, from foundation to the present day. It boasts the triumphs of former students in their publications as novelists, poets, academics, lawyers and engineers. It holds the College's Archive, which charts the institution's history and progress. And now, in the twenty-first century, it offers extensive IT resources as part of its academic support, and professional expertise in their deployment. The Library is the guardian of the College's history, the expression of its present and a key to its future. It does not stand still, even if it offers the illusion of doing so.

For example, when the Archive was first gathered together, it drew a picture of Girton's pioneering past and the profiles of many remarkable women associated with its foundation and development. However, an archive continues to grow and, as it does so, the picture is shown not to be a tableau of the past but a kinetic representation of an institution on the march, moving with, and often ahead of, its time. Since the establishment of the Girton Archive in the mid-1980s, we have acquired many significant collections, and, as the reputation of the Archive grows and spreads, so we become the repository of choice for many Girtonians and Girton supporters. Among the papers that have come to us in the last twenty years are those of Barbara Wootton, Dorothy Marshall, Helen Cam, Bertha Philpotts, Chrystabel

Procter, Dorothy Needham, Michelle Proud, Helen Megaw and the Power sisters. At the same time we actively seek current material from Girtonians working in both arts and sciences. This is how, for example, we come to have manuscript material as diverse as working drafts of the majority of her novels from P D James, and material from a major social-science survey by Sylvia Hewlett. We have taken in the archives of the Society for the Promotion of the Training of Women, and also that of the Cambridge Women's Liberation Group.

Girton's Archive continues, of course, to collect its own institutional records, a procedure now formalised and streamlined by the College's newly established records management system. Just as we still have researchers from all over the world working on our early institutional history from the 1870s, so now we have researchers interested in various aspects of the College going mixed in the 1970s. And just as we gain insights, from their personal papers, into the lives of individuals associated with the foundation of the College, so we quarry modern material from those who were up fifty years ago or less. These days we can also hear the voices, as our papers are supplemented by our growing oral history collection of recorded interviews and recording transcripts.

A library appears to order its collections into a predetermined schema of the world by means of its chosen classification scheme. In reality, no classification is absolute because it is in the nature of knowledge and scholarship to be continually crossing the boundaries and blurring the edges of what has gone before. Girton's classification tables, typed on flimsy paper long ago and kept in their well-worn red binders, show deletions, additions, recategorisations and reorderings made by a succession of Girton's Librarians (Allen, Fegan, McMorran, Gaskell and now me). The tables illustrate the constant state of flux in the ordering of knowledge and the representation of change, while the outward manifestation, in the arrangement of books on the shelves, suggests the illusion of a long-established order.

Since I was appointed Librarian in 1987, computer technology has transformed our idea of what constitutes the Library. In 1988 Bertha Jeffreys donated the first computer to the Library in memory of her mother and in commemoration of fifty years as a Fellow of the College. I remember driving her down to the University Computer Laboratory for a meeting with the computer advisor. After discussing carefully the pros and cons of various models she turned to me and said, 'Well – I suppose you'll want the most expensive one.' Of course she bought it for us, and we began the long process of transposing all our catalogue records to computer. We started with our most heavily used undergraduate collections and gradually added more computers, networked them, compiled subject indexes for improving searches and computerised the borrowing system. We took down a book stack to make space and set up a small IT resources area to offer academic web searching for students to use alongside their hard-copy texts. We wrote guides to the best use of web resources some time before the University provided them. Then we

mounted our catalogue on the web so that the Girton collections could be searched from anywhere in the world. Gradually, we extended the computer cataloguing to the special collections, a process that is still in train. The Archive too was gradually catalogued electronically and many of its collections can now be searched on the web. This too is work in progress.

Nothing exemplifies the interrelation of old and new, tradition and progress, more strongly than the new building – the Duke Building – with its IT area, new offices, repository for the Archive and the special collections and the new reading room for researchers. As you enter, you are presented, not with a mirror, like the library of Babel, but with the illuminated glass of the staff desk. You have a choice: should you go left to the books and the refuge of the upper Library, or straight on for the IT resources, the Archive and the special collections? It doesn't matter; even if you

continue in the wrong direction, this is now the Library of forking paths, so you can cut through and double back. The new walls are glass, not mirrors, so you will know where you are. The books are where they always were, as are the reference bay, the stack room and the extension. The much-loved upper Library is untouched – except that you may now look down on a fine roof of flowering sedum, the pie-crust lead of the new repository and the herringbone paving of the new courtyard. If, on the other hand, you are emboldened and strike out towards the IT resources area, you will have sixteen workstations at your disposal: possibly another version of the infinite library. As you work on your computer, researching for a weekly essay perhaps, you will look directly at the new repository for the Archive and the special collections and, through the glass wall of the new reading room (the Littler Reading Room), you will see researchers working on that historic material.

At night, if you look across Campbell Court from the Chapel, the original Library is lit up from the base of the buttresses so that you can admire its lines through the transparency of the new building. This has the effect of drawing attention to aspects of the older building that had not been noticed before. At the same time elements of the new building are illuminated – red brick, pink stone, terracotta, grey metal and quantities of glass – all speak to Girton's architectural past, while lightness, transparency and space distinguish this essentially modern building. The new does not just sit alongside the old, it throws it into a new perspective, so that you read the building again and afresh, as though for the first time. All activities are made transparent to each other in this new building and all activities are interconnected.

For first-year students in 2004 the appearance of the Library will have struck them as the norm: another aspect for them of what Girton is, or appears to be – a combination of their present and the College's tradition. For the rest of us, who have been planning this building since 1996, it strikes a dramatic shift and exemplifies that aspect of Girton that is forever moving forward. We may not offer the infinite library, but we certainly offer twenty-first-century Girtonians a working platform for the next thirty years.

Frances Gandy has, since 1987, been an Official Fellow of Girton, where she is Librarian, Curator and Graduate Tutor for Sciences. She gained her professional charter in 1970, and worked as a librarian in London for several years. Between 1981 and 1987 she read English at Lucy Cavendish College, Cambridge, as an undergraduate and graduate student. She teaches American literature, and has been Project Coordinator for the design and construction of the Duke Building at Girton.

1 Quoted (p. 121) in M C Bradbrook, *'That Infidel Place'. A Short History of Girton College, 1869–1969*, with an essay on the collegiate university in the modern world, Chatto & Windus, 1969

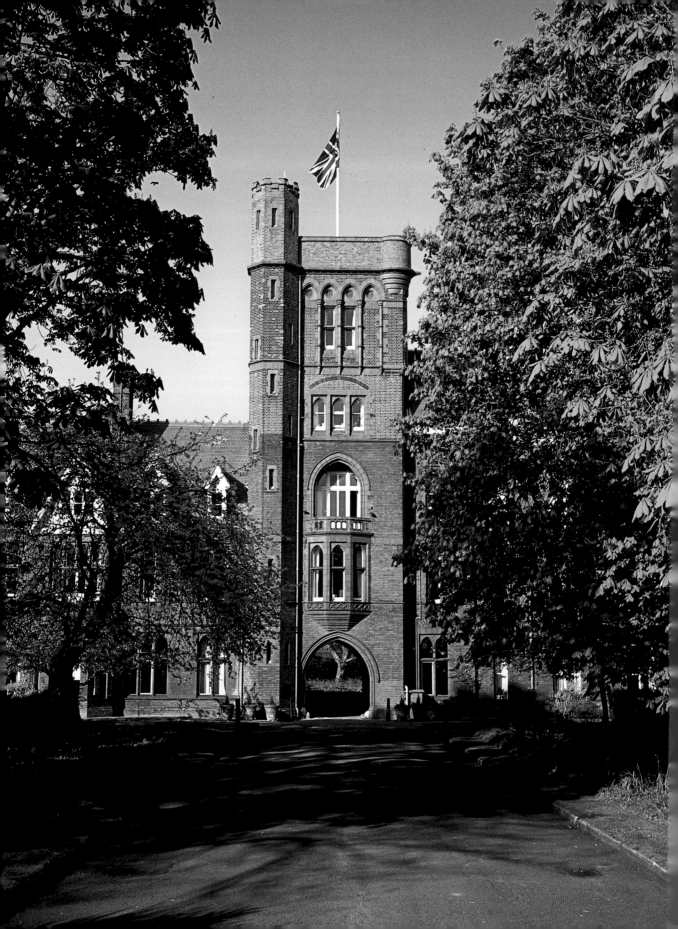

List of Subscribers

Norma Acland 1967
Dawn Airey 1981
Dr Harriet Allen 1977
Rosemary Allen (nee Green) 1955
Joelle Hatem Ancel 1991
Mark Anderson 1987
The Hon. Mrs Hugh Arbuthnott
(Anne Terdre) 1953
Gresham and Rachel Arnold 1993
Andrew John Ashcroft 1990
Julie Ashcroft (nee Cooke) 1983
Mr and Mrs D Askew 1979 and 1980
Lady Atiyah (nee Lily Brown) 1949
Prof. Helen Atkinson 1978
Audrey P Attree (nee Chapman) 1953
Mrs Catherine Avery Jones
(nee Bobbett) 1970
Kjell Ivar Wefring Bache 1990
Alison Bagenal (nee Adams) 1945
Caroline Bailes (nee Ward) 1991
Catherine Bailey (nee Crick) 1978
Dr Lucy E M Baker 1998, 2000
Shanika and Nick Baker 1994
Dr Janet Baldock (nee Cottrell) 1964
Ms Sigrun K Baldvinsdottir
Kay Barker 1946
Suzanne Barkham (nee Ratcliffe) 1961
Dr Diana Barkley
Tamsin Barnes 1993
Hugh Barrass 1981
Jane Barwick-Nesbit (nee Nicolson) 1979
Neil Bass 1980
Lynn Bassett (nee Pinnegar) 1992
Revd Dr Anne C Bayley 1952
Anthea Bazin 1970
Caroline Beasley-Murray
(nee Griffiths) 1964
Jennifer Beechey (nee Gibbons) 1973

Carol Bell 1977
Mrs Janet Bell 1972
Amanda Bell 1988
Nicole Bell 2001
Fenella Bennetts (nee Farrar) 1958
Mrs Margaret Beringer (nee Powell) 1973
Mrs Patricia Berry (nee Rignold)
Sue Best (nee Pulford) 1962
Keva Marie Bethel (nee Eldon) 1959
Jorg Bibow 1992
Daisy Bickley (nee Hurn) 1960
Valerie Biggs
Julie Bignell (nee Loveless) 1975
D C Bishop 1982
Jennifer Blackburn (nee Saunders) 1958
Ann M Blackburn 1971
Timothy Blackburn 1994
Richard Blyth 1979
Mrs D Boatman
Dr Debra Bourne 1986
Rachel Amy Bowes 1999
Anne Bowker (nee Bennett) 1960
Yvonne Boyle
Paul Brabin 1989
Christine Brack (nee Cashin) 1961
Dr Kate Bradbrook 1991
Margaret Braddock (nee Weale);
Louise Tod (nee Braddock) 1943; 1968
Dr Mary K Bradley 1972
Kathleen Bady 1973
Mrs Judith Braid (nee Slater) 1963
M A Branthwaite 1953
Tracy Brennand 1984
Dominic Bridgstocke 1979
Peter Bright 1983
Jacqueline Broadbent 1979
Miss Anna Brocklesby Davis
Dr Rosalind Brooke (nee Clark) 1943

Karen Brookfield 1976
Mrs Sheelagh M Brooks
(nee Foster Smith) 1940
Chloe Brown 1977
Dr S M Brown
Isla H Brownless (nee Forbes) 1948
Margaret E Bryant
Felicity V Bryson 1988
Alexy Buck 1993
Elaine M Bullock (nee Pomeroy) 1949
Anne Burgess PECC 1986
Jean Burnham (nee Rushton) 1972
Ian Burrows 1993
Steven J Butterworth 1980
Sir Adrian Cadbury
Bob and Jane Cadwalladr (nee Peel) 1983
Pauline Cakebread (nee James) 1976
Mrs Jane Cambidge (nee Dryden) 1980
Neil Campbell 1979
Juliet Campbell
Christopher Cannon 1993
Dr Elizabeth Capewell (nee Aldridge) 1966
Renee Carambela-Sgourda 1952
Mrs Ann Carey (nee Patrick) 1952
Viscountess Clare Carlow
(nee Garside) 1986–9
Hazel Catton (nee Middleton) 1954
Lesley Curgenven (nee Charlton) 1969
Dr Elizabeth Challis (nee Lincoln) 1962
Rosalie Challis (nee Hughes Jones) 1957
Dr Penny Chaloner 1970
Amy Chandler 2000
Lucy Chandler 1951
Marjorie Chibnall Staff 1947
Patricia A Child (nee Skeggs) 1979
J K Chilton
Mrs J K Chilton (nee Anderson) 1963–6
Dr Irena Cholij 1978

Mrs Rosemary Chorley (nee More)	1955	Margaret Double	1950	Mrs E M M Goriely (nee Molly Taylor)	1946
P J Christie		Mike Dowce	1981	Margaret Gourlay (nee Faulkner)	1956
Gim Hwa Chua	1995	Professor Ann Dowling	1970	Chris Gowland	1996
Pamela R Churchill		Fiona M Doyle	1975	Hilary J Goy (nee Corke)	1968
(nee Harwood)	1942–4	Dr Marko Dragosavac	1996	Sharon Gray	1975
Celia Ingham Clark (nee Parsons)	1977	Judith Drinkwater	1979	Susan Francis Gray	1968
Kelly Clark	1998	Carrie A Duckworth	2003	Hilda Gray	1947
Dr Sarah C Clarke MA MD MRCP	1984	Gemma D Durkin		Dr A M Griffin (nee Ryder)	1969
Monica Clarkson (nee Light-Burne)	1956	Dr Rosalind Dyer (nee Snelling)	1980	Alexandra Griffiths	2001
Mrs Cliffe (nee Morton)	1952	Mary Dyson	1958	Angela Griffiths	1977
Jeanette Clifford (nee Floyd)	1978	Tim Earl	1985	Sue Griffith (nee Greenfield)	1974
Mrs M E L Clifford		Mrs Pauline Eaton (nee Mills)	1965	Ann Elinor Griffiths (nee Evans)	1976
Alison M Clinch	1996	Dr Alison J S Edmonds	1972	Ken Grocott	1979
A E Cobby	1971	Claire Edwards	1981	Karen Guinand-Gerard	1988
Jane Coggins (nee Hinckley)	1964	Merriell Edwards (nee Bland)	1944	Audrey Gulland (nee James)	1947
Gerda Cohen		Christopher Edwards	1979	Eileen Guppy	
Lavinia Cohn-Sherbok (nee Heath)	1970	Anna-Marie Edwards	1981	Dr Angie Gurner	1949
Angela Conyers (nee Williams)	1961	Carmel Egan	1977	Susan Haggard	1979
Karen M Coombe (nee Clegg)	1978	Anita Eglitis		Roger Hakes	1997
Professor Sheila Corrall (nee Lowry)	1970	Claire Elias		John Halfpenny	
Alison Cotton	1998	Clare Ella	1987	Dr Jennifer Hall (nee Biggs)	1957
Karen Coumbe (nee Clegg)	1978	Judith Elliman	1999	Mrs Valerie Hall (nee Heard)	1959
Heather Covey	2001	Joyce Elsom (nee Grant)	1943	Valarie Hallet	1949
E Jane Cowdery (nee Shaw)	1975	Dr Elizabeth Emerson (Mrs Love)	1967	Fiona Hallworth	1977
Carole Cracknell (nee Taylor)	1979	Lady English (Judith Milne)	1959	Sally Hamwee	1966
Hannah Craik	2002	Dr M W Ennis		Alison Harding (nee Moore)	1978
Gwendoline Crane (nee Hughes)	1931	Mary Epstein (nee Noake)	1927	Sarah Hargreaves	1970
Ward and Sarah Crawford		Gareth Evans and Barbara Knowles	1979	Jane Harington	1949
(nee Brown)	1979	Jonathan P Evans	2001	Rosemary A Harris (nee Barry)	1952
Sheila M Crawford	1941	Sue Evans	1990	Liz Hartley	1995
Mr and Mrs W Crawford		Alan Every	1995	Vicky Harvey	1985
Adrian Creedy	1981	Diana M Farley	1974	Jonathan Hawes	1997
Julia M Crick (nee Boness)	1979	Jenni Ferrans	1976	Dr Valerie M Haynes	1960
Professor Sheila Crispin	1967	Ben Fetton	1996	Dr M S Hedges (nee Smith) Fellow	1969
Claire Cross	1952	Mary Field (nee Chisholm)	1960	Catherine Hemsworth	1993
Dr Christine Crow	1959	Simon Firth	1980	Franklin Heng	1988
Gwen Curnow	1953	Rebecca and Shaun Fitzgerald	1986	Ms Sylvia Ann Hewlett	
Susan Curtis-Bennett	1949	Anna Fitzsimmons;		Molly Hill (nee Bell)	1945
Dr K Dale		James Fitzsimmons	1994; 1993	Prof. R L Himsworth	1955
Joanna Dales (nee Parry)	1962	Sarah Follen	1990	Beatrice Hines (nee Fejtek)	1972
Dr Louise Dalton		Jeremy Ford	1982	Sarah Hirom (nee Wells)	1962
Nicholas Davidson	1977	Philip Ford	1977	Simon K M Ho	1996
Michael Davidson	1991	Suzanne Forward (nee Wallace)	1991	Sarah Hobbs (nee Wall)	1974
Michelle Davies (nee Baldry)	1964	Felix Franks DSc PHD FRSC		Leif Hoegh	1983
Elwyn Davies	1979	Bye Fellow	1979–97	Wendy Holden	1983
Stella M Davies	1944	Ruth Freeman	1976	Dr Deirdre M Holes	1968
Mrs Rosemary Davies		Amanda Jones Fritz	1979	Mrs Stephanie K Holmans (nee Edge)	1955
(nee Womersley)	1942	Norah K Frost (nee Manley)	1967	Mary Holroyd	1977
Miss Anna B Davis		Dr Sandra Fulton		Rachel Hood	1949
Caroline Dawes	1991	Dr Isla Furlong	1989	Cherry Hopkins (nee Busbridge)	1959
Meg Day	1967	Ian Furlonger	1993	Felicity Horowitz	1977
Chiara de Bonnecorse Lubieres	1958	Dr Sarah N Galbraith (nee Bowes)	1980	Rebecca Hourston (nee Madden)	1992
Isabel de Minvielle Devaux	1984	Monica Gale	1984	Guy C Howard	1986
Dr Catherine J De Vile	1980	Marion Gaskin	1977	Janet Howarth	1965
Dr John P Dear	1985	Elizabeth Gass (nee Acland-Hood)	1958	Sarah Hubbard	1981
Diana Devlin	1960	Patricia Gauci (nee Hooper)	1989	P G Hudson	
Mrs Dora M B Dibben		Adam Gee	1986	E Hughes	1999
(nee Tunbridge)	1938	Jo Glasson	1993	Dr M E J Hughes	1977
Margaret Diggle	1923	Fiona Gledhill	1975	Janice Hughes	1974
Kevin Dobson	1983	Marie Golding (nee Fahey)	1974	Janet Hughes	1964
Gillian Dobson		Randal Goldsmith	1992	Margaret Hughes	
Geoffrey Doggart	1995	Karen Jane Goodfellow	2000	Fiona L Hughes (nee Harrison)	1967
A Babara Donnison	1949	Richard Goodhead	1991	Laurence J Hulatt	1997
Dr Karen Dorn	1969	Janet Gordon-Cumming (nee Cleave)	1951	Mrs Jenny Hull (nee Mee)	1957

Chris Hulatt	1994
Sue Hunt (nee Robin)	1977
Wynell Hunt	1946
Felicity Hurwitz	1974
The Indian School	
Barbara Isaac (nee Miller)	1955
Margaret C Ives	Fellow 1962–70
Anne Jackson (nee Carnson)	
Anne Jackson (nee Burgoyne)	1979
Stephen Jacquest	1980
Karoline Jahn	1996
Dr Joe Jaina	Visiting Fellow 2001
Deborah Jarman (nee Skinner)	1972
Miss C F Jayne	
Will Jeffers	1984
Professor Jeffreys (nee Brown)	1960
Vivienne Johnson (nee Howell)	1942
Faith Sargent Lewis Johnson	1967
P Jolowicz	1948
Miss Nesta Jones	1937
Richard John Vann Jones	1991
David Charles Kadarauch	1985
Hutoxi Kandawalla-Bharucha	1971
Azza Kararah	1955
Martin and Laura Kasparek	
Karen L Kearney	1984
Anne Kent (nee Hartnack)	1965
Mujahid Khalid	1989
Jacqueline Kingsley (nee Schofield)	1958
Veronica Knight (nee Hammerton)	1973
Bianca Knox (nee Baur)	1933
Toshio Kusamitsu	
	Helen Cam Visiting Fellow 2003–4
Ms Susan Leong	1985
Dr Mark D Lacy	1989
Audrey Lambart (nee Field)	1952
Adam Lambert	1988
Dr Alison Lamming	1960
Anna-Louise Lancaster (nee Mills)	1993
Dr Valerie Langfield	1969
Kathryn Langridge (nee Shaw)	1977–80
Helen Langslow (nee Addison)	1966
Kay Larkin (nee Gibson)	1953
Paul and Helen Latham	
(nee Whitby)	1992
Nicola R Lawrence (nee Cox)	1978
Mrs C Sarah Lawrence	1958
Katherine Lawther (nee Cameron)	
and Eleanor Lawther	1959; 1991
Leonie Lazarus (nee Sharp)	1948
Dr Jennifer Lebus (nee Harvey)	1969
Stephen K W Lee	1983
Ann B Leech	
Diana Lees-Jones (nee Nayler)	1954
Miss S F Lesley OBE	
Maggie Lewis	1979
Marion I Lewis (nee Powell)	1969
Sylvia Lightburne	1946
J Lindgren	1952
S A C Lingard	1998
Suzannah Lishman	1986
Shirley Littler (nee Marsh)	1950
Gloria J Lo	1997
Michael Loebinger	1993

John Longstaff	1979
Joan Loveday (nee Predergast)	1955
Judith Lowe (nee Denner)	1974
Ms Debbie Lowther	
Mary Lumb	1939
Dr P Anne Lyon	1973
Mary Lyon	1943
Kevan James Mabbutt	1985
M E Macglashan	1957
D B MacGregor	
E A C MacRobbie	1958
Masako Maekawa	Visiting Scholar 1972–3
Alexander A Mair	2002
Janie Lai Chun Kaung	1964
Dr Rima Makarem	1990
Judith Mandeville Atkinson	1963
Joan Mangold	1935
Susan Mani	2000
K Mann	
Professor Jill Mann	1972
Dr and Mrs John Marks	
J Markwick Smith	1979
Susan Marsden-Smedley	1951
Penelope Martin	1991
Virginia Henry Martins	1984
Mrs Mary Mason	
Ann Mason (nee Harroway)	1965
Oliver Matthew	1996
Deryn McAndrew (nee Harrison)	1967
Isabel McBryde	
Professor John McCusker	1996
Vicki McGlade (nee Whitney)	1968
Wendy McKenzie (nee Diggins)	1967
Mrs Helen McKiernan	1972
Mrs J E McKnight (nee Ruddle)	1971
Jane McLarty	1982
Professor John McMullen	1980
Peter C M McWilliams	1984
S Mead	
Revd Dr C H Methuen	1982
The Mighty Grot Residents	
of Springroll	1994
E Joan Wilson Miller PhD	1941
Kevin G Miller	1981
Paul Miller	1991
Christopher Milne MBE	1980
Dr Jane Milton (nee Natsu)	1975
Mrs Christine Mitchell (nee Teall)	1975
Tamara Mitchell	2002
Gill Monsell (nee Thomas)	1969
Lynn Montgomery (nee Alexander)	1964
Pamela Moores (nee North)	1972
Bronwen Moran (nee Jones)	1967
Heather Morrison	1976
Karen E Morrison	1980
D Morrison	
Helen Morrison (nee Sheard)	1997
Rachel E L Morse	2001
Caroline Hanson Moseley	1956
Andrew Moutu	1998
Dr Judy Moyes (nee Paul)	1975
Pauline Moylan (nee James)	1957
Dr Christine Murphy	
(nee Robinson)	1979

Eleanor V de B. Murray	1953
Dr Anne Mynors-Wallis	
(nee Lloyd-Thomas)	1978
Siva Namasivayam	1982
Edith Navasargian	2002
R G Naylor	
James Naylor	1997
Professor Ana Neiva	1966
J A Nightingale (nee Langley)	1960
Professor D C North	
Philippa O'Driscoll (nee Thrower)	1976
Dr Elizabeth O'Keefe	
Jennie Oldham	1996
Anne Oldroyd (nee Holloway);	
Eleanor Oldroyd	1951; 1981
Judith O 'Riordan	1942-45
Ruth Osborn	
S Otty	
M Overington	
Roger Owens	1982
Elizabeth Palmer	2000
Susan Palmer	1970
S M Pargeter	1975
Mary Parker	1967
Robert Paterson	1992
Robert J C Paterson	1992
Derryan Paul	1957
Mrs Paulson-Ellis	1958
Mrs Ceri Payne (nee Bryant)	1979
Roger Peabody	1985
Susan Peatfield (nee Charles)	1984
The Hon. Mrs Perks	
Lucinda Perriam (nee Dickson)	1982
Baroness Perry (Pauline Welch)	1949
Dr T and Mrs J Pestell	1987
Allison Petch	1968
June Petrie (nee Adcock)	1948
Marie Pickering (nee Luckhurst)	1957
Robert Pigott	1979
Jon Pike	1983
Josephine Margaret Pike	
	Ex research student
	Leicester University 2002
Dr Lynda Pillidge (nee Robinson)	1977
Mrs Samantha Morton Pirkowski	1986
Mrs R I Polkinghorne (nee Martin)	1949
Dr David Poole	1982
Vicky Adrian Pope	1982
Jim Pottow	1985
Ian Power	1979
Michael Power	1979
Professor David Price	1979
Ed Pugh	1994
Andy and Cathy Pymer	
(nee Wernham)	1986
Miranda Quinney (nee Smyth)	1987
Shanti Radcliffe	
(nee Wickramasinghe)	1955–8
Dr David Ramm	1991
Margaret Ramsay	1978
Cheryl Denise Alexandra Ramsey	1979
Dr Deana Rankin	2002
Betty Rathbone (nee Bright-Smith)	1952
Vivek Rawal	1993

Tim Raybould	1985
Andy Redfern	1991
Mark G Reed	1992
C Mary E Rees	1941
Michaela Reid (nee Kier)	1953
Hetty Reid	2001
Deian Rhys	1996
Bryony Richards (nee Goodridge)	1996
David Richardson	
Jenny Richardson	1982
Janet Mary Riddett (nee Francis)	1961
Phyllis Ride	1945
Alan Ridgewell	
Mrs Margaret Ridler (nee O'Hara)	1949
Jennifer Ridley (nee Ames)	1958
Rosemary Riley	1981
James Huw Roberts	1993
Catrin H Roberts	2000
Pauline Roberts	1988
Una Robertson (nee Spearing)	1958
Elizabeth Robertson	1979
Janet F C Robinson (nee Callow)	1943
Kathleen Romain	1977
Mrs Nicholas Roskill (Julia Cooke)	1952
Jose Rowe (nee Peeters)	1957
Patsy Roynon (nee Beard)	1956
Eileen Rubery (nee McDonnell)	1966
Nicky Runeckles (nee Tweed)	1991–4
Mary Russell (nee Knott)	1977
Dr Helen Ryley	1981
Prof. Dr Jutta Rymarczyk	1987
Elizabeth Salmon	1965
Professor Valerie Sanders	1978
Clare Sargent	
Nicholas Sartain	1997
Diana V Scott	1937
Vera G Seal	
Olive M Searles	1944
Margaret Senior	1940
Claire L Seward (nee Stanley)	1989
Lindsay K Shaddy	1975
Pratik P Shah	2003
Sue Shaw (nee Everett)	1977
Dr George Shaw	1980
Mrs P Shaw	
Helen C Shead	1997
Kay Sheard	1991
Deborah Shellard	1980
Muriel E Sheridan (nee Sidaway)	1942
Miss Louise Nicola Sherwin	2001
Thomas Sherwood	
Andrew J Shiels	1992
Sheila Edith Hutton Shuttleworth	1945
Elizabeth Siddall (nee Stone)	1960
R Simonson	
Elizabeth Simpson; Helen Williams	1957
Audrey Sinnhuber (nee Daubercies)	1942
Peter and Andrea Skevington	
Lucy Joan Slater	1950
Phyllis Smart	1942
Sally-Ann Smith	1993
Dominic Smith	2000

Mrs Sarah Smith (nee Wildash)	1978
Dr Vivien Smith (nee Tate)	1978
Jennifer Smith (nee Roberts)	1968
Katherine Smyth	1941
Janet Sondheimer (nee Matthews)	1941
Peter Sparks	1985
Jonathan MacNeill Spears	1991
Dr Laurel Spooner	1979
Mary Spyromilio (nee Morison)	1959
J L Stainer (Adams)	1964–7
Kay Standidge	1997
M Shirley Stanley (nee Wright)	1950
Anne Stebbing	1975
Diana Shaw Stewart (nee Lewis)	1952
Kathryn Stewart	1990
Professor Marilyn Strathern	1960
A Streetly	
Felicity Strong (nee Ranger)	1994
Hilary Strong	1984
E M Strudwick (nee Stemson)	1932
Joyce Struthers (nee McMurran)	1948
Emma Stuart	1985
Joanna E M Sulek	1976
Anne-Marie Sutcliffe (nee Mutton)	1966
Helen Swallow (nee Symes)	1968
Angela Sydenham	
Teresa Tan (nee The)	1979
Miss Susan M Tate	1981
Elizabeth Tavner	1966
John Taylor	1988
Professor Alice Teichova	
T Teparagul	1998
Dr Anne Thackray	1970–3
Charis R Theocharis	1982
Eng San Thian	2003
Dorothy J Thompson	1958
Jane Thompson	1971
Elizabeth Thompson (nee Sherwood)	1959
Dr D D Thompson (nee Webb)	1943
Christine Thorp	1964
Mrs Rosemary Thorpe	
Charles Thursby-Pelham; Mia Thursby-Pelham (nee Williams)	1981; 1982
Dr Mary Tiffen (nee Steele-Perkins)	1949
Richard Till	1993
Lesley Timings	1971–4
Lauren Tinker	1999
To'Puan Chit Wha Gunn-Lau	1951
Nicole Trask	2000
Fiona Tremethick	1982
Jennifer Treutenaere (nee Amos)	1990
Lorna Troake	
Warden, Wolfson Court 1977–93	
Mrs M Trotman (nee Pocock)	1952
Wendy Tucker (nee Jones)	1962
Susan Tuffin	1971
Shirley Turner (nee Davis)	1950
Dr Priscilla Turner	
Eugenie Turton	1964
Margaret Tyler (nee Hughes)	1953
Dr Althea Tyndale	1965
M Tyndall	1936

Adam Tyrer	1988
Anita Tyszkiewicz Hooper	1956
Virginia van der Lande	1949
Patricia Van der Zee (nee Turner)	1964
Bianca Van Onden; Betty Knox	1933–4
Dr Carol Vielba (nee Burtchett)	1966
Joyce Lady Waley-Cohen (nee Nathan)	1941
Joanna Waley-Cohen	1970
Sandra Walker (nee Hunt)	1970
Gavin Walker	1993
Flora Wallace (nee Macleod)	1952
Edward Chung Yern Wang	1986
Gregory Warner	1979
Baroness Warnock	
John Warren	1996
Dr Ruth Warren	
Valerie M Warrior	1955
Margaret Warton-Woods (nee Johnson)	1979
Dr Christopher Warwick	1992
Professor Deryn Watson (nee Morgan)	1964
Jane Way (nee Whitehead)	1962
Hilary R Weale	2000
Harvey and Catherine Weaver (Catherine Mansfield)	1991; 1993
Dorothy Wedderburn	1943
Ann Weitzel	1981
Mavis Weitzel (nee Leigh)	1946
June Wellington (nee Horwood)	1947
Elizabeth Werry	1955
Carolyn West (nee Horton)	1973
Eileen Louise West (nee Yardley)	1947
Fidelity Weston (nee Simpson)	1982
Dr Matthew J D Weston	1990
Joyce Westwood (nee Murrant)	1935
Ruth M Whaley	1977
Patrick G Wheeler	1982
Sue White	1986
Hilary Wilderspin (nee Chatters)	1980
Gesine Kramer-Wilke	1984
Dr Ruth M Williams	1962
Margaret Williams (nee Thomas)	1965
Katherine Williams	1966
Greg Williams	1996
Alexander Willmott	
S D Wilson (Waller)	1961–4
Susanna Wilson	1999
Jenepner Wolff Moseley	
Dr Howard Wong	1990
Jean Woo	1968
Mrs A M Wood (nee Hynam)	1968
Gill Woon (nee Doubleday)	1977
Veronica Wootten (nee Cadbury)	1951
Josephine Wright (nee Payne)	1978
Barbara Wrigley (nee Adams)	1943
Marina Wyatt	
Mrs Deidre York (nee Macdonald)	1955
Caroline Young	1979
Jeremy Young	1987
Alexander P Zorn	1998